INTERACTION

ARTISTIC PRACTICE IN THE NETWORK

EDITED BY AMY SCHOLDER
WITH JORDAN CRANDALL

EYEBEAM | atelier

D.A.P. / Distributed Art Publishers, Inc. New York

Published in 2001 by

D.A.P./Distributed Art Publishers, Inc.
155 Sixth Ave. 2nd Floor
New York NY 10013
T 212.627.1999
F 212.627.9484
E dap@dapinc.com

ISBN 1-891024-24-8

See ww.eyebeam.org for a study guide to this book

First Edition

Printed and bound in the United States

Design by Rex Ray

INTERACTION

NEXT>

FOREWORD

IN1997 I founded Eyebeam Atelier, a not-for-profit organization for artists and audiences interested in the educational, aesthetic, theoretical, and conceptual potential of new media art. By advancing the discourse between art and technology, Eyebeam serves to reflect and expand the scope of contemporary artistic practices. One of Eyebeam Atelier's programs is the online forum, an annual virtual event that aims to further critical discourse on artistic practices in the global communications network. *INTERACTION: Artistic Practice in the Network* is the distillation of our first online forum <eyebeam><blast> and the original essays and visual projects it inspired. Featuring an international group of scholars, critics, and artists, *INTERACTION* articulates the changing modes of perception, representation, and identification as a result of the internet and new technologies. We hope readers will gain insight into the clashes and exchanges of cultures that are awakening in the dawn of this new media, and embark on an exciting exploration of issues that constellate around the World Wide Web and its users.

In the next two years we will break ground for Eyebeam Atelier's largest endeavor, the construction of a new museum of art and technology in the Chelsea area of New York City at 540 West 21st Street. This new structure will be New York City's first venue dedicated exclusively to new media art, a dynamic center with exhibition

NEXT>

galleries, artist studios, multi-media classrooms, a theater, a new media art archive, and a bookstore. The Museum will provide unprecedented opportunities for artists exploring new media in video, moving image, DVD, installation, film, 2D/3D digital imaging, and sound. *INTERACTION* is the inaugural publication of an original series of critical books that will be produced by Eyebeam Atelier.

The production of this book has required the insight, expertise, and dedication of many individuals, all to whom I am most appreciative. Beth Rosenberg, Education Director of Eyebeam Atelier, brought the online panel to the Atelier and oversaw its live production, while Elizabeth Slagus, Education Coordinator, took it to its printed format. Together they managed and nurtured the development of the printed publication from its inception as a virtual symposium. The director of the online forum, Jordan Crandall, has been a wise and discerning advisor to all involved. I am most grateful to Amy Scholder, editor of this work, who helped us to fill in the blanks with her knowledge of the industry while still remaining sensitive to our unique needs. Many thanks to Rex Ray, for his clear-eyed and befitting design work. I would like to extend my appreciation to Cat Mazza, who fact-checked and proofread each contribution with delicate care, and to Myia Williams, our professional copy editor. I would also like to recognize D.A.P. for their support and attentive tutelage in the publication of this work. My gratitude also extends to L. Claire Davis, former Administrative Director at Eyebeam, who worked on this project in its formative stages. Also, Lis Smith, an intern from the University of Rochester; Lawrence Berman, an intern from SUNY-Purchase; Purvi Shah, an intern from Parsons School of Design; and Andjelika Jovanic, an intern from City College-CUNY, all donated their time as well as their enthusiasm to this project in various ways. Special thanks to the invaluable assistance from the Atlantic Foundation and from the New York State Council for the Arts. And most importantly, on behalf of everyone involved in this book, I would like to thank all artists, writers, and visionaries who so graciously contributed to this body of work.

—John S. Johnson
Executive Director
July 2000

INTRODUCTION

JORDAN CRANDALL

THE INTERNET provides an extended studio for creative production as it compels one out into the world, into new kinds of cultural conversations and identifications. It is an environment for proliferating arrays of expressive means, a system for entirely new modes of exchanging goods, a vehicle for new forms of community structure and media strategy. It marks a volatile time that cries out for passionate critical and political debates. If the problematics of access, cultural bias, and media literacy were resolved, the Internet could very well become the ideal medium—an inclusive, global intertwining of the best that broadcast and interactive media have to offer. The question is: What will we say with it? What kinds of cultural questions will we ask?

The contributors to *INTERACTION: Artistic Practice in the Network* approach these questions as if the very public nature of the Net were at stake. They see the Internet as nothing less than a new kind of urban realm, or a vast extension of the urban, with all of its problematics, pleasures, and urgencies. The degree to which one feels and expresses this situation will be the gauge of artistic work that endures as we enter an accelerated century characterized by multiple inputs, attention wars, waves of desire-inducing stimuli, and the intoxicating instantaneity of all things digital.

NEXT>

For three months in the spring of 1998 an online forum called <eyebeam><blast> joined hundreds of participants across the globe. The discussions concern what it means to be alive at this historical moment, at the crossroads of so many profound changes. At center stage are the transformations wrought by the Internet, especially their implications for artistic practices. Emphasizing the material and the local—the sensoria and situatedness of everyday life across diverse regions of the globe—as it integrates with the displacement fueled by global networks, this forum is an elaborate social world criss-crossed with new kinds of presences. It has intersected with embodied realities in very complex and surprising ways, facilitating illuminating encounters with others. Studiously self-reflexive, it has generated passionate debates on precisely what constitutes this "other." Playful and encouraging of experimentation, it has inspired artistic interventions that toy with questions of embodiment, identity, and locality.

Bracha Lichtenberg-Ettinger writes that the borderlines between aesthetics and ethics have to be renegotiated and re-attuned daily. Political concerns fuel the discussions because questions of identity and power are so acute, so near to heart, especially for those who sense the promise of the Net and the potential for its abuse. The relevance of artistic practice for cultures in transition, overwhelmed by the forces of globalization and grappling with new forms of cultural identity, is challenged. At the same time, the emergence of entirely new visual languages and the possibilities for artistic interventions in the symbolic fields of the Net suggest new directions for artistic work. Whether political or formal, art can help illuminate changes in perception and representation at the same time that it can offer new possibilities for critical endeavor. As Margaret Morse suggests, direct and symbolic forms of intervention are equally in play as the distinctions between symbols and realities increasingly erode. What volatile combinations are masked by this seemingly uniform space of the Net, smoothed over with a lulling glow.

The texts reproduced here represent only one possible journey through this forum. Many contributions have been omitted due to publishing constraints. We have regrouped the forum into seven thematic chapters—"Embodiment: Human-Machine Connection," "Networks: Bodies, Symbols, Cities," "Identity: Where is Global?," "Institutions: Architectures of Attention," "Language: The Tyranny of Theory," "Disappearance: Art

on Life Support," and "Politics: Power in Cyberspace." Commissioned visual projects and essays elaborate on crucial themes initiated in the forum discussions, including the intersections of technology, body, and code; the aesthetics and politics of programming; the poetics of online communication; and the relays between urban structures and distributed networks. What emerges is an unequivocal assertion of the relevance of artistic practices at this moment in time, as we witness the corporate invasion of the Web, when new critical strategies need to be developed within market systems and the question of civil space must be situated across another private/public divide.

As Ursula Biemann reminds us, artists were never really able to access broadcast space as a medium. The possibilities of broadcast intervention were simply incorporated as "video art" and safely ensconced within the museum. Will "net art" meet the same fate? With the Internet, we have a vehicle of artistic production and distribution on a scale we have never known before. Its relationship to the museum/gallery system is not as urgent as the need for the continual development of inclusive platforms that take full advantage of networks—especially since, with media consolidation and rampant commercialization, those platforms are endangered. At the same time, the relevance of art must be debated in a US-dominated, globalized culture that, on the one hand has no use for art, and on the other hand regards everyone as an artist who can take advantage of digital tools.

At least in the wealthy countries, the tools are indeed in the hands of more people. One could celebrate this situation and say that, since there are more venues for creative expression on a global scale, the beleaguered context of art is rapidly expanding to a much more inclusive and democratic realm. Even business people—intoxicated with the revolutionary spirit arguably lost by the avant garde and the creative impulse for "thinking outside the box"—consider themselves artists today. While no one would deny the need for creative outlets, there is a danger in subsuming all artistic activity into a vast expressionistic soup. If everything is art—design, business, streamed videos, advertising, lifestyle ("the art of living")—what exactly does it mean?

NEXT>

On the other hand, as a culture of specialization, one could certainly see the context of art as rapidly diminishing. It is under siege as its western bias is undermined through the hard-won inclusion of alternate histories and as its elitist underpinnings are attacked in a consumer culture ever more hostile to the humanities and to intellectual pursuits. Just what is its relevance at this moment? What is the difference between expressive work and critical work? Between art work and "media practice"? Should these differences be fought for? How do we evaluate what is meaningful? In whose terms?

INTERACTION: Artistic Practice in the Network is engaged precisely with these issues, from diverse points of view and from various regions throughout the globe. Our contributors are artists, technicians, students, scholars, critics, architects, curators, and media practitioners from Russia, Brazil, Yugoslavia, United States, India, Japan, South Africa, Canada, Australia, Mexico, and many countries throughout Europe, linked across radically reconfigured geographies and shifting speeds of access.

Creating an instantiation of an online forum has been an enormous challenge, since online conversations are multi-threaded and anchored in time, poised somewhere between writing and speaking. Carlos Basualdo describes them in terms of voices coinciding and diverging, presences coming and going, and whole paragraphs migrating from one voice to another. For Myron Turner, these online conversations exhibit a structured unstructuring that allows participants to "move fluidly between the personal and the theoretical, from the formalism of structured thought to the tentative, untried thought spoken as an aside." Unfairly favoring those who write well in English and who have fast Net connections, they challenge one to meet the demands of accelerating, multitasked realities while at the same time to confront enormous divisions of access, literacy, and cultural bias. They show that forms of social organization across the diverse regions of the network—new kinds of communities, discourses, and friendships—can be vast and deeply etched onto this most transitory of landscapes. Since these interactions helped to launch an extraordinary new organization—Eyebeam Atelier—they also show the need for such inventive kinds of institutions, which are able to account for, and further, diverse community forms and media practices. With the dedication of such organizations, we will all surely encounter one another (and others) again and again, in the construction of this strange new networked urban space.

ARCHIVE AND EXPERIENCE:
IMAGINING THE <EYEBEAM><BLAST> FORUM
BRIAN HOLMES

EARLY IN THE three-month electronic free-for-all that ultimately produced this book, a woman wrote to say that for her, email had always seemed anachronistic. In nineteenth-century Paris, didn't the postman come four times a day? The word "forum" could make you imagine something elevated, dignified, idyllic. But <eyebeam><blast> proved somehow very different: an endless stream of intricate reflections, obscure rants, heartfelt intimacies. The Republic of Letters in megabytes of ASCII. The woman I mentioned didn't know how to respond—for her it was "information overload."

In the pages of this book, that problem has entirely disappeared. The sprawling archive (around 650 messages all told) has been deftly edited and re-threaded, producing a relatively short text that is surprisingly easy to read. The writing is alert, wide-ranging, complex and contradictory—nothing like a linear discourse, and still very much a conversation, despite the occasional gaps and absent references that will make you sense something is missing. The diamonds have been cut from the rough, the precious stones are polished, it's strewn out on the table in artful disarray. I never thought chaos could be so nicely arranged.

And yet the overload, the surplus, the tag-ends, the non-sequiturs, all that is worth remembering. It's like the experience of the city: jostling sidewalks, honking horns, milling crowds, and everywhere the Babel of conversation, from café tables and gallery

NEXT>

openings to flea-market hucksters and soapbox democracy. You can easily imagine that experience in a setting of glass and steel and stone—but how does it come through in an email forum? There, the registers of feeling, the sights, smells, sounds, and general emotional tone of the crowd all have to be carried by the modulations and rhythms of writing. At best, what emerges is the elusive quality of "voice," which only seems to take on its modern timbers in the midst of blaring noise, or outright cacophony.

Now, it seems to me that <eyebeam> had that quality of cacophonic voice to a high degree. That's why it was so successful as an experience. Since it's impossible to fully reproduce that quality in a book, I'd like to delve back into the archive (still online at www.eyebeam.org), and use it to speculate on why this particular listserve experiment came to be such a compelling one. What was its underlying architecture? How was it inhabited? These questions are worth asking, because retrospectively imagining an event like this can also be a way of projecting it toward the future. And I'd like to meet the literati out on the street again.

FORMS AND FORMATIONS

The most intriguing chaos arises not from an absence but from a surplus of form. Which is another way of saying that organizing this kind of electronic speak-easy is more difficult than it seems. To spark off the conversation, twenty-two people with something particular to say about "artistic practice in the network" were invited as guests. Their names and concerns were then circulated, along with a basic statement of intentions, through all the print and electronic channels that could be mobilized by two small institutions, Blast/The X-Art Foundation and Eyebeam Atelier. Once the forum was underway, the guests appeared at more-or-less regular intervals—one, two, or sometimes three times a week. Being a guest often involved posting a manifesto, but any kind of self-presentation was possible. Some said their piece and disappeared, others followed the forum throughout its duration. The insurgency of the guests was matched by the tenacity of the "hosts," six in number, who were theoretically there to be warm and welcoming but who, at least in my case, I must admit, could be as outspoken as any ruffian from the virtual "street."

Beyond the guests and hosts, the forum was open to all kinds of offerings, ranging from the casual to the highly conceptual or artistic. Jordan Crandall, as moderator, had the responsibility of "filtering" the messages, which involved eliminating spam, calming the ardors of self-promotion (i.e., posts with fifteen self-addressed URLs), and diverting certain overly personalized messages to their single addressee. The fact that a human being dealt with the inflow, rather than a listbot, meant that the posts came grouped in one or two arrivals per day, introducing a pattern of lags and bursts into the conversations.

The form of the proposal—its underlying architecture—was this rhythmic, partially structured, complementary/contradictory flow of written ideas. But as Raymond Williams spent most of his life telling us, form is mostly significant for the kinds of meetings it makes possible. It is inseparable from social formations. The question then becomes, can we really talk about social formations in the disjointed global network of the internet?

Looking back into the archive, it appears that the two main groups involved were artists and media enthusiasts actively experimenting with the internet, and artists, critics, or curators using the net for communication—that is to say, two very loose formations which shade into each other and yet are by no means the same, particularly in terms of their familiarity with the technology and history of the medium. The year was 1998, just before the cresting wave of new and curious internet-users would be overcome by the tidal-wave of near-obligatory competency for anyone involved with the international dimensions of art and culture generally, not to mention business. This particular point in time meant that access had become an established fact at various levels of society and in far-flung corners of the world, even while the particular conventions, lingo and mores of the early, experimental aficionados, going all the way back to the scientific communities and the early American bulletin board systems like The Thing and The Well, were still very present in the choice of subjects and the style of conversations. Of course, this was also the moment when the citizenries of the world were beginning to take stock of the realities of globalization—responding with a mix of bewilderment at the changes and elation at the new possibilities, scrambling to take a position in the flux and beginning to show

NEXT>

concern about the patterns of positionality which were finally emerging into day-light. With the result that the core population of relatively young, in-the-know, high-ly educated, largely Anglo-American artists, critics, scholars, and media people were likely to be interrupted and challenged in their certainties by practically anyone, from anywhere with a phone line—a possibility which, for me at least, was the best part of the experience.

MOODS AND GESTURES

The internet is a distribution system, as broadcast technologies were in the past, but also a distributed system, which is a very different thing. It is both a set of sophisticated conduits for delivering messages to far-off receivers, and a disjunct, virtual whole that can only function through the cooperation of its distant parts. This means that it creates a huge new audience or market in which the old problematics of power and seduction come quite differently into play, while at the same time it offers a recursively structured feedback environment for exploring every kind of social or intersubjective relation, from psychoanalytic transference to performance art to political confrontation in public space. Most of the theoretical discussions in this book revolve around the implications of this two-pronged definition. But as the expe-rience unfolded, there was also a relatively keen awareness of what each specific post could do within that double dimension, between broadcast and feedback on the group.

The identity of an online exchange like this one comes not from any pre-existing common ground—which can hardly be assumed—but from the ways that the free-dom of gesture is used in the give-and-take of exchange. Most obviously this con-cerns the nature of the debates, the kinds of questions asked, the polemics, the flame wars (of which there were really very few). But theatrical and artistic gestures can also be enacted within the window of an email: in the archive you'll find Angus Trumble's fantasies of the dancer Vitruvius; or long posts from Mez, with comic sce-narios of robot-human conversations; or the ASCII drawings and informational scram-blings from jodi.org; or Eve Andrée Laramée's stochastic science fiction ("The Fissiaultian Paradigm"); or Clifford Duffy's poetic diatribes; or Greg Ulmer's philo-futurological creations ("electracy," "cyberpidgin," the "emerAgency"). All these were

ways to shake up the discursive flow, to play with the medium and offer a different point of view, a different way into the conversation.

Of course, artistic display can easily become a seductive ploy for wider distribution in the "attention economy," just like the intellectual pyrotechnics of the theorists. This hunger to show off, to be part of a fantasized cyber-elite, was the target of the Afrika group in an early, preemptive post that just said: "e-race." But there was another sort of self-reflexivity here, dealing with the patterns of interaction in a distributed system. I'm thinking again of Eve Andrée Laramée, with her periodic postings of "Only Questions," long lists which served to map the collective inquiry; of Andreas Broeckmann's thoughtfully annotated recaps of the conversations; of Carlos Basualdo's and Bracha Lichtenberg-Ettinger's explorations of transference over the net; of m@'s "mail thread index" (posted under the title "Re:"). The desire to lend shape to a conversation without controlling it, to precipitate a shared unknown— this was definitely a mood of <eyebeam>.

Threads were maintained with a certain care amidst anarchy, by a tacit agreement that had something to do with the early, cooperative ethos of the net (rapidly disappearing today). Questions were tossed back and forth, the answers emerging in chains of replies where the original subject gradually modulated. One can't speak of discipline in these exchanges. But there was an experimentalism that has everything to do with the example of a work brought up by Gilane Tawadros, in a post reproduced in this book: a LED display in central London, registering artist Simon Tegala's heart rate as it fluctuated throughout the day. <eyebeam> was a place both to watch and to play with a kind of collective heartbeat, in a new kind of public space. In this respect, the fascinating discussions of interactivity and hypertext—especially by Bill Seaman and Simon Biggs—could have been applied directly to the context in which they were formulated.

In terms of the group's reflection on itself, the most telling gestures were undoubtedly the "localization" posts, in which people tried to give an idea of where they were, physically and socially: like Ricardo Basbaum's message from a neighborhood of Rio de Janeiro (which made its way into this book) or Tglatz's from a shack in the

NEXT>

Alaskan bush (which didn't). These descriptive posts tended to cut through the rhetoric of disembodied virtuality, and at the same time, to give strength and depth to the speculations on proximity, intersubjectivity, and agency in immaterial exchange. They were a necessary anchor (though based entirely on "faith," as Carlos Basualdo pointed out) to the intense debates on the question of the Other that ran throughout the forum, pushed ahead by Lev Manovich's polemical essay, "On the impossibility of 'national schools' in net.art," and by Olu Oguibe's refusal to accept an "ethno-designated Internet." Rather than furthering the infinite categorizations of official multiculturalism, the localizations brought ideology up short, cleared the field. Through these situated postings, cast into the very medium of globalization, you sometimes got the impression that another individual was trying to look you right in the eye—a strange and powerful experience through the standardized, impersonal window of an email.

PASTS AND FUTURES

Reflecting on the changes in technology and its uses, Alan Sondheim pointed to the quasi-demise of the "darknet," the older, text-based interfaces (Usenet, the MUDs and MOOs, and so on). Today, a scant two years later, the "bright net" is already the predominant reality, as TV corporations leer out at us from the web and hyperconnectivity becomes the mantra of the new economy. At the same time as broadcasting power increases, the fascination with interactivity is everywhere, not least in the spectacular correlation between the planetary propagation of "popular" moods through the communications media and the portentous fluctuations of the collective heartbeat that the stock markets have come to represent—for the rich or the cleverly indebted, at least. In this light, the threaded conversations of <eyebeam> seem theoretically astute, experimentally vital, and yet politically somewhat naive. Not only because these impending changes were so little discussed, and not only because—Zapatista references notwithstanding—the practical methods of net activism and "tactical media" remained largely absent from the debate, even while the networked campaign against the MAI treaty (Multilateral Agreement on Investment) was being waged and won. But above all, because such slight attention was paid to the "artistic practice in the network" in which we were actually engaged: the constitution of an experimental social formation on a global scale, with specific characteristics and possibilities.

After reading the last, densest chapter of the forum in this book, on politics and power in cyberspace, a question still lingers in my mind: how to make a genuinely artistic contribution to the emergence of a global civil society? As the world market consolidates, at a pace with military alliances and increasingly binding international laws and regulations, we can see this new scale of civil society taking on various shapes and counter-shapes, in what is essentially a struggle over diverging values and rights to existence. Fascinating as these new global formations are, they are clearly not all artistic. But I would argue that the form of an internet exchange, or its architecture if you will, can be usefully considered as the artistic departure point of a collective experiment, one which develops recursively, through creative tensions both with its own foundations and with other, coexisting forms and formations. It is important that the givens of this formal architecture be constantly reworked and extended, brought into relation with other elements and domains (for instance: old and new media, events and exhibitions, physical gatherings and debates, long-term collaborations). Only if such experimental endeavors are sustained within the artistic community, in many directions and at sufficiently large scales, can we expect the extremely rich pasts of artistic culture to continue exerting an influence in global exchanges, beyond the safe havens of universities and museums.

The <eyebeam> forum was promising in this respect, because it was large (around 800 subscribers at the high point) and relatively mainstream in art-world terms, while still remaining open to confrontation with all kinds of outsiders, to creative tension with "thought from outside." In this way it almost seemed to contradict a troubling phrase from Richard Sennet, quoted by a forum participant in a thread called "The Politics of New Technologies": "The geography of the modern city, like modern technology, brings to the fore deep-seated problems in Western civilization in imagining spaces for the human body which might make human bodies aware of one another." As geography and media technology increasingly intertwine, it is clear that the ultimate stakes of our imaginary constructions and communications are the architecture of the city itself, the ways we inhabit it and move through it physically, the kinds of encounters we look for. At certain moments—for instance, during the virtual uproar of the <eyebeam> forum—email debates have been an important resource for the collective imagination. But as the uses of the net are normalized and integrated into

NEXT>

the eternal present of a commodity-oriented culture, there is the danger of forgetting even to look for such resources, of ignoring the virtual cacophony and its relations to the real one. At the very best, this book—and the archive that underlies it—could be a way of remembering possible futures.

FORUM

EMBODIMENT: HUMAN—MACHINE CONNECTION

FROM: MARINA GRZINIC
<grzinic@img.t-kougei.ac.jp>

After living and working in Tokyo for eight months with my family, living not as a single researcher, but being in connection with the Japanese reality through different roles, from researcher, woman, artist, wife, and mother of my seven-year-old son, I understood that technology is functioning in Japan more in a way of masking, recoding, and transcoding the body than as a way of communication and connection. It is a process that allows the user to completely hide his or her physical body. Layers of images are very suitable for deepening the hierarchical facades of the Japanese society. But when the body starts to be disobedient and cataleptic, mass hysteria is provoked. We were taught by the Pokémon story that something holds true about the intersection between the body, technology, and the image.

In December 1997, TV Tokyo suspended the weekly broadcasting of the popular Pocket Monster cartoon known as Pokémon because nearly 700 people, mostly children, nation-wide were taken to hospitals after watching the show. TV viewers were afflicted by an outbreak of convulsions and faintness, ending with catalepsy. The scene from Pokémon suspected to have sent hundreds to hospitals can be described as four seconds of flashing red, blue, white, and black lights. It was a kind of strobe flash, like second sunlight. The Japanese National Association of Broadcasting industry immediately launched an investigation of the whole case.

Pocket Monster is not only one of the leading metaphors of Japanese pop culture—a culture fascinated by cartoons—but moreover through Pokémon we can discuss some other important points connected to the relation between the physical body and the image. Instead of falling into the mass psychological hysterical readings of TV as always a bad and dangerous influence to generations of viewers, I would like to establish an almost heretical interpretation of the event. The TV epilepsy-like illnesses attack brought back to a mass of Japanese TV viewers the reality of their physical bodies. The human body was for more than a century almost captured and frozen as an image. In 1877-80, the psychiatrist Martin Charcot, at the Paris Salpetrière Hospital, took photographs of hysterical patients with the purpose to make the illness visible. In the 1990s, the body fights back! With the reaction to Pokémon, we witness the disobedience of the hitherto immobile, suffering body in relation to the image. Hysteria was recognized as an illness only through making visible by photography the woman's hysterical body. The success of photography in anchoring hysteria had to do precisely with mechanisms internal to photography, which are connected with its "reality effect," and with the photographic potentiality to freeze the convulsive hysterical body. It seems that

NEXT>

today in the world overfilled with images, to make the body visible and to sense that we have a physical body, the body had to fall back again into hysteria, into an outbreak of convulsions and faintness, ending with catalepsy.

Pokémon also allows us to discuss the idea of total visibility that is constantly produced by the mass media. Total visibility is media processed, it is a construction. In reality we have, as Peter Weibel once noted, zones of visibility and zones of invisibility. The Pokémon Cataleptic Tuesday Event (Pokémon has been aired every Tuesday since April 1997) reveals not only the core of the process of representation and the so-called zero point of representation in relation to the physical body, but it is an almost psychotical appearance of these constantly hidden zones of invisibility. These zones flashed for a moment so brightly on the surface of the image, allowing the body to be blind and hysteric.

FROM: N. KATHERINE HAYLES
<hayles@humnet.ucla.edu>
I have just finished my book, *How We Became Posthuman*, so it is uppermost in my mind. The issues that the book raises center around three interconnected stories. The first is how information lost its body, that is, how it became reified as a technoscientific concept and conceptualized as distinct from the physical markers that embody it. In my view, this reification of a disembodied concept of information has led to such fantasies as Hans Moravec's, that it will soon be possible to download human consciousness into a computer.

The second story centers on the cultural and technological construction of the cyborg in American cybernetics from 1945 to the present. Here I see three waves or periods. The first, going from 1945 to 1960, focused on the idea of homeostasis, the ability of systems to maintain steady states despite upheavals in the environment. Cybernetics in this guise was associated with a "return to normalcy" after World War II, but also with the thought that American expertise could be used to create machine-human amalgams that would be more efficient war machines and information-processing systems than ever before. The second phase, from 1960 to 1985, focused on trying to incorporate reflexivity into the system, that is, to acknowledge that the observer is part of the system he or she observes. This led, among other results, to the formation of a radical epistemology in the work of Humberto Maturana. The third wave, from 1985 to the present, focuses on virtual technologies, including cyberspace and artificial life. Here the idea of emergence is foremost—the thought that complex systems, when recursively structured, can spontaneously evolve in directions their creators did not anticipate.

The upshot of these two stories is registered in the third, the transformation of the human to the posthuman. Basically, I argue for the importance of embodiment in rethinking issues around cyberspace, and for the posthuman as a distributed cognitive system, with human and nonhuman components. The posthuman is best understood, in my view, not as an antihuman annihilation of human life as we know it, but rather as the newest phase of a process that has been ongoing for thousands of years of cognitively enriched environments. Edwin Hutchins points to this process when he asks why modern humans are capable of more sophisticated cognition than cavemen. We can achieve this, he suggests, not because we are smarter, but

because we have built smarter environments in which to function. Seen in this way, the posthuman offers us a way to think about human-machine interfaces in ways that are life-enhancing rather than life-threatening. It also offers opportunities to get out of some old boxes, particularly the mind/body split, and to put embodiment back into the picture.

FROM: BRIAN HOLMES
<106271.223@compuserve.com>
Katherine, your approach demystifies cybernetic technology and relates it to older mnemonic technologies such as books, architecture, frescoes, cave paintings, and so on— all the forms that humans have impressed more or less permanently upon matter, either to save themselves the physical energy of doing a job, or the mental energy of remembering a thought, or both at once. In this sense we have always lived in a "distributed cognitive system," part living, part inanimate. But there has been some disquiet for a long time about the perception that the accumulation of disciplinary technologies— relating, for instance, to the structure of the state, or the organization of industrial production and the management of its symbolic equivalents (that is money)—could become so great and so rigid as to effectively block human autonomy, freeze it into certain very limited patterns. When people complain about being reduced to the status of machines, they're generally complaining about the imposition of such a discipline.

Are you suggesting that the development of cybernetic technologies, as such, may help alleviate that problem? Will posthuman cyber-intelligence have a more supple approach to human relations than the earlier varieties? Or will it just be more efficient?

FROM: N. KATHERINE HAYLES
<hayles@humnet.ucla.edu>
Of course, it depends on what technologies one focuses upon. But it seems to me that a good example of a "supple" technology is the World Wide Web. In my view, the Web, for all its problems, has been one of the important progressive developments of this century. Its potential for opening up communication between people who would otherwise have a difficult time finding one another still amazes me. Embodiment in my view is very much related to political questions. Briefly, I see the prospect of an axis of physicality/virtuality coming into existence, where the privileged end is the virtual one (understood as a removal from the consequences of embodiment, for example when American pilots used virtual technologies to bomb people on the ground in the Gulf War). My response to this situation is to try to point out the ways in which all technologies, including virtual technologies, are of course embodied; they couldn't exist in the world if they weren't. At issue here, then, is not only how the technologies are constructed in fact, but also how they are constructed in discourse. I see the rhetoric of disembodiment (e.g., Gibson's *Neuromancer*, John Perry Barlow's take on Virtual Reality) to be politically dangerous.

FROM: MARTIN JAY
<martjay@socrates.berkeley.edu>
Regarding the technological mediation of light, I agree that we cannot begin to make sense of what light might be without attending to the media that allow us to see it. The most basic, of course, is the eye itself, with all of its lenses, humors, rods, cones, etc., which are (roughly) continuous with the prosthetic devices that we've invented to extend its power. As a contact lens wearer who is beginning to develop incipient cataracts, I am

NEXT>

very sensitive to the continuum between internal and external lenses in my ability to see. Whether incorporating more and more external devices leads to a posthuman outcome depends on your definition of the human. We don't deny human status to those without sight, so why deny it to those with especially enhanced vision?

FROM: BRIAN HOLMES
<106271.223@compuserve.com>
Maurice Merleau-Ponty wrote a lovely little book called *Eye and Mind*, against the reduction of thought to abstract, atemporal representations like the perspective system or projective geometry. He considered the machines that develop and implement such representations to be a poor metaphor of the self. For Merleau-Ponty, thought is inseparable from perception, which in turn is inseparable from the particularisms of one's body in time: the right side is not the left, seeing out of two eyes is not the same as seeing with one, youth is not old age, and so on. His book is an invitation to develop a certain kind of attention to the connection between self and world through the bodily senses. In the end, even the various technological amplifications of perception no longer seem to annihilate the possibility of relations between specifically embodied bearers of consciousness. "All techniques," he says, "are techniques of the body."

This attitude can apply to the extremely supple technology of the Net, and I sense, from time to time, the presence of bodies through their electro-poetic traces on my screen—traces that remain material-energetic and finite, despite the immense scope of their reproduction through the Net. But I think Merleau-Ponty's invitation to a certain kind of practice has to be renewed in our day. The

dissociation between what I send out over the Net and its effects can be so great as to encourage me to forget other bodies (or what Levinas calls the face of others). The example of American jet-pilots bombing Irakis seen through a VR helmet is a case in point; the current workings of the finance economy are, I'd say, a parallel writ large. And despite the self-teaching capacities built into their feedback loops, cybernetic information processing machines do not yet seem to me to offer a very good metaphor of the way to make decisions about birth, death, and what to do in between those potent thresholds.

FROM: N. KATHERINE HAYLES
<hayles@humnet.ucla.edu>
As I see it, one of the major driving forces behind the posthuman is the desire to conceptualize human being and human cognition in terms that allow it to be articulated seamlessly with intelligent machines. Very often, in practice, this means erasing the importance of embodiment (as when Hans Moravec foresees human consciousness being downloaded into a computer), because as soon as one attends to embodiment, it becomes obvious that humans and computers are built (and operate) very differently. Far from wanting to simply reinscribe the posthuman as it is currently formulated, I want in some very specific ways to contest it as a term, to draw into question certain assumptions now associated with it.

FROM: JOEL WEISHAUS
<reality@unm.edu>
The human is "seamlessly articulated with intelligent machines" that sh/e designed! Seems like a feedback loop to me. Thus, is this posthuman any different than the human inscribing itself?

FROM: BEN WILLIAMS
<bwilliams@citysearch.com>
I'm very mistrustful of equations between human and computer. I think the reference to Foucault's idea of language as a paradigm for the human condition as justification for the computer-human equation reveals the limitations of structuralism in general: its tendency to ignore material difference in favor of abstract similarity.

FROM: SIMON BIGGS
<simon@babar.demon.co.uk>
I think the essence of Foucault's argument was to avoid the paradoxes implicit in an essentialist view of the human. He sought to establish the human not as a thing in itself, but as a field of relations, of actions and reactions. He deduced the importance of language as a primary expression of these relations and as the medium through which they came into being.

As such, Foucault did not argue that language is a paradigm for the human, but that it is the means and expression of the human. When extending Foucault's arguments to cover the issue of computing, and in particular the human factors involved in computing, what is being established is not a mapping between computer and human, but rather a dynamic of relations. The computer, as a language machine, is first and foremost an extension of the technology of writing, in fact a form of writing, and thus a linguistically determined artifact, operating within a linguistic field, which in turn alters (or at least interacts with) the textuality of things.

The computer has an important role in terms of the definition of the human, if we are to accept Foucault's argument regarding the human as a linguistically determined thing. If the computer is part of language, then it must, per se, be part of the human, and thus speak of the human. However, this in no way implies a mapping. Like a human, the computer can also exist at a nexus of complex relations, and in this sense Foucault's work does not help us at all in differentiating between the machine and the human. Other discourses have to be developed to deal with that. While I see strong relations between computers and people (especially in terms of their mutual relations to the linguistic field), I am certain that the two are very different things, of entirely different natures. For me the discussion of the human/machine relation is only interesting insofar as it tells us of the human. The machine, in itself, is not interesting.

FROM: BRIAN HOLMES
<106271.223@compuserve.com>
I think there is a richer understanding of the notion of discourse. Foucault also speaks of discourses as "technologies of power," and shows that all discursive formations are bound up in specific material practices, each with their own potential for mobility and inertia. The question then becomes one of our position in collective structures or systems (or what some people here have called "distributed systems," situations where part of the deck you're playing with is embedded somewhere outside your control). Based on one's sense of position, one then makes tactical moves in the hope that they'll ripple out through the larger system.

The question is, on what basis do you make the tactical moves? Using what common sense? I'm not sure that we should always use technologies as conceptual models or metaphors for consciousness. The model of networked systems has given rise to ideas of

NEXT>

cultural nomadism, the schizophrenic personality, punctual or disjunctive identity, and so on. These ideas have been liberating in some ways, but the tactics and experiments they enable often seem to make ripples for ripples' sake, which can be individually interesting—like Bram van Velde painting in the dark—but which give no purchase for action at the systems level (the collective level). I feel that the schizo-paradigm in the universities has helped neutralize a lot of potential resistance to the new forms of domination at work in the abstracted, highly channeled societies of information exchange.

FROM: ALAN MYOUKA SONDHEIM
<sondheim@panix.com>
It's not only time, it's lag that drives the Net, and in particular, lag that is both random (stochastic) and effective through human expectation. In other words, there are time dumps that drive both seduction and interference on the Net, and these are rarely taken into account. For example, a fast online email connection results in the ability to chat through email; slower connections or downloading the mailspool (Eudora, etc.) changes the phenomenology. I would write more on this, but the current lag between this Sydney, Australia, suburb and my New York City provider is two minutes, and I literally cannot see what I am typing.

FROM: GILANE TAWADROS
<gtawadros@iniva.org>
Walking through the streets of central London in February, you might have come across the large LED sign in a shop window. "Simon Tegala's heart beat is 110 bpm" reads the sign. The number of beats per minute fluctuates. And as is so often the case with statistical information, it is compelling to watch and monitor this person's heart rate get high-

er and higher and then suddenly get lower. But what does this information actually tell you? Every minute shift in Tegala's heart rate, his most intimate bodily changes, are on public display, and yet we know nothing about this person and where he is. This site-specific artwork (and related Website www.iniva.org/anabiosis) made by the artist Simon Tegala earlier this year has its beginnings during the Gulf War when the artist reflected upon the impact of new technology and, in particular, the relay of "live" events and images into our homes from different parts of the globe, virtually as soon as they occur. For a period of two weeks, the artist was wired to a personal heart rate monitor for twenty-four hours a day. The signal from the heart rate monitor was then transmitted digitally via mobile phone to the electronic sign. The piece was an eloquent investigation of the relationship between individual experience and public communication systems. The most important question posed by this artwork was the thorny issue of collective responsibility and critical interrogation of new media. When the images of "precise" target bombings were beamed into our homes, how many of us questioned the precision of this new technology or considered the effects of this anonymous technology on individual (and invisible) lives?

FROM: ADNAN ASHRAF
<adnan.ashraf@bender.com>
Regarding the interface between a user and her computer, I've observed phenomenal idiosyncrasies manifest between my qi-field (my life, my energy) and the PowerPC that I use to write, Web design, email, research, and so on. At the risk of seeming paranoid and/or solipsistic, there's been evidence on a regular basis of a bioelectric interface between me and the machine. It probably has a lot to do

with intentionality, and the quality of qi. A while back when I was stressed, or ill, or stuck in a feedback loop of contrary expectations, the machine would backfire, lock up, or crash. In fact, I view this as further proof in the ongoing accumulation of daily proofs of a holistic paradigm. I'm not saying the machine's alive, but I've suspected that it interacts with my qi. I bring this up because I'm curious to know if anyone can point to research on the bioelectric interface between the user and the machine.

FROM: JUDITH THORN
<jjthorn@sirius.com>
Although I have not participated in a research project on this observation, I can attest to the phenomenon myself. A number of years ago when I was struggling with life/world issues, I had a few days in which every piece of electronic equipment I touched would fail. A friend and skeptic who worked in theoretical physics was present on one of these down days and said that had he not seen it for himself he would not have believed it. I think that the electronic and magnetic circuits of the body release currents/ions/charges that have effects on machines. I associate the application of this energy with other sorts of what are known as supernatural or spiritual practices.

FROM: WALTRAUD SCHWAB
<schwab@ipn-b.de>
I live in Berlin. My first and fairly new computer crashed the night the Berlin Wall came down, and I thought it was because the air was magnetic, tense, and electric that night. I had watched the eight o'clock news on which they already announced some strange message of the politbureau that said that whoever wanted to cross the border could do so. I didn't quite understand. Was it a metaphor? Which border was meant to be

open? I continued listening to the radio. Within the next few hours a tension built up that I have never since experienced. The guy who commented on the music started to talk about people crossing the border to West Berlin, his voice taking on an almost hysteric tone, because he also noticed some hesitation and disbelief in people he spoke to, whereas for him the whole thing had already turned into a real event. Suddenly my computer crashed and I thought, That is it. I have to go to see what is happening.

In the courtyard I met my sister. I told her, The wall is open. We drove to the next checkpoint, stood around together with other West Berliners, and indeed gradually people came through the security areas. Once in West Berlin, strangers hugged each other. Some were lost, others just wanted to have a beer. Some never wanted to go back, others did want to go back. People in cars were coming into West Berlin. Champagne and money were handed around. We decided to go to Oberbaumbrücke, a different checkpoint where no cars could pass. The atmosphere was more relaxed there. People from East and West Berlin were talking to each other. Some punks had brought their flag with the A in a circle for anarchy; one woman was playing the "Internationale" on her trumpet, but she didn't quite know how to do it. She said, I only had my first lesson yesterday. The changes happen so fast these days, you can't quite keep up.

The night my computer broke down, there was a chance that people of opposite backgrounds would take the opportunity to talk to each other. Back at a computer now, I wonder if the new media have been helpful in creating a common language between people from the east and people from the west.

NEXT>

FROM: CRITICAL ART ENSEMBLE
<ensemble@critical-art.net>

Two technological revolutions are currently taking place. The first, and most hyped, is the revolution in information and communications technologies (ICT). The second is the revolution in biotechnology. While the former seems to be rapidly enveloping the lives of more and more people, the latter appears to be progressing at a lower velocity in a specialized area outside of peoples' everyday lives. In one sense, this general perception is true: ICT is more developed and more pervasive. However, Critical Art Ensemble would like to suggest that the developments in biotech are gaining velocity at a higher rate than those in ICT, and that biotechnology is having a far greater impact on everyday life than it appears. The reason that ICT seems to be of such greater significance is less because of its material effect and more on account of its utopian spectacle. Everyone has heard the promises about new virtual markets, electronic communities, total convenience, maximum entertainment value, global linkage, and electronic liberty, just to name a few. Indeed, this hype has brought a lot of consumers to ICT; however, this explicit spectacularized relationship with the technology has also brought about much skepticism born of painful experience. Those who work with ICT on a daily basis are becoming increasingly aware of office health problems, work intensification, the production of invasive consumption and work spaces, electronic isolation, the collapse of public space, and so on. The problems being generated by ICT are as apparent as its alleged advantages, much as one can enjoy the transport advantages of an auto while at the same time suffer from the disadvantages of smogged-out urban sprawls.

On the other hand, biotechnology has proceeded along a much different route. If ICT is representative of spectacular product deployment, biotechnology has been much more secretive about its progress and deployment. Its spectacle is limited to sporadic news reports on breakthroughs in some of the flagship projects, such as the unexpected rapidity of progress in the Human Genome Project, with the birth of Dolly the cloned sheep (and now her daughter, Polly, a recombinant lamb containing human DNA), or the birth of a donor-program baby to a sixty-three-year-old mother. Each of these events is contextualized within the legitimizing mantles of science and medicine to keep the public calm; however, the biotech developers and researchers walk a very fine line, because developments that go public can easily cause as much panic as they do elation (just as the aforementioned examples did). Consequently, the biotech revolution is a silent revolution; even its most mundane activities remain outside popular discourse and perception. For example, almost all people have eaten some kind of transgenic food (most likely without knowing it). Transgenic food production, while advantageous for producing industrial quantities and qualities of food, is not a big selling point that marketers want to promote, because there exists a deeply entrenched, historically founded popular suspicion (emerging from both secular and religious experience) of anything that could be construed as bioengineering. Unfortunately, this very sort of research and development is progressing without contestation, and (to make matters more surprising) there are strong links between developments in biotech and ICT.

For example, when imagining the cyborg society of the near future, considering the rapidity of ICT development within the context

of pancapitalism is only half the task. The question, Who is going to use the technology? becomes increasingly significant. ICT has pushed the velocity of market vectors to such an extreme that humans immersed in technoculture can no longer sustain organic equilibrium. Given the pathological conditions of the electronic workspace, the body often fails to meet the demands of its technological interface or the ideological imperatives of socioeconomic space. Feelings of stress, tension, and alienation can compel the organic platform to act out nonrational behavior patterns that are perceived by power vectors to be useless, counterproductive, and even dangerous to the technological superstructure. In addition, the body can only interact with ICT for a limited period of time before exhaustion, and work is constantly disrupted by libidinal impulses. Many strategies have been used by pancapitalist institutions in an attempt to keep the body producing and consuming at maximum intensity, but most fail. One strategy of control is the use of legitimized drugs. Sedatives, antidepressants, and mood stabilizers are used to bring the body back to a normalized state of being and to prevent disruption of collective activity. (For example, 600,000 new prescriptions were written in the United States for Prozac in 1993, and this number has continued to advance throughout the decade.) Unfortunately, social control drugs often rapidly lose their effectiveness, and can damage the platform before it completes its expected productive life span.

In order to bring the body up to code and prepare it for the high-speed social conditions of technoculture, a pancapitalist institutional subapparatus with knowledge specializations in genetics, cell biology, neurology, biochemistry, pharmacology, embryology, and so on

have begun an aggressive body invasion. Their intention is to map and rationalize the body in a manner that will allow the extention of authoritarian policies of fiscal and social control into organic space. We know this network as the Flesh Machine. Its primary mandate is eventually to design and engineer organic constellations with predispositions toward certain task-oriented activities, and to create bodies better suited to extreme technological interaction. The need to redesign the body to meet dromological imperatives (whether in warfare, business, or communications) has been prompted by the ICT revolution. ICT developers must now wait for the engineering gap between ICT and its organic complement to close; because of this, ICT development is slowing down (the World Wide Web was the last high-velocity moment in the popular ICT revolution) compared to the rate at which investment and research in biotechnological processes and products for humans is growing. Critical Art Ensemble believes that while we will continue to see ICT upgrades (such as in bandwidth) and further technological development in domestic space, radically significant change in the communication and information technology of everyday life will not take place until the gap between the technology and its organic platform is closed.

Given the entrenched skepticism about bioengineering, what would make an individual embrace reproductive technologies (the most extreme form of biotech)? For the same reasons people rushed to embrace new ICT. In the predatory, antiwelfare market of pancapitalism, one must seek any advantage to survive its pathological socioeconomic environment. The extremes that function in the best interest of pancapitalist power vectors are instantly transformed into the common in a

NEXT>

society that only profits from perpetual increases in economic velocity.

At the same time, the institutional foundation that produces the desire for bioengineering has blossomed in late capital. The eugenic visionary Frederick Osborn recognized that more hospitable conditions for eugenic policy were emerging in capitalist nations as early as the 1930s. Osborn argued that people would never accept eugenics if it were forced on them by militarized directives; rather, eugenic practices would have to emerge structurally from capitalist economy. The primary social components that would make eugenic behavior voluntary are the dominance of the nuclear family within a rationalized economy of surplus. Under these conditions, Osborn predicted, familial reproduction would become a matter of quality (owing to the value of efficiency inscribed on the family unit) rather than a matter of quantity (as with the extended family). Quality of offspring would be defined by the child's potential for economic success. To assure success, breeders (particularly of the middle class) would be willing to purchase any legitimized medical goods and services to increase the probability of "high quality" offspring. The economy would recognize this market, and provide goods and services for it. These conditions have come to pass, and the development of these goods and services is well under way.

FROM: JOY GARNETT
<rglib3@metgate.metro.org>
The public is always a part of the equation, especially when they're being led on. Money is key, and the public is there to be manipulated. Think of NASA. Think of the repertoire of astronomy photographs and images that have been bled to the public over the years.

The image(s) of the Moon or Saturn you have in your head are not there by accident. Our layman's sense of what is out there was carefully constructed for us. These industries are highly dependent on their ability to construct a public face. The Human Genome Project is almost all show. The problem is, there isn't as much of real importance—real headway in terms of reducing human suffering—going on as they would like us to think. A lot of mediocre ideas get substantial funding.

Every now and then, someone on the inside writes a tell-all book. (Try *The Billion Dollar Molecule: One Company's Quest for the Perfect Drug*, by Barry Werth. It reads well.) The primary problem that afflicts the sciences, indeed our culture in general, is not a lack in terms of tools of facilitation or technological prowess. The problem is a lack of substance to the inquiries actually undertaken, and a tremendous failure to support individuals who do have substantive ideas— a lack of desire to do good, or to support those whose research is to do good, whether or not their methods of inquiry lie outside the fashions and trends of the moment. (This is also a problem in the arts.) A good treatment that has little moneymaking potential may never be brought to market. Areas of research that aren't potential moneymakers seldom get enough funding or attention. Substance carries little clout; credentials and prestige are only badges. The AIDS epidemic has engendered the only true "revolution" I can think of, in terms of how pressure from the social sector can actually change the direction of technology and its uses. Public perception, gained through radical programs devised by groups such as Visual AIDS, Gran Fury, and ACT UP, forced the issue on the medical establishment and has had unexpectedly positive results.

FROM: JORDAN CRANDALL
<crandall@blast.org>

"The gap between the technology and its organic platform" is also being closed by making ICT wearable, attached directly to the body, or inserted into the skin. At the same time that biotech seeks to close the gap by building from the cellular level upward, ICT advances from exterior computational systems to bodily attachments and insertions, which augment sensorial and perceptual processes (among others). Each an attempt to bring the body "up to code." On the one hand, we have the biological metaphors of the Net and curious alignments with sociobiology, and on the other hand, the computational metaphors of biotech (body as decipherable code, etc.) most of which rely on ICT. And there are odd fields like nanotechnology, where the computational is inserted into the cellular level, but relying on the cellular already figured as an information processor. In any case, the need to redesign the body to meet dromological imperatives (whether in warfare, business, or communications)" is clear. What is the role in this landscape for critical artistic practice?

FROM: CRITICAL ART ENSEMBLE
<ensemble@critical-art.net>

The current normalized body cannot carry the proposed technological superstructure. For example, the McDonnell-Douglas's Pilot's Associate is a pilot-machine interface that feeds the pilot immediate information on mission planning, tactics, system status, and situation assessment. Of course, it has a fail-safe. The computer is trusted more than the pilot. The computer is programmed to take control if the pilot is failing in his mission (HAL 9000 is back). The organic infrastructure of the cyborg has to be organically modified to close the gap, using techology to prepare the organic for the technology that is not going to work.

What is the role in this landscape for critical artistic practice? I think this is a moment in which artists can do what artists do best—mediate information in a manner that yields new perceptions and narratives. And I don't mean science fiction narratives; I mean narratives that engage the real and the practical, and have resonance in everyday life. Critical artists can bring the knowledge out of the labs and into the lives of nonspecialists. Then we can offer fluid possibilities for interpretation of this knowledge (both applied and theoretical). The problem now is that the nonspecialist public does not have a clue what is happening in the labs and clinics. The only regular intersection between the general public discourse and specialized scientific discourse is in the realm of ethics (the most impoverished and reactionary of language systems). Artists can play a significant role in developing an awareness about biotech and languages with which to speak about it critically. However, to accomplish these goals, artists have some self-educating to do too.

FROM: JOY GARNETT
<rglib3@metgate.metro.org>

First of all, how can "critical artists" bring the knowledge out of the labs? You presume there is knowledge to be brought out. What if you're wrong? What if there is no "knowledge" in the labs, only paths of inquiry, experiments with all their ups and downs, tricky revelations that need years of interpretation, debunking, and repeating, scads of disappointing results that also need eons of interpreting, etc.? Within science itself, specialists from different areas find themselves outsiders regarding one anothers' viewpoints, agendas, attendant data, and interpretations.

NEXT>

Where does this leave "critical artists"? What you end up with are nonspecialists who, in their zeal to dig out and interpret things for which they lack the specialized language and tools to begin to understand, end up misinterpreting incomplete data and projecting a lot of inaccurate "fluid possibilities." The blind leading the blind.

How could the nonspecialist public have a clue what is happening in the labs in clinics? Do they know about Deleuze and Guattari, or Lacan? Are not the languages used in these special-ized fields highly specialized themselves? Do you, as a critical artist, think you can, without years of dedication, without learning the language, begin to understand particle physics or the habits of retro viruses enough to present them to the nonspecialist public? We have a problem here of ultra-specialization in our culture, and it's going to take the efforts of specialists themselves to resolve it.

The only valid way for us to play that significant role is through collaboration with the scientists and other specialists outside our field. This would provide a way to achieve a genuine understanding within each discipline and an understanding of the value of each other, and to stretch each discipline ever so slightly: collaboration between individuals in different fields.

FROM: CRITICAL ART ENSEMBLE
<ensemble@critical-art.net>
I am not speaking of experimental work so much (although it would depend on the initiative), but the done-deals which are manifesting in technological systems that are already having material impact on society. To understand much of this impact and its relation to scientific discourse, it is not necessary to have a Ph.D in a scientific field in much the same way that a person can understand the social and political impact of computers without having a Ph.D in computer science or political science.

On our latest project, "Flesh Machine," Critical Art Ensemble spent a year in the labs at the Mellon Institute, and lived with a couple as they went through IVF, so we do agree that research is required, but I do not have to be an expert on fertility to critique the use of "selective reduction" in human reproductive clinics. It's not that mysterious and complicated.

As a critical artist, I do think you can "without years of dedication, without learning the language, begin to understand particle physics or the habits of retro viruses enough to present them to the nonspecialist public." Let me give you an example. Information concerning the AIDS crisis at all levels was taken from the "experts," remade, and redistributed. I found the information provided by ACT UP and GMHC to be much more helpful than what was coming from the scientific community. I think the same can be said of the feminist movement's treatment of abortion and other women's medical issues. In art "proper," a work like Group Material's AIDS Timeline was a brilliant and substantial social history of the relationship of the political, scientific, and medical discourse surrounding AIDS. As with AIDS and abortion, it's time for artists and activists to make similar inquiries into other issues of biology and biotechnology.

The rhetoric that only the experts have the right to speak because only they can understand a subject, and that any nonexpert who speaks is simply presumptuous (the blind leading the blind) is one of the primary

ideologies that confounds the development of interdisciplinarity and collaboration. There is much biotech work that certain branches of science does not want represented to the public. In these cases, I doubt that corporate and military scientists will offer the rope that hangs them. Sometimes you just have to go it alone rather than do nothing at all, and hope that the experts will play nice.

FROM: OLADELE AJIBOYE BAMGBOYE
<bamgboye@globalnet.co.uk>

There has to be more talk about what I would call the Westernization of the culture of science that mandates it be north of the equator. Without going too much into the connections between non-Western and Western scientific approaches—the ways in which anything non-Western is relegated to alchemy or to the mysterious, hence the recent resurgence of interest in this area by Western conceptual art makers as a backlash—this bias also fuels the interest in the "low tech" end of technology as applied to art.

While the boundaries of science and art need to be brought together, it is vital to ask what we aim to achieve by this process. A new "truth"? In a recent symposium in London, artists were brought head to head with their scientific "counterparts" in what was an attempt to either open up science to the public (the official Wellcome Foundation line), or to prove that artists are on a par with their science cousins. The underlying interest in this strategy and in what Critical Art Ensamble is talking about is the question of intellect and intellectual property. Rather than bickering among ourselves as to whether artists are clever, there are still some Hegelian headaches to be cleared up: recently in a conference an elderly member of the audience asked me what right I had as a non-Westerner

to use Western technology for my practice. Such a blatant question was one I relished tackling. I went back to the origins of a purported technological advancement. Even American Scientist magazine has published amply (1995 issue) on the nature of African iron smelting. "Experts" now agree that iron was being smelted in sub-Saharah Africa as early as the sixth to ninth centuries b.c. In any case, what is significant is that the iron diffusion theory about the diffusion of knowledge from Europe and an area now known as Turkey, or as a Northern African phenomenon passed through trade to the lower Sahara is now refuted. But refuted by whom? Who has that power to define scientific history? In any case, the process of iron smelting stopped a long time ago, with some very fine technological and aesthetic achievements like the Benin bronze heads or the Yoruba iron casts. This must make the society there now post-technological by Western definition.

I applaud Critical Art Ensemble's motives in somehow "redressing" the balance between the lab and the outside, but why should artists be ethical doctors of this ailment? I am worried about the utopian and emancipatory possibility that is projected on the work of CAE as a result. Can anyone tell me when in the history of Western art it has been possible to change societal aims through the emancipatory aspects of art? Russian realism didn't achieve this and neither did any rigidly centered politics of identity strategy. Is this not a case of borrowing from the language of the institution to show how clever we artists are? I think this will extend our institutional privileges too far.

To be more hard-core, many artists dive into technology as a "tool" without, as Coco Fusco

NEXT>

suggests [see Chapter 4], appreciating the more political and cultural aspects of the medium, in their attempt to satisfy the ego. There are real differences between artist Ph.Ds and those in the scientific and technological realm, in terms of the drive. Most technology Ph.Ds are already predefined by the interest of the industry through research fellowships into "outstanding issues," and as such are very different from those having more of a choice in what one wants to research in the humanities.

I think the inevitable need for artists to embrace certain elements of technology is paramount, and may require a complete rethinking of our strategies of practice. Many understand the fundamentals of the technology we use, but see as a more superior aim to rise above the technical into the realm of the philosophical abstract. The reason why the artists and technology debate is often the blind leading the blind is all about egos. Sometimes we artists simply have to stop playing god when it suits us. We can rip into science or anything because we somehow come from a privileged position with the all seeing eye that is above criticism. We only want to collaborate on our terms, to make them understand; in short, science and technology are the Other. I speak from an experience of both fields, and I frankly cannot wait for the day when artists take their profession seriously enough to realize that they are not above extending their own knowledge base.

FROM: MEZ
<mezandwalt@wollongong.starway.net.au>
INFODOM INC has been striving to establish a prototype AI (Artificial Intelligence) with an autonomous function that will mimic the behaviors and emotional responses of a human being. Trials run to date have proven to be successful with the results including the development of a computer-generated entity that partially achieves this aim. The entity is the Multi Artificial Life Form Interface, or MALFI for short.

MALFI is essentially a variation of the earlier discontinued versions of INFODOM INC's attempts to merge biotechnological advanced robotics with competent decision-capable hardware. These attempts invariably ended in failure, with the resulting entity either 1. having its humanoid and decision making components successfully integrated, only to break down as its awareness of its cyborg self evoked a response equivalent to an human emotional or nervous breakdown. For example, the COMPAKER 1.0 was constructed using a gene splice of human, mammal, and insect DNA in an effort to create an android that would be physiologically capable of performing difficult duties under extreme meteorological conditions, like polar miners or deep earth core workers. The resulting organic components cultivated created sensations too advanced for the corresponding learning curve-oriented hardware, resulting in massive circuitry damage and overall entity instability. Or 2. having its structural and decision-making components successfully integrated, only to experience a similar breakdown/unacceptable stress reaction as its awareness of its androidal self became evident. For example, the android INVITRO-LATOR 1-1.97 was specifically created to address the problem of infertility in certain financially capable clients. The androids were constructed exactly to resemble physically and mentally specified client-designed humanoid types, but frequently displayed an unaccountable codependency reaction to the client in question. The android line was discontinued after this fact was made evident.

MALFI is therefore, at present, restricted to the confines of a cyberally-generated program. Considering the results to date with the integration of organics and hardware elements, it was decided that the meld of a conscious entity and a physical/structural component was impossible within the parameters of this trial. The boundaries of this MALFI entity, however, are to be tested and eventually extended as the trials progress. This program will be extended into virtual technology with the assistance of INFODOM INC's latest nanotech development, the THREEDEEPER, as soon as the establishment of primary autonomy is attained.

This autonomy goal is crucial to the MALFI acting independently of several subservient direct-controlled programs, such as the CONTEXT EMBEDDER (an INFODOM INC system designed to automatically assist MALFI in conversation contextual nuances and subtleties) and various other peripheral circuitry such as DIALOGEL (a phonetic based translator). This will eliminate the necessity to morph the computer-generated consciousness with a physical element, and enable the virtual physical mode to be made operational.

NEXT>

The telescope, telephone, and the Internet were invented to bridge distances. Today we have remote controls for the garage door and the television (the latter a remote for the remote). But as our reach is extended we're increasingly vulnerable to error, deception, and forgery. What is the relationship between distance, authenticity, and the thing we call knowledge? I'm interested in provoking anxiety about these issues. www.ken.goldberg.net

KEN GOLDBERG

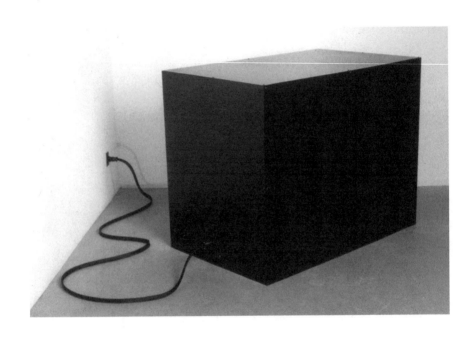

INDEX, DISTANCE, AND DISBELIEF

> Everyday the urge grows stronger to get hold of an object at very close
> range by way of its likeness, its reproduction.
> —Walter Benjamin

For the past several years I've been investigating "telepistemology": the conditions for knowing at a distance. This was motivated by several Internet installations. The *Telegarden* (1995-) is a living online garden tended telerobotically by remote users. *Dislocation of Intimacy* (1998) allows Internet users to view and control the interior of a minimalist black box. And *Invisible Cantilever* (1996) is a 1/1 millionth scale version of Fallingwater etched from silicon using microchip technology. The first two projects emphasize distance in space and the third emphasizes distance in scale.

I say "emphasize" because I'm trying to exaggerate the conditions of perception on the Internet. Consider Peirce's concept of indexical trace (further analyzed by Rosalind Krauss). An index such as the footprint of a fox is distinct from a sign such as the word "fox" or a fox-like icon or logo. The footprint bears an indexical trace that carries the residue of physical contact with what is signified. Peirce notes that chemical photographs bear such an indexical trace.

Generally the index is diminished with digital reproduction and even further on the Internet, but live telerobotic installations may contain an indexical trace as follows. The telerobotic image is generated on demand by the viewer, so the camera must co-exist in the presence of an authentic object. The image is live; the viewer participates in the means of reproduction. Thus the telerobotic reproduction is not fully detached from its referent.

I'm currently working with the Ars Electronica Center on a project entitled *Telezone*, where remote participants will build structures in the zone by directing a robot, via the Internet, to move elemental blocks into place.

Scanning Electron Microphoto

all the more engaging (or outrageous) when they are so obviously separated from the body, so clearly fetish and fantasy. Yet, such fantasy has actual effects. Indeed, symbols are also events.

Less than a year later, my friend in the New Orleans adventure notified me by email that she had breast cancer. I wondered if she was able to avoid superstitious feelings about our transgression (whatever that was, perhaps our power). I made an intimate health revelation in exchange. Who knows where our conversation would have led, had not my next email message been from a Net functionary at my university warning me that my email was not private.

In my book *Virtualities: Television, Media Art and Cyberculture*, among many other things, I propose the notion of "symbolic events." That is, my insight is that distinctions between words, images, and symbols and "real life" are often misguided, especially once machines can say "I" and "you" and we are immersed visually, aurally, and kinetically in symbolic worlds of our own creation. I offer examples of symbolic events from the Gulf War, the Romanian uprising/coup, and in the experience of various pieces of art. I consider the Internet a vast externalization of a symbolic system that is also manifest in other degrees of materialization, including the infrastructure and the proto-cyberspace of the built environment.

CHAPTER 2
NETWORKS:
BODIES,
SYMBOLS,
CITIES

FROM: MARGARET MORSE
<morse@sirius.com>
I love this time of year—Carnival into Lent—because it works through extremes, letting the flesh and repressed desires have their way, then exerting will over the body in self-elected privation. In this evocative season, I catch a glimpse of myself with my paper dress (foolish of me) torn to shreds on a similar Monday during Fasching when I was an exchange student in Berlin in the 60s. On a similar Tuesday in the early 90s in New Orleans, a journal editor/new friend and I were offered breasts for sale from a cart at the edge of the carnival parade. She and I tied the plastic breasts over our jackets. Despite our age and the unreality of our "breasts" (aside from the bumpy nipples), the effect on the young men in the crowd around us was sensational. One of them spontaneously pierced his ear in a fit of enthusiasm. The commotion we created followed in our wake throughout the night. The incident underlined for me that when it comes to desire, breasts are symbols that are

FROM: KELLER EASTERLING
<kae3@columbia.edu>
I find interesting the speculations about a posthuman culture where mind is distributed beyond the body (Hayles, Morse, and others), and those discussions of the ways in which invisible or ephemeral technologies establish

NEXT>

protocols for the actual arrangement of physical development and political groupings. When I read postings by Saskia Sassen, a colleague of mine at Columbia, I realize that part of my interest is in the behavior of each writer, the way each reassures the other or has the courage to reveal something about themselves.

My work as an architect and writer has been about how the mind is distributed by technology, and the direct relationships between technology and the physical arrangements of urbanism. I have been interested in the ways in which we reciprocally respond to our new tools and use them as models for thinking and making physical arrangements. I have been interested in the ways in which organizations of physical development and production mimic network organizations, even when they are not entirely reliant on the actual hardware of new technologies. I completed a book last year about various ways in which development for landscapes, offices, suburbs, shopping malls, etc., are "formatted" by network protocols embedded within business organizations. Many of these invisible protocols have enormous physical and material consequences.

For example, the shifting scales of retail development, familiar to everyone, perhaps dramatize these kinds of changes. SKU number tracking, mass-customization, and new network models for global shipping/freight hubs are partly responsible for increased scales of production and larger warehouse, priceclub, and superstore buildings. Most of these congregate around the outer ring of the old shopping mall feeding off the lulls in parking volume generated by the central formation. And now, almost overnight, they are actually making that enormous, distributed mall format obsolete. New so-called "powercenters," made up of only superstores, actually turn the mall format inside out by locating parking in the center of a ring of stores. And a new global distribution superhub like Ross Perot's Alliance Airport in Fort Worth, Texas, operates as the giant physicalization of a design for computing hardware—a big box with peripherals and room for more memory cartridges. The pertinent issue for me is how powerful a new and ephemeral network format can be. Franchises and home-building formats are relevant in this way as well.

I have been interested in treating the network organization as a site itself. The specifications for initializing or formatting a franchise are, though not geographic, extremely explicit. Adjusting the format is powerful, since it is often amplified by repetition. I now try to draw "site plans" for cultural habits or production protocols in an attempt to impact the real spatial changes that occur to find points of entry and partial adjustment. Although perhaps artful, I hesitate to treat this work as a performance art. I want the work to remain disguised behind the mask of a ham-faced businessman—to pretend to be ignorant of any predictions of utopia or crisis. I want this work to have the silly enthusiasm associated with any invention, or the opportunism fed by the many accidents in the marketplace.

While I think new technological tools are good at modeling our preoccupations and reciprocally shaping those preoccupations, I tried to find a similar habit of mind about network organizations in historical episodes prefiguring our contemporary situation with new technology. Some of those episodes involved other time-based models (for example, geological, mechanical, theatrical, military) to generate a network thinking or thinking about active

organizations. I wanted to avoid the twentieth-century tendency to regard intelligence as successive rather than coexistent.

FROM: N. KATHERINE HAYLES
<hayles@humnet.ucla.edu>

One of the approaches I've found interesting is that of Bruno Latour in *We Have Never Been Modern*. Latour defines a concept he calls the "quasi-object"—quasi because it has objectlike properties, but also cognitive properties that make it very different from our traditional concept of an object. What Latour wants to do by defining a "quasi-object" is to break down traditional boundaries that put animate objects in one category, inanimate in another. Rather, he places both into a single field of actors interacting with one another; in this scheme, it is more or less incidental that some actors are human, some are not.

FROM: YUKIKO SHIKATA
<yshikata@crpg.canon.co.jp>

For Barthes, the Japanese city was reached with a map, not with words (address), and was grasped by images that became visible by moving around. It might be explained as a chain of memory. This city structure, which consists of a collection of independent particulars, creates an image-generated city. In order to exchange maps to get to a place, Japanese people were in need of facsimile machines, and the product spread immediately. At present, the popularity of a car navigation system is significant for this characteristic. The system, which shows images constantly changing as the car moves, navigates the car until it reaches the destination. The system offers interactive maps based on the position of the car. Through the images projected onto a monitor, an electronic skin, in a personal and closed space of the car, and through the thorough navigation of the streets,

the driver feels the mutually circulating virtuality and reality for which the change in outside scenery means mobility. There is a sense of a feeler as an extension of the skin. This feeling of having a feeler is awakened in the interaction of images and senses, and it can be grasped as connection and mutual circulation of the driver's self to images (the self as visual extension), then to the moving car (the self as his/her physical extension).

In Japan, the subject and the object are not completely separated within their images, words, and behaviors; the other kind of subjectivity, or inter-subjectivity, as an extension of areas of the self, is constantly generated. It is different from Western thought where all the noises that cannot be controlled have always been excluded as incomprehensible. Western music, for example, generated a higher system of a geometrical basis by perfecting the scale and the key. And at the same time, what is not recognizable as music (= noise) is excluded.

After the end of the cold war, the social structures that used to be based on the static systems neighboring or opposing each other are no longer valid. Now the issue is that the theory on communication has to come prior to the theory on system. That communication is not subordinate to system means that noise needs to be introduced to communication. In other words, communication in language should shift to communication through images and a world of senses. Image, of course, includes the noise area.

The only modernism that Japan has adapted is the multiplication of industry and its economic system, and it is the same thing as the multiplication of images (a superficial world; facade culture lacking content). Especially

NEXT>

after World War II, precise high-tech industry flourished since the nation and corporations made up to be parts of the homogeneous machine, and promoted economic development. Since the 80s, Japan has started to mass-produce precision techno products that are substantially made, compact, and light. The symbolic product is the Sony Walkman cassette player sold since 1980, which architect Arata Isozaki described as "one of the most important inventions of this century." What is important is the personal quality of Walkman, and the mobile sensory culture realized by it. Other important characteristics include: the area which one moves around can be transformed to space—personal space and extension of the self—with the music of his/her taste; the separation of audio/physical world from the visual/sensory world (public world) is made possible while traveling through space; comfortable distance is created from the outer world by creating a personal space, which is at the same time accompanied by the paradoxical solitude.

The reason Japanese tend to accept technology without resistance or criticism is probably because we understand it as a sensory tool which expands ourselves and is, in a sense, something wearable, not as something opposing humans. After Walkman, personal-scale technologies invented in Japan—like the handy-cam videos, MD players, and computer games—have been received smoothly, and are being made compact and wearable (as extension of the physical senses). Wearability is not confined to practical materials (i.e., as clothes), but it includes the range of interfaces of the self and the Other, and wearing shared images.

Such extension of the body and one's senses is causing change in communication.

Especially among the generation of junior and senior high school students, low-priced, handy, and portable personal tools are very popular and considered accessories (which are also the extension of one's self). Pagers, mobile phones, instant cameras, computer games—high-quality images are not required. Rather, the users feel more comfortable with the noise; that is, they prefer the rough and shaggy images. Hundreds of cheap and small instant stickers called "purikura" (club sticker ads filling high school girls' pocket diaries), wearable virtual pets, Tamagotch (tamago/egg + watch), Pokémon—they all function as wearable communication tools. The possibilities of communication and wearability brought by such tools are more important than the content of the images themselves.

The content of the message is not important, but to feel "connected" and to wear that "possibility" of being connected are important. (In Western society, there is a reason for human existence, and ethics is maintained on the imaginary premise that God is watching over us. For Japanese teenagers, the self is maintained by the possibility of being connected to someone, even if that someone is anonymous.) Hungarian film critic Bela Balazs once said, "I maintain my consciousness only through shooting." It can be paraphrased as "I maintain myself only through the possibility of being connected." The self (the subject) is the image only recognizable as it exists in the communication network and being connected. They, "the tribe," share the "self," which can only be maintained through the invisible community, arming themselves with survival tools such as mobile phones, pagers, and club stickers.

This kind of relationship is rooted in the anxiety that they would lose their selves if

they were not connected. Those who are skeptical of such communications will be isolated. When the possibility of communication with the other is shattered, people need to prescribe themselves autonomously. An increasing number of junior high school students are now armed with butterfly knives to protect themselves. Sociologist Shinji Miyadai commented that "they are always prepared." Pagers as well as knives are necessities for those whose identities are in crisis; they are ready for daily war conditions, although they do not have definite enemies.

Japanese society is going through a transformation phase. The economic recovery promoted by the modernist idea is already a product of the past. At the same time, the illusion of a community imagined from a modernist viewpoint is ending in failure. The younger generation depends on communications that are confined to a small scale and limited level. However, this communication is a multiplying act to evade the identity crisis, and is the product of the community's illusion as noise-proof. This dying yet essential communication is exchanged as if it were the signs of SOS.

FROM: JORDAN CRANDALL
<crandall@blast.org>

Yukiko provides a fascinating example of a network image, and the way that it is always a part of a body-machine-image complex. The body-machine-image complex is about transport, orientation, and acclimation, and we read the image within it as a particular kind of readout. It marks a "mobility matrix," in which the visual field is a ruse for more pervasive procedures of mobilization, which occur within fields of movement tracking. We don't mind the tracking because it's safer, more convenient, faster, and sexier.

Ensconced in a mobile bubble, safely removed from the messy, unreliable world outside, one is propelled along through a landscape in a protective coating, with "feelers" (as Yukiko calls them).

For those who don't know about this system: I think one of the systems in Japan is called the VICS (the Vehicle Information and Communication System). Here is how it works. It uses a computer linked to the GPS satellite system to locate precisely the position of a moving car, displaying the car's position as a mobile dot on a dashboard LCD panel loaded with city maps. It indicates traffic jams and congested roads, suggests alternate routes, and estimates travel times. (Daimler-Benz and other organizations are developing more sophisticated two-way systems that allow users to request more customized information, such as the latest travel updates, weather, fishing reports, airline information, restaurant locations, and schedules of events. Daimler-Benz has even larger plans—an electronic system that automatically steers and controls the cars for their drivers.)

The driver internalizes the routines and mechanisms of this apparatus and is trained to drive as such. At the same time, the car as a monitoring agency learns the patterns and routines of the driver. The image complex "sees" what the driver does, how it moves, what it wants, down to the smallest increments, eventually the tiniest eye flickers, the tiniest vacillations of desire. Armed with this knowledge, it helps to mobilize or transport an occupant through a landscape and normalizes this procedure. The protective enclosure of the vehicle, a bubble of subjectivity, defines (and resolves) an "in here" versus an "out there," a here against a there, or a now against a later, between which its occupant is physically,

NEXT>

mentally, or virtually transported. It is a figure for a condition of protected intimacy cast against a larger condition of the urban. It is a figure for technologically-mediated mobilization, as it encapsulates the body in a bubble of immediacy and shuttles it about.

Much can be said about a culture by the way in which it figures this body-machine-image complex. It's a culturally and historically specific construct, while it simultaneously advances toward global ahistoricity.

FROM: YUKIKO SHIKATA
<yshikata@crpg.canon.co.jp>
The digital video camera created the new world of expressions by its mobility. It can work as a memory device, apart from the intention of the one who shoots, or it can automatically record something beyond one's consciousness, by being worn somewhere on the body.

The moving images of this century were static and linear (the syntax of images), but now we are approaching a change of moving images which are para- or multi-layered, not only creating images by cut-ups and remixes, but totally new "images by ecriture" are emerging which cannot be controlled intentionally by ourselves. This new state of images can also be called "trajective" (Paul Virilio), beyond "subjective" or "objective," which is a kind of in-between state and open to various ways of interrelations, by transferring or multiplying images by themselves. Those "images by ecriture" might change our perception and memories, as memories can always be revised or newly generated depending on the environments. In the twenty-first century, a neurotic trajective communications might organize the sphere of interface. By exchanging data or memories, by creating

new ecriture of images, we are now approaching a change in the existing notion of time and space that is based on the linear, static understanding of the world. Artists using the Internet or digital technologies should face this substantial change, and keep interventions for the new dimensions.

FROM: MARINA GRZINIC
<grzinic@img.t-kougei.ac.jp>
Why I love Japan: You are taught that technology is no innocent communication tool, that within the form of an innocent communication technological tool there is always the specter of ideology.

FROM: MARGARET MORSE
<morse@sirius.com>
Oral logic as a way of creating identity or constructing a self through "introjection" or putting something inside or around oneself is pervasive and not at all restricted to cyberculture, though it remains a largely unacknowledged part of psychic life. Nonetheless, oral logic seems to predominate in a cyberculture that loathes, denies, disavows, and repudiates the mortal body in many ways. I link fantasies of the body eating or being eaten by the computer to smart drugs, downloading consciousness, immersion in virtual reality, and lots more. I could have added the basic topological logic of the graphic interface to oral logic, since it is based on "eating," "being eaten by" icons.

Identity is a bizarre concept, since I think most of us do not believe it is possible to achieve this perfect mathematical equation. The concept seems to be fundamentally caught in the mirror/observing eye, appearance/reality model and in a visually based identification process that forgets other senses and other modes of appropriating and

transforming self and world (such as oral logic). It also suggests that the self is a unified whole that can be known.

The visual realm of appearance and mirroring is only one contributing factor to selfhood. Whatever a self is, it is at least partly an invisible and unknowable generative or enunciative agency. Yet, this agency leaves traces—aural and visual records, writing, kinetic clues to a "movement personality," virtual personas on the Net, and so on.

FROM: KNOWBOTIC RESEARCH
<kr+cf@khm.de>

Our project IO_DENCIES explores the possibilities of intervening and acting in complex urban processes taking place in distributed and networked environments. The project looks at urban environments, analyses the forces present in particular urban situations, and offers experimental interfaces for dealing with these force fields. The aim, however, is not to develop advanced tools for architectural and urban design, but to create events through which it becomes possible to rethink urban planning and construction. IO_DENCIES challenges the potentials that digital technologies might offer toward connective, participatory models of planning processes and of public agency.

In Tokyo, the central Shimbashi area was analyzed in collaboration with local architects. Several "zones of intensities" were selected: Ginza Shopping Area, Imperial Hotel, Fish Market, Highway Entrance, Hamarikyu Garden + Homeless Area, Shimbashi Station, Hinode Passenger Terminal, JR Apartment House, World Trade Center. In these zones, several qualities of urban movements (architectural, traffic, human, information, economic) were distinguished. These movements

and their mutual interferences are represented by dynamic particle flows that can be observed and manipulated through an Internet interface: in a Java-applet users can deploy a series of specially designed movement attractors, each of which has a different function in manipulating or modifying those processes. These are functions like confirming, opposing, drifting, confusing, repulsing, organizing, deleting, merging, weakening, and so on. Participants can collaboratively develop hypothetical urban dynamics. As soon as one participant starts working on and modifying the urban profile by changing the particle streams with movement attractors, a search engine in the background starts looking in the IP-space for other participants with similar manipulation interests and connects to them. They become present for each other; the activated movement attractors of connected participants will appear in the applet. Some of these can be "absent" users whose activities are remembered and reactivated by the system for some time after the intervention took place. If another participant or more are found, the characters of the data movements can be changed collaboratively in tendencies, they can be made stronger, weaker, more turbulent, denser, etc. Streams of urban movements can shift between dynamic clusters of participants; chains of events are passing through. Participants can develop new processes or react to already existing, on-going ones. The streams of the manipulated movements are visualized in the activated segment of each participant; however, each participant will work on and experience a singular and different segment. The software modules allow for the variation and transformation of data clusters by connective activities. We see the project as an approach to a discursive object, where aesthetical and action-oriented interests occupy and reappropriate urban sites.

NEXT>

Ursula Biemann's cultural practice focuses on gender in the global economy, particularly as it relates to the production and consumption of high technology. Her video essay "Performing the Border" examines the ways in which gender is articulated and regulated in post-urban zones of the assembly industry along the US-Mexican border. On the consuming end, her recent video work deals with female sexuality and the bride market in cyberspace. Aesthetically, it attempts to translate the compressed, multi-layered web space into the video format. Her aesthetic strategies also include an exploration of performativity of gender, borders, and representation.

URSULA BIEMANN

DREAD ANGELS

In the past we have always assumed that the external world
around us represented reality, and that the inner worlds of
our minds represented the realm of fantasy and imagination.
We know this is no longer so. We see a reversal of these
representations wherein the boundaries between private
fantasy and the public sphere are to be redefined. Consider
them as unstable for the time being. The major changes in
the technological landscape of electronic text-based and
visual communication, where personal appearance is
increasingly subject to manipulation, affect the notion of self.
Hence it is assumed, although imperfectly understood, that
these changes would also slowly transform users' psychic
structures.

In the erotic interchange, for instance, patterns of seduction
are shifting. Heterosexual seductive strategies don't follow
the usual order anymore of first sight, approach, physical
recognition, verbal exchange, awareness of the inexplicable
fields surrounding the body's extension, eye contact,
emanation of erotic secretions, minor tactile sensations like
wiping hair out of the other's face or a coincidental touch of
fingers, more verbal communication, awkward silence, lengthy

ntuals of declaring sexual interest, to the moment when he would stand behind her, quietly slide the blouse off her shoulders, hold her right breast firmly in his left hand and kiss her neck. These traditional procedures of seduction may not be entirely obsolete, but they would clearly not have to follow that order anymore.

In a text-based encounter, most likely, first erotic interest is rather evoked through the intellectual seduction of common theoretical references. A shared reading experience creates an atmosphere of trust. Then the process is expanded to the communication of cultural preferences and, at a more advanced stage, to psychoanalytic glimpses into the biographies, where issues of sexuality could be addressed discursively. Once an erotic interest is established, though, things get easier. No longer do we need to worry about an encounter in space (transcendence of geographical distance), about physical appearances or even about mundane details of how to position a particular body part (feasibility of bodily gestures) or when to apply a condom (appropriate timing). Fantasies can freely travel the wires in their coded text-based manner. And there are many efficient encryptions techniques available to maintain a certain level of anonymity of the practitioners of erotic electronic communication.

It would occasionally happen that unidentified entities infiltrate in the communication line and start to take on a life of their own. Dread Angels they are called, because it's never quite clear whether their intention is good or bad. In the beginning, these special contacts resemble any other in practically every respect, i.e. seduction by revealing theoretical references and cultural preferences, except, for the perceptive eye, they would be radically

unencumbered by irrelevant information regarding their life. The spectacle is reduced to the essentials, disembodied, in focus. And irresistible. Sublimation techniques mastered to perfection. A Dread Angel is a true professional in cracking the codes to the correspondent's desire and then recoding it. Written words would create images would create desires would create real bodily sensations would create emotions. A whole chain of delicious reactions. For any user these are indeed rare and exciting moments, but the feeling of dread never quite lifts entirely, the dread and excitement of uncertainty.

In the isolation of the private space of writing, released from the experience of physical proximity, personal fantasies would reach a hightened intensity. As if distance and the immediacy of communication enabled a never experienced intimacy. A paradoxical situation, in fact, where extremely mediated communication allows a most immediate experience. The sensation of pure desire. The perfect one, the one emanating from no image, no aura, no voice, no body, no physical experience whatsoever, one that emerges completely from one's imagination. Culturally coded, of course. Suspended realities that simulate a permanent state of being in love. A fantasy forever unfulfilled in its enactments. A sense of always approaching but never reaching.

CHAPTER 3
IDENTITY: WHERE IS GLOBAL?

FROM: SASKIA SASSEN
<sassen@columbia.edu>

It is extremely important in this current phase of the history of the Net to multiply the diversity of Net subcultures and practices and to intensify their presence and engagement. I think of Net criticism and of artistic practices as crucial to secure the public dimension of the Net. We need a diversity of cultures, of languages, of optics. Here lie the beginnings of new notions of membership/citizenship, a shift to presence/citizenship. Being present is a form of citizenship—you do not need to be made a member by some superior entity, such as the state. This could be the beginning of a new form of transnational politics.

FROM: RICARDO BASBAUM
<rirobas@visualnet.com.br>

My computer screen is located in a neighborhood in Rio de Janeiro. I live here. Like many other parts of the city, it is surrounded by hills, where different classes of people live. One thing is strongly visible in Rio: the middle-class apartments stand side by side along the hills where the "favelas" are constructed.

Favelas are wood or even concrete/brick houses inhabited by poor people, built over and on the side of the hills, one house on the top of the other. Favela could be translated as "slum," but in Portuguese it sounds better. In Rio you can see the favelas every direction you look.

The artist Hélio Oiticica wrote about favela's architecture as organic spaces, where life meets an ethical and aesthetic dimension. The favelas are fascinating, but today they are also dangerous. I can listen at night to the sound of people shooting, testing their modern guns (AR-15s, AK-47s, automatic weapons, and so on). A friend of mine, artist Rosangela Renno, who lives close to me, can identify those weapons by the sound of the shots. While most of the people from the favelas are sleeping now ("honest people" or "workers" have to identify themselves to the police to avoid being arrested), a powerful minority is awake, watching, hiding, taking strategic positions for defense or attack. They have economic reason to behave this way— they sell drugs and make a lot of money. They have to protect themselves from the police and from other gangs. The favelas are not only a good place to hide from the police, it is a place to exercise control, apply some special rules, play high "status" roles, and find people who need money to work for you.

Why do I write this story for all you Net people? In every big city there are ghettoes, places controlled by a kind of parallel power, apart from official policy. But in Rio the favelas have had a strong role in the history of the country's culture—maybe comparable only to the city of Salvador in Bahia (the state where Afro-Brazilian culture is stronger). Brazilian popular music history, for instance, is strongly connected to Mangueira, where

NEXT>

some of the best composers are from. Today, the favelas are innovating in music a mix of funk with samba.

FROM: LUIZ CAMILLO OSORIO
<lcosorio@openlink.com.br>
Favela is a word like Saudade: it liquefies when translated. It is extremely important to our culture—a lyrical memory from the 50s, and a threatening presence today, with its weapons and drugs. This image of a land of disorder misleads the reality. Of course it is a dangerous place, but because it responds to a high demand for drugs that is created somewhere else. Last Wednesday I went to Mangueira after the Escola de Samba, and from there to the Carnival parade. It was a huge party, where people from all the communities were joined in their happiness—rich and poor, black and white. While I was there I remembered Hélio Oiticica's Tropicalia, his big installation from 1967 that gave the name for the Tropicalismo movement (Caetano Veloso, Gilberto Gil, etc.). He intended with that work to build a new image of Brazil, based on "the miscegenation myth." That's exactly where our energy is. Our miscegenation means favelas + Brasilia, an organic architecture mixed with the modern formalist ideal. We are the Other who has incorporated the Same. This phenomenon is unique.

FROM: CARLOS BASUALDO
<Cbasualdo@aol.com>
Luiz and Ricardo, why is it so difficult for you to think of Brazil in relation to any other country/culture that is not the United States? In your writing, the United States appears recurrently as that which is always already counterposed to Brazil, defining its identity. Even if you both define Brazilian identity as, fundamentally, an open process of noniden-tification. Why is it that the open process of nonidentification that you call cannibalism, tropicalism, and so on, is re-inscribed in both your discourses as a national(istic) trend? It is quite puzzling to see this reassertion of national (romantic) values happening in the Net.

FROM: LUIZ CAMILLO OSORIO
<lcosorio@openlink.com.br>
In a way, we are all living under the cultural influence of the United States; we are a bit Americanizados, as Carmen Miranda was accused when she came back from America. The ideal of a "new civilization," a "new world," belongs to these two continental countries. Eugenio d'Ors in his marvelous book *Lo Barroco* says that Greece and Portugal are the only two examples of civilizatorial movement in the Western tradition. Why? They exported Otherness. They were both destroyed by the desire to be Other.

I distinguish these three continents in America: the anglo North America, the Spanish America, and Brazil. I really don't feel Brazil belongs to the rest of South America, apart from its political and economical disorganization, which makes them look similar. Culturally and spiritually we are different. North America's hegemony challenges our imagination, our desire to be something different. It is almost imposed on us. Nonetheless, this fascination isn't a resignation. The other day I was talking with a Brazilian artist, Waltercio Caldaas, who said that during an interview after a show in an American gallery, the critic was trying to link his work with minimalism, and he said that no, there was no direct influence of it. Our tradition didn't start yesterday; we have our own modern tradition. And I complement his story saying: we have not only modern art

in Brazil; we have a Brazilian modern art. Our fascination is actually an ambition to be something different. I don't think that the national reinscription that is happening on the Net is romantic and out of place. "All the nations are mystery. Each is all the world alone" (Fernando Pessoa). When I said that Oiticica's work has in itself the experience of the favela and that favela is an untranslatable word and experience, I didn't say that it is impossible for a foreigner to experience the work. That's what makes it a work of art: it translates the untranslatable. The challenge is to think about nationality in a world that disqualifies identity in essentialist terms. Can we think about nationality out of traditional categories? Can we think about nationality in a globalized world? Can this fortify without bringing back its conservative sublimated memory?

FROM: RICARDO BASBAUM
<rirobas@visualnet.com.br>
Cultural borderlines are different from a country's borders; they do not fit perfectly with each other. New York is an obvious example, being very "international" and not the "true" United States. As practicing artists, writers, and thinkers, we are continuously re-tracing cultural borderlines, re-inventing language, investigating behavior, humor, provocation, and so on. Any strategy of "defining identities" seems suspicious to me as it is a perverse process of domination of the Other: forcing me to identify myself, isn't it to trap me in an already known position? My role in facing the problem would be to raise the complexity and contradictions involved. "Brazilian identity as, fundamentally, an open process of nonidentification" sounds nice, comfortable, as no compromise. But it annoys me, because it reveals our limitations in comprehending the cultural scene: we can only recognize nonidentification in relation to what we have already identified, but as artists, writers, thinkers, and so on, we (Brazilians) surely respond to a cultural environment that we can't see exactly, but we can feel. Anguish. No cultural tradition (as Europe), and no money (as United States). Over this void were built the cultural utopias for Brazil, known as Antropofagia, Tropicalismo, etc., based in the possibility of recognizing here the seeds of a new civilization, where the European cultural heritage would mingle with Africans and native Indians. A dream, but also a nightmare. And, it seems to me, a big trap, that makes us not look ahead and accept and investigate the environment around us. What is important now is to accept looking around and experience local environmental and cultural specificities without fear. But maybe it will take too long.

It is impossible to survive without questioning the cultural environment, be it Rio, Buenos Aires, or New York. I do not want to talk about national values, because from my recent past they are linked to military dictatorship and its slogans like "Ame-o ou Deixe-o" (Love it or leave it). The need for discussing local cultures has been a consequence of the so-called globalization; it has been happening in other parts of the world. Possibly the global network is changing and the cultural lines are being re-traced differently. Where is "global"? Obviously it is located in the economic centers: New York, London, Paris, Berlin, Tokyo. The rest of the world is local.

FROM: CARLOS BASUALDO
<Cbasualdo@aol.com>
I do not really think Brazil is so different from other countries in the South. São Paulo looks like Caracas, the people behave as Argentines

NEXT>

from Rosario or Cordoba. Where does Brazil end? in Punta del Este? The North of Brazil is a whole different story. My point is that the most interesting thing about de Andrade, Rocha, Oiticica, and so on, is to leave the question of nationalism open and free floating. There is a strong tendency today among some Brazilians to close it down again. Oiticica said that Parangolès were the "open root of Brazilian culture." If we want to extract something of that thinking which is still relevant today, maybe we should not leave aside that word Open.

FROM: LUIZ CAMILLO OSORIO
<lcosorio@openlink.com.br>
In 1946 Jorge Luis Borges wrote a small text called "Our Poor Individualism" in which he compares Argentineans with Europeans and North Americans. He observes that "an Argentinean differently from an European and a North American doesn't identify himself with the state. The world for a European is a cosmos, that each one corresponds intimally to its proper function; for an Argentinean it is a chaos." The point that I want to make isn't against an open process of absorption and transformation of a tradition. I agree with the privilege of the periphery. But it doesn't mean that the world is one, that we cannot speak of national/cultural differences, and that certain differences are more interesting than others. About the difference between Brazil and Mercosul I answer as Tom Jobim did when asked if he makes a difference between classic (erudita) and popular music: I don't, but they are different.

I agree that Oiticica and Glauber e Oswald (although they are very different) leave the question of nationalism open. On the other hand, I don't see among Brazilians nowadays the tendency to close it down again. My

problem is more about how to articulate their open conception of nationality today.

FROM: PEDRO MEYER
<zonezero@mail.Internet.com.mx>
We in Mexico are going through much the same process of redefining what this nation is about. History, however important, can also become a yoke when not recontextualized into a more contemporary reality. A case in point is what is happening with Chiapas. To summarize, the government finds itself in a losing battle for the public as they proceed to renege on past signed agreements with the Indian communities. Now they have created an artificial xenophobic environment expelling all foreigners who are accused of meddling in Mexican politics. So all foreign observers who are in Chiapas, even a French priest who lived in Chiapas for the last thirty-seven years, are expelled from the country for having dared to accuse the government of being the culprits of recent massacres in the town of Acteal in Chiapas. The argument is that our constitution states clearly that no foreigner can intervene in Mexican politics. Such an article is obviously a result of all the terrible experiences under imperialism and colonialism that this country had in the past. The defensive attitude is justified. The tragedy, however, is that the present persecution of foreigners in Mexico who participate in politics in Chiapas is happening at the exact same time as Mexico is being defined in its economic planning by the International Monetary Fund, not exactly a Mexican institution. And by the huge investments that Nestlé from Switzerland are going to make for cacao plantations, in the state of Chiapas. Some foreigners are less foreign than others. What does this have to do with the Internet? Everything. The Mexican government is acting like no one outside can intervene in

Mexican politics. They forgot about the Internet. This new reality suggests what Carlos brings up, that these past "enemies," or the "us versus them" attitudes, are going to be a whole lot different in the near future as the Internet's penetration makes itself present at an ever-increasing speed.

FROM: MARGARET MORSE
<morse@sirius.com>
I just got back from a talk by Luc Courchesne, the Montreal artist. I thought his remarks on "identity" and "home" were provocative. He jokingly compared himself to Martha Stewart and Oscar Wilde, who apparently also wrote on home decoration. He said that we are "reformulating identity as a culture" and that as systems become more complex, we may well be dwarfed by them, surrendering something of ourselves or losing parts of our identity in the process. "Home," Luc says, has become dysfunctional in that it is no longer a way of organizing the relations of a family or group with itself and with the community. Instead, people in houses are prey to isolation, since the house is no longer the site of communal life. Like Luc, I know social isolates who spend a great deal of time with the media. (Before the media, isolates like my uncles might read or invented engines—whatever it took to hook up human endeavor.) What could replace the house as "home" in Luc's vision was vague, but I got a picture of a networked, cell-phone connected, mobile receiving center.

I told him that the more drift I experience, the more I travel and commute, the more virtual my daily life becomes, the more significance "home" as a locality and field of smells, touches, tastes, and sounds gains. Similarly, as socioeconomic entities take on a global scale, local differences (your diasporic

rhythms and music, your language) become all the more precious. In fact, globals may envy you and attempt to use your unique qualities to decorate their commodities. I think "home" can gain hyperbolic importance for the networked and will remain a locus of desire for the foreseeable future.

FROM: LEV MANOVICH
<manovich@ucsd.edu>
The Internet functions as an agent of modernization, just as other means of communication did before it—railroad, post, telephone, motor car, air travel, radio. The Internet is a way for people to enter into a singular socio-linguistic space, defined by a certain Euro-English vocabulary. It is a way for people in different places to enter modernity—the space of homogeneity, of currency exchange shops, of Coca-Cola signs, of raves and fashion of CDs, of constant youth, itself the best symbol for movement and constant change, the symbol for leaving your roots and traditions behind, the space where everything can be converted into money signs, just like a computer can convert everything into bits.

And this is why we, in the West, should not expect culturally-specific Internet art, should not wait for Internet dialects, for some national schools of Net art. This simply would be a contradiction in terms. To expect different countries to create their own national schools of Net art is the same as to expect them to create their own customized brands of Coca-Cola. The sole meaning of Coca-Cola, its sole function, is that it is the same everywhere.

The Net is an agent of modernization as well as a perfect metaphor for it. It is a post, a telephone, a motor car, plane travel, taken to the extreme. Thus, we should not be surprised that a typical Net art project, whether

NEXT>

it is done in Seattle or in Bucharest, in Berlin or in Odessa, is about communication itself, is about the Internet. Net art projects are materializations of social networks. These projects make the networks visible and create them at the same time. It is a way for young people in Oslo and Warsaw, in Belgrade and Glasgow, to enter modernity and to become its agents for the rest of a society. And just as it would be naive to take seriously "the art of a gas station" (although of course we can imagine some serious museum show on the image of a gas station in modern landscape painting, and even thick art historical or anthropological monographs on the subject), the category of "Net art" is a mistake. So-called Net art projects are simply manifestations of social, linguistic, and psychological networks being created or at least made visible by these very projects, of people entering the space of modernity, the space where old cities pay the price for entering the global economy by Disney-fying themselves, where everybody is paying some price: exchanging person-to-person communication for virtual communication (telephone, fax, Internet); exchanging close groups for distributed virtual communities, which more often than not are like train stations, with everybody constantly coming and leaving, rather than the cozy cafés of the old avant-garde; exchanging decayed but warm interiors for shiny, bright, but cold surfaces. In short, exchanging the light of a candle for the light of an electric bulb, with all the consequences this exchange involves.

FROM: PEDRO MEYER
<zonezero@mail.Internet.com.mx>
I would conclude differently that there will indeed be "national schools," and not the World Wide Washout that Lev suggests. That such "national schools" are not yet happen-

ing has more to do with the unequal levels of technological development throughout the world, and artistic communities being at the tail end of it all, because of their traditional lack of resources, than any postmodernist arguments. I would even go as far as stating the exact opposite from Lev, that it is precisely the Internet that will offer the possibility for art to create "national schools" as expressions of diversity, because no longer does such art require that they travel through the gauntlet of the traditional metropolitan centers of dominance for them to circulate and be seen.

FROM: ANDY DECK
<andyman@mail.slc.edu>
Lev Manovich's claim that looking for local schools of Net art would be like looking for regional variations on Coca-Cola may be overstating the case. It denies the possibility of culturally specific computer languages. Object oriented languages may impose functional similarities, but they may not prevent local "vocabularies" inflected with the spiritual and cultural biases of their collective authors. Thus far computers have been inaccessible to much of the world, so it may be too soon to discount the potential for regionalisms.

FROM: SIMON BIGGS
<simon@babar.demon.co.uk>
While I think a lot of what Lev has said is interesting and partially true, I feel he is missing one of the most important factors regarding the Net, perhaps because as yet the Net isn't as international in its image as we would all like to think (it is still largely dominated by the wealthy populations of the United States and similar countries). Lev mentions that the Net is a modernizing influence. I really wonder what he means by modernization. Over the

past twenty years this word and all its attendant associations has become deeply problematic.

The Net began as an almost strictly language-based medium. I am not referring to the binary systems that underlie it, or the ASCII conventions on top of that. I am referring to "natural language," the spoken/written word.

Bandwidth has always been, and will remain for some time, one of the determining factors in the nature of the Net. As a result the written word has been, and still is, dominant among the media diffused across the Net. One of the most interesting factors in language is its regional differences and cultural peculiarities. The French are very different from the English, in large part owing to the differences between their languages. Language functions to both communicate and encode the status quo. Of course languages evolve, some more quickly than others, but as the European experience shows, languages (and the differences they encode) are quite resilient. The more resilient, the more open they are to change.

Language is one of the great cultural specifiers, one of the main forces of difference on our planet. So long as the Internet remains a language-dominated medium, and the more the Internet is internationalized and thus becomes available to various linguistic groups, then the more the Internet will tend to fragment, and thus possibilities for linguistic/cultural difference will be enhanced.

Strangely, I get the feeling that in the world of art this is rather less the case than in other cultural areas. The main factor may be the dominance of the dollar in international art markets (and the role of New York and London in the art star system). Thus, rather ironically, art is a force against local cultural differentiation. But the art world represented by magazines such as *ArtForum* and *Flash Art*, and by institutions such as MoMA, is only a small part of the world's artistic cultures.

It is very possible, although I am not saying it is probable, that the Net will lead to an accelerated localization of creative activity in relation to socio-linguistic space. If this happens, then whether this might occur in contra-distinction to the international art market, or whether it will actually have an impact on that market, remains to be seen.

FROM: ADNAN ASHRAF
<adnan.ashraf@bender.com>
I'm a Pakistani with dual American/British nationality, working and living in downtown Manhattan. My approach to the Web is total embrace. I can transmit my experience, ideas, visions, interviews, to friends and family in Pakistan, to South Asians who came of age in the States and the United Kingdom, and to a generation of ravers, junglists, and tranceheadz that's interested in the current wave of transcultural artmusik coming out of places like Anokha, Mutiny, Abstrakt, and so on. I don't know of any sites that wholly cater to my tastes, that's why I've been doing my own on a free time basis for the past couple years.

If you're asking whether there's strong Web work coming out of places other than the United States and Europe, the answer is yes. But you have to look for it. It's reductive to say the Net has or hasn't a nationality. I own my computer and modem, pay my phone bills and taxes, buy my stuff in America, so the equipment is in a sense American, but the stuff I receive and transmit is a mix of every-

NEXT>

thing I know and see, a phenomenon which is quite American, I suppose. So is the Net a bunch of hardware and phone lines that can be ascribed a nationality, or is it a bunch of people who belong to the "nation" of the Net itself? I think William Burroughs's notion of the Interzone suits my experience of Net life more than any notion of a nation.

FROM: ALEX GALLOWAY
<agalloway@rhizome.com>
To paraphrase Donna Haraway, diversity is to us today what money was to Marx: the ultimate fetish. This is the 500-channel argument, or the thirty-one-flavors argument. Having tons of different options is crucial to our contemporary experience, yet we must also recognize that difference is always a regulated difference, that specificity is always at the same time indeterminate.

There is (at least) one other response to Lev Manovich: I don't think that there will be many culturally-specific categories within future Net art, especially culturally-specific categories as there have been in art history. However, the terms have shifted a little; diversity has become a virtue.

There will be specificity in future Net arts in these two ways: 1. After the "one world" euphoria, I predict a general relapse to nationalist/localizing networks as a style, that is, let's do cyberfeminism from Adelaide, or let's act like European Net artists (we are already seeing jodi being turned into a type of euro.crash style), or let's do marginalized email lists, or let's do NYC art criticism (heaven forbid). Watch out for localist chic coming soon! 2. You will create your own private Net art—the niche-ing of culture, in the same way that amazon.com wants to show a differently tailored store interface for each customer: advertisements particularly made for you, your favorite books up front, site redesigns to suit your individual tastes. Net art will remake itself upon each viewing as a sort of personal fantasy art.

FROM: ANDREJ TISMA
<aart@EUnet.yu>
I think the Internet makes us citizens of the world. It is a chance for all of us to become individuals, since on the Internet there are no frontiers, no distances, physical or temporal. We are all part of one huge web of individuals. In that web everyone plays a role as he can.

We here in Yugoslavia are isolated from the rest of the world by technical and financial possibilities because, for instance, we don't have much access to PC technology, first of all because of costs (our average monthly incomes are about $200), and because we have to pay for time on the Internet ($1 per hour). But the Internet gives us the possibility to come out into the world, to participate in world events, Net art scenes, discussions, projects, and so on, which is very important for an individual. Even though I work in more difficult circumstances than Westerners, or people from richer societies, I feel equal in my possibilities in creative ways. Maybe I can appreciate the Internet more than some Westerners, and use it more effectively because it means (and costs) so much more to me. I am satisfied with my place and role in Internet communication. The question of language is irrelevant, because there are even people who do not "speak" their own native language, and cannot establish communication with their own countrymen.

FROM: JUDITH THORN
<jjthorn@sirius.com>
Any discourse is double-edged. Globalization is often an assumption for Westerners whereas in countries who have only been the objects of the conversation, the possibility of participation globally is not necessarily negative, rather it is fraught with possible perils. Localization is a way of life for many countries. The search for lost uniqueness of localized product is discussed through the Western system as reclaiming history, pastiche, and nostalgia. This is the heart of the Western postmodern problem of philosophy—the way things are is quite different depending on the circumstances, whether we are in Paris or San Francisco or Chiapas. The Zapatista commandeering of the government of Mexico's Web site is a crucial piece of intervention, using the technology that Westerners are finding problematic to exciting ends. Perhaps the problem is that we don't really care about what is happening to groups of Maya in Chiapas. Life is often separated from theory in the Western ideological system. It is not an abstraction for Maya who have experienced systematic destruction of their cultural system for more than 500 years. They are fighting not so much against tyranny as for life, even though those two things may intersect. Which is not to say that we should not address the world from our point of understanding, but others may not see it the same way who do not operate within the same system of values that we have. We need to hear them speak, for which we need a common language. The one world idea may well be utopian. One aspect of diversity that is constant is change within systems of power. Cubans have a saying: the thing is not to die. Although the Net may become a stranglehold a bit farther on from now, it provides at this moment a possibility for carnival and expression.

FROM: GILANE TAWADROS
<gtawadros@iniva.org>
What Oladele Ajiboye Bamgboye writes about the desire of others to anchor him in some originary location—"What is non-Western about my practice? Why do reviewers feel the need to label me as a Nigerian, when I hold now a British citizenship?"—is a deep-seated desire within Western discourse that is not easily (if at all) derailed by countless volumes on hybridity and the complexity of cultural identity. It is rooted in notions of origins and authenticity which (curiously) seem only to apply to those of us whose cultural backgrounds lie outside of Europe and America. Your "authenticity," which is assessed by others, is always in question if you fail to conform or fit within certain fixed categories and identities. It is all very well to say we should get beyond identity, but it is not we who are fixed by identity but others who desire to fix us.

I recall Catherine David saying something not dissimilar in Johannesburg at the conference organized by Olu Oguibe during the second Bienniale. She said that identity had now been eclipsed by "identification processes." The implication of course was that it was all of us "others" who were hung up about our identity, and it was obviously in our hands and through our own agency that we could identify ourselves in whatever way we chose. The irony of her words did not escape many people sitting in a conference in South Africa where for almost fifty years, men, women, and children have been systematically denied their human rights and their lives by the apartheid system that

NEXT>

meticulously "identified" and "graded" South Africans according to their race.

FROM: SASKIA SASSEN
<sassen@columbia.edu>
It is very important to multiply the different cultures, subcultures, practices, nationalities on the Net. Right now it is too Western because the Western component is massive. There are a lot of others on the Web, but they are not enough to dissolve the Westerness of it.

FROM: TIM JORDAN
<t.jordan@hps.unimelb.edu.au>
Olu Oguibe argues that there is no Other on the Net already and there is no dominant way of constructing selves, only the PONA who are to come. I disagree. There are already Others and dominance on the Net—calling it Western is one way of trying to grasp this fact. Ignoring the Western nature of the Net means leaving it in place and hoping this bogey really is only of our dreams.

Put another way, the claim that the Net is Western raises the bogey of a dominant self because there simply is a dominant self on the Net, both because it is embedded in its technology and because of who has access. For example, through ASCII, English has become the de facto linguistic standard of Usenet, email, the Web, and most Internet-based applications, not just because for a long time the Internet could only carry ASCII characters, but because the software that carries the characters itself often relies on ASCII. How Other are you if you have to express yourself in someone else's language? And, therefore in someone else's culture and their civilization? As Fanon said, "To speak means to be in a position to use a certain syntax, to grasp the morphology of this or that language,

but it means above all to assume a culture, to support the weight of a civilisation."

Another example is that ubiquitous feature of electronic communication: flaming (a heated argument via email that often happens in public forums). How damaging is the competitive, individualist sort of communication that flaming embodies, to any culture based on more collective principles? It is not just a matter of questioning the meaning of flaming but recognizing that it is so widespread one wonders if it is an indicator of the Net's dominant culture of communication.

Arguing that there is a bogey and it needs definition does not equal stigmatizing new arrivals on the Net, nor does it mean the Net is defined as irretrievably lost. One of the other great measures of the Net's self is its demographic profile that has been (since it was first realistically measured in about 1994) stable as overwhelmingly white, highly educated, highly paid, and aged twenty-five to thirty-five. Though there may be some slow shifts in this pattern emerging in 1999, over the years the only significant change in this profile is its gender, which began at about ten percent women and now is between forty and fifty percent women. Along with this change have come campaigns against various forms of harassment that had previously been accepted because it was part of a dominant culture. Change is possible, but it must be explored as part of the complex array of forces and powers that already exists. Recognizing someone's Otherness is not necessarily demanding their Otherness, and may be part of destroying an Otherness.

The Net is not a political blank slate. The nature of software and hardware, and who it is written/created by and for, is one of the

biggest political questions for virtual life—both for the Net that exists and that is being built.

FROM: JOSEPHINE BOSMA
<jesis@xs4all.nl>

I was very happy with Olu Oguibe's reply to the threads of the inclusion of the so-called Other and the locality/nationality illusion. What he writes about his difficulty with the Other reminds me of discussions I have been having on a women-only mailing list. The discussions focused mostly on the definition of cyberfeminism. It is not so much that certain women are placed outside of whatever group, but that they do it themselves. When talking about a discourse and presence online, the separatist approach makes no sense. It is reductive and paralyzing. Also, when one takes a closer look at what the real Other is on the Net, it is not so much found in social and political structures as we know them off the Net, but the way the Net transforms all issues. The Net itself is the Other everyone here is trying to deal with.

Issues around equal rights for women and other minority groups (non-Westerners are a minority on the Net), and the question of the preservation of the uniqueness of certain national and personal features needs a special focus. This is a matter of resisting an apparent homogenization through so-called Disney-fication and the influences of commerce and repressive politics. One has to keep a constant awareness not to fall into the victim/complainer/master/benefactor roles. Situations and tactics have to be continually reevaluated. It is not easy; one has to realize how, for instance, noise, humor, and the different layers of communication that are inevitable on the Net will always trouble

the waters of aesthetics and ethics. And they have to.

FROM: ROBERT ATKINS
<ratkins@idt.net>

I agree and disagree with Josephine's viewpoint. It seems to me that the Net both reproduces and transforms the nature of life offline. Those who are marginalized offline (people of color, queers, women) remain marginalized online. But, oddly enough, the Net still offers the democratizing potential of the niche audience that many of us thought cable TV's hundreds (if not thousands) of channels once promised. As an art-type now trying to chart the commercial terrain of creating online commercial community and content, it's clear to me that unless you've got unlimited resources, a specialized audience becomes the only viable focus. Art, for instance, is too large a subject to create a site or email list about. But when coupled with those identity-related modifiers to which we are so strongly attached (Jewish, gay, Nigerian, or female, but not Protestant, American, straight, or male), meaningful discourse is possible.

Ah, those Net paradoxes! In the same way that online communities seem to stimulate offline socializing, perhaps Other cultures are strengthened through the increasing hegemony of the mainstream. I have no doubt that the Disney-fication of life offline is mirrored online. But sometimes that image is warped, as if reflected in a fun house mirror.

FROM: CRAIG BROZEFSKY
<craig@onshore.com>

I'm afraid I am the Other, and I won't go away. With or without the Net you still have to deal with me and my desires. The Internet is a conglomeration of hundreds of Nets each

NEXT>

with their own policies, protocols, hierarchies of control, interests, and designs. It is crisscrossed with lines of demarcation, some legal, others technical, or founded differences of desire and politics.

FROM: SASKIA SASSEN
<sassen@columbia.edu>

I agree with Tim Jordan: there are already Others on the Net and there is already dominance. Robert Atkins writes of online life affecting offline life and back. Yes, in many ways it does, digital space is embedded and hence cannot escape the dynamics and presences of offline. But there is also a specificity to digital space; this specificity is not a given except in some basic technical sense, but even here we could wire the systems with a different politics. It needs to be produced, via software, practices, sustained, contested, and so on.

FROM: RICARDO BASBAUM
<rirobas@visualnet.com.br>

There are two different meanings for "margins, marginal." 1. Deleuze and Guattari's topological view of margins as privileged position for creation, invention (production), having the power of the membranes, interfaces, open to the outside; 2. margins as hierarchical inferior, the powerless position in respect to the center, where power is located. We also could say that in 1. the subject locates itself in the margins as a strategical decision, or at least accepts the place as an important position for resistance, to capture the "devenir minoritaire"; while in 2. the subject is put against his/her will into an eccentric position, forced to live a deprived existence, which he/she must fight against.

It is interesting to note that both positions share a sense of strategy, be it resistance (stay forever on the margins) or combat and capture (occupy the center position). The question is: are these positions mutually exclusive, or can we combine 1. and 2. as parts of the same "guerrilla" (life, art, existence)? Are both figures adequate for a model of artistic action as intervention inside/outside a culture? Is there a certain topology where center and margins interchange continuously, so in one moment the subject locates him/herself as center and in another moment as margin, membrane (that is, fighting for different kinds of power, each particular form of power producing specific results)?

Artistic practice seems to play ambiguously with both positions, as the artwork is always evoked as the center of the world at a given moment, mobilizing affects, precepts, thoughts, a myriad of forces (chaos, cosmos) around it. The artwork, wherever it is, has this particular capacity of aggregate things around it (material, immaterial). But the art object (sculpture, installation, performance, action, drawing, painting, etc.) plays a complex role as a membranous creature opening itself to unknown regions yet to come, reordering the borderlines of culture/territory, opening up spaces.

Olu Oguibe writes about not accepting being put on the margins, and relocating oneself as a powerful person with dignity, on the center. But at the same time the center as a local for production/invention necessarily "discenters" itself when assuming its membranous/marginal condition of revealing more and more newly opened up territories, the importance of which is stressed by Carlos Basualdo.

FROM: BRIAN HOLMES
<106271.223@compuserve.com>
The progressive elimination of the state sectors devoted to national cultural traditions (with their admittedly debatable merits) has allowed a dual, often schizophrenic postmodern culture to develop at high speed over the past two decades. To the extent that globe-girdling information technologies, including the Internet, are used to exert hierarchical control over the relatively small managerial class, we will see as a result (and have been seeing for some time now) the increasing homogenization of a world culture oriented by the double imperative of consumption/competition.

Nonetheless, the notion that this homogeneity is the inevitable modern condition is absurd. Over the past three centuries a tremendous amount of cultural energy has been expended on the achievement of autonomy from fatalistic representations of existence. Etymologically, autonomy means giving oneself (autos) one's own law (nomos). The modern ideal of autonomy is about self-invention, not acquiescence to dominant models. However, to invent oneself in a vacuum is impossible, if only because the materials of self-reflection (particularly language, but also images, etc.) always come from outside, from some preexisting environment. So the practice of autonomy generally means exploring, with others, some threads of cultural history, some specific groups of words, images, gestures, and so on, that can be reworked and transformed into something usable in the present. And the threads that one chooses are important. The idea that an extremely limited and homogeneous stock of mass-distributed cultural products is enough to make possible everyone's free self-invention is an attempt to put blinders on people.

Everyone, even those like myself who were born in hyper-standardized California suburbs, has access to a tremendously rich human history, and of that history, infinite modernities can be made. You just have to put out the effort, and above all, form associations with people over time.

FROM: JUDITH THORN
<jjthorn@sirius.com>
Who is this Other if not the person who is not me? Is the difference between the national and intranational Others not a social construction of the West? Do these Others see themselves as self-identified Others? The word subaltern comes to mind in Western theory—from Gramsci, but used specifically within the discourse of postcolonial studies. How many of the street poor in India self-identify as subaltern? Do they watch and say, Oh here comes another subaltern? I don't think so. They say here comes Raita, or whatever. There is always an interplay of sameness and difference. This function has to do with the interconnection of naming and identity. Within the understanding of naming and identity there is an investigation of the words of the Other—in this case, the one with the power. Is it possible others learn the language at the same time that we are unlearning our own preconceived notions of whom we want to talk to?

There are some tricky problems socially and ethically when we are discussing dominant language difficulties encountered within the web of the Web. It is always a two-edged discourse, not only an exclusionary one. Something here reminds me of the arguments about monolingualism. Are we interested in hearing what the putative Other has to say? What are we willing to displace within

NEXT>

ourselves to hear? What is the function of the specular, here?

What is the access to the mechanical/technical means of transmission? Just as the technological advancement keeps me from seeing as much as I like on the screen, the dumping of older computers in nontechnological countries allows access to the World Web in ways that appropriate the technology and not the ideology that produced them necessarily. But some folks need food more than the Internet. Others can use the Net for their own purposes, whether to do art or call attention to those who need food. But it is important not to set the hungry up as victims only so that they can be rescued.

Last night I got a call from within Haiti to confirm that the satellite space was going to be available for communication, with me outside. The phone system in Haiti reminds me of France in the 70s. An international philanthropy is wiring parts of the Caribbean and Guatemala, where now Maya are using computers for day-keeping and religious practice. They are able to keep their spirituality alive by the production of texts, not necessarily art. Maya are in diaspora all over the Americas, and the production of these texts in Quiche, Mam, etc., using Western alphabet transliteration, has enabled the production of books on all aspects of their culture that allow families who don't live within communities in Guatemala and Mexico to share their stories, narratives, and other histories. With regard to computer-generated texts for spiritual practice (to train sacerdotes, day-keepers in the Maya religious practice) one example comes to mind in Zunil, Guatemala. Roberto Poz Perez is more avant-garde—for want of a better word—than the Sorbonne-educated folk that I work with in

Haiti who see the Net as a bogey. I think mostly because they don't understand what it is useful for in Haitian terms. Haitians who reside in Haiti do visit here and see what can be done. The seed is planted as it was with Pere Jan IV who ran the only Kreyol-language newspaper in Port au Prince for years—a radical journal in anyone's eyes. He got online a couple of years ago and tied in with world news, a small thing for us, but not for Haitians who were in a text block because of the Duvaliers. Texts are now sent all over the world in Kreyol, not only French. Sometimes they are translated and sent out again; I can read them in French or English.

Folks do need to see a reason for having access and a vision of what it can do. But like everything, it is not for all of us. This does not mitigate the ethical borders around the question, just places an uncertainty around every expression because there are always alternatives to what we see. This first reading is within my (our) own eyes. On the second reading we can begin to hear others even if we do not understand them.

An aside about Franz Fanon: he saw through his eyes too—the woman in the veil as the carrier of the weapons, a heroine, etc. Yet, Assia Djebar, another thoughtful and poetic writer of the Algerian resistance (Fantasia Algerian Cavalcade) questioned, What did it do for these women? It placed them in the highest jeopardy. Once again, the double-edged discourse of liberation.

"Diagram for Invention in Rio de Janeiro" is lines, images, and words working together to create a dynamic verbal and visual context. The diagram can be either printed in a book or presented as an installation, where it can be combined with other media like sound, color surfaces, and sensorial objects. For me the diagram is a method for generating thought from processes, displaying a network of relations: thought as a landscape, revealing a moment where images and texts are interwoven in the complexity of geography, geology, psychology, and art—maps and plans for present and future interventions.

RICARDO BASBAUM

NEXT>

diagram for intervention in Rio de Janeiro

diagram

The diagram in the
following pages was
designed after a
map of the South
Zone of Rio (the
wealthiest part of
the city), showing
the *Morro do Can-
tagalo* (Cantagalo
Hill) and its proximi-
ty to the famous
Copacabana and
Ipanema beaches.
Two of the most
important favelas in
Rio are located on
the hillsides:
Pavão-Pavãozinho
and **Cantagalo**, oc-
cupying an area of
100,240 m^2 with a
population of 5073.

The **NBP** object shown
is a 120 x 80 x 15 cm
container, made of
enameled steel, which
is carried home by peo-
ple to be part of an
artistic experience. The
project is in progress
since 1994, having
already involved more
than 40 people in 8
cities of 3 countries. In
the diagram I suggest
that the object should
be carried to the favelas
to be experienced by
people who live there.

Geographic information about the city is mixed
with references to samba composer Zé Keti
(through the lyrics of his great samba **Nega Dina**),
to the artist Hélio Oiticica (represented by his pen-
etrable **Tropicália**) and to my project **NBP - New
Bases for Personality**. Different cultural moments
are mixed together.

All the elements on the diagram work
simultaneously. The intervention should
occur during a certain period of time.
The different cultural trends necessarily
influence each other, producing open
and uncertain results, to be recorded
through audiovisual media. Also, the
results will be recorded in the minds of
those who will experience it, as body-
memory and as part of their lives.

object to be sent to the favelas
to be experienced there:

"Would you like to participate in an artistic experience?"
"Would you like to use this object in your home for one month?"

n b p

Zé Keti *Nega Dina (1965)*
"A Dina subiu o Morro do Pinto
prá me procurar / Não me encontrando
foi ao Morro da Favela com a filha da
Stela prá me perturbar/ Mas eu estava
lá no Morro de São Carlos quando ela
chegou / Fazendo escândalo, fazendo
quizumba / dizendo que levou meu nome
prá macumba / Só porque faz uma semana
que não deixo uma grana prá nossa despeza /
Ela pensa que a minha vida é uma beleza /
Eu dou duro no baralho prá poder viver /
A minha vida não é mole não / Entro em
cana toda hora sem apelação / Eu já ando
assustado e sem paradeiro / Sou um
marginal brasileiro"

*Morro
do
Cantagalo*

HO ...Hélio Oiticica (1937-1980)
Tropicália............................1967 Oiticica's penetrable
nbp.......................................new bases for personality project
Zé Keti (b. 1921)................samba composer
Morro do Cantagalo..........Cantagalo Hill
■ **Cantagalo**............................favela
■ **Pavão-Pavãozinho**.............favela
Ipanema................................famous beach
Copacabana......................famous beach

N

Rio de Janeiro
City population: 5,480,768
Population living in favelas: 941,750
573 favelas

outside

inside

Copacabana

"...it seemed to me, while walking about the environs and set of **Tropicália**, that I was going through the gullies and over the curves of the Morro, which were organic, like the fantastic architecture of the favelas..."

HO

Pavão-Pavãozinho

Population: 3041
Area: 48,760 m2
Year of occupation: 1931
824 houses
3.84 persons per household
Average income (head of family): $140/month

Ipanema

Cantagalo

Population: 2032
Area: 51,480 m2
Year of occupation: 1907
444 houses
4.39 persons per household
Average income (head of family): $102/month

CHAPTER 4
INSTITUTIONS: ARCHITECTURES OF ATTENTION

FROM: TIM JORDAN
<t.r.jordan@uel.ac.uk>
The Web Stalker (http://www.backspace. org/iod) is a Web browser, but rather than attempting to integrate all the Web's resources into one multimedia experience, it deliberately dissects Web sites. It begins as a blank page. You then draw up to six boxes and assign one of six functions to them: crawler (connects to Web sites), map (maps links between html documents in a site as lines to circles, the more links a circle has the brighter it is), dismantle (maps the links between different elements—text, sound, picture, etc.—of a specific html document, also in lines and circles), stash (a way of saving urls), html stream (shows all the html language as the crawler window reads it), and extract (shows all the text from an url). You can have six different windows of different sizes, all dissecting and mapping the particular Web site you have chosen. By clicking on the circles produced in map or dismantle, you can navigate around the Web site.

The Web Stalker provides a means of exploring the structure of any Web site. Almost by accident it produces fascinating pictures that seem to draw out meaning, though often it's hard to know exactly what that meaning is. Whereas the usual experience of the Web hides its underlying structure, the Stalker's windows each bring to the surface a different view of the Web's construction. The Stalker offers a way of drawing the particular structure of any Web site and producing simultaneously art and power-analysis. A friend who spent some time using the Stalker on the Microsoft site claimed to have begun to see the more important corporate connections of the Web site through the mapping produced by the Stalker. He also concluded that, ultimately, the Stalker's productions were both beautiful and pointless.

FROM: URSULA BIEMANN
<biemann@access.ch>
The strategy of the Web Stalker analyzing and revealing underlying structures of the medium corresponds to a Michael Asher/Hans Haacke/Andrea Fraser type of institutional criticism. I believe until 1991, this practice of demystifying art as a site of economic and political interests could have an impact on the reception of art. Following neo-liberalization, I doubt that art practices which remain in the museum/gallery space or work on a level of individual site-specific intervention can have an impact of adequate proportion. At a time when the Getty Museum buys up any pictures to become the second largest picture archive in the world after Bill Gates's, we see where the museum world is heading.

Artists were never really able to use television as a medium and network; but they took over video as a new technological medium and kept showing it in the art space. The public

NEXT>

sphere of the major audio-visual media was not successfully accessed by artists. I'm afraid that if we skip to the new medium without having done our homework with the previous one, we risk running into the same incapabilities. Remaining in the white cube, be it with VCRs or PCs, is not going to bring us into the digital age.

Alan Myouka Sondheim wrote: "But when is this history, among others, going to be recuperated? And what's the point of pronouncement of the imminent if it's forgotten?" Right now it might appear as if reflecting on media participation is a waste of time because as far as television goes, the cards are dealt. But it won't be long before stronger links between television and the Internet will be forged.

If we have such a clear experience of how participation of artists and countercultural producers has been squeezed out over the past few years, why not take it into consideration when theorizing the use and full capacities of the Net? (Art in) cyberspace is not just about using the computer to its fullest; in my estimation, it's about creating a different social environment with new services and institutions, employments, built realities, real estate, and territories. Cultural studies scholars may stick to their disciplines and apply a critical self-reflection providing useful instructions for a critique of our practice in the Net. As cultural (visual) producers, though, we draw on all these theories that brought fundamental changes into art production, which go somewhat unrecognized.

While all this was happening with television, art continued to refer to art history as its main canon and sought recognition in art defined spaces. Art has a tendency to assimilate everything that runs through its discourse and

to classify it neatly into mediums. I find it a problem, for example, that practices that relate to a notion of cultural production that draws on the extended field of critical inquiry of cultural studies crop up in art magazines as "new public art" or as "the information aesthetic" and the like. But there is little evidence of institutions who attempt to develop a visual program that would correspond consistently to the content and methods of cultural studies. Why are there still art historians filling curatorial positions in institutions when there could be urban planners, postcolonial critics, gender theoreticians, media analysts, and Net critics? Why didn't museums ever bother to buy satellite time? Art as an industry has a strong tendency to resist structural changes.

In terms of the Internet, an important question would be, How could the Net influence art as an institution? Does it make sense to show computers running digital projects in the art space (appropriating it as yet another medium) or to continue to do individual aesthetic productions on the Net and develop a proper digital art discourse (but remaining marginal if not irrelevant to the public's affairs)? I'm aware that this discussion is more about how we can use the Internet, but I'm also interested in the question of what it will or can do to us.

FROM: MICHAEL H. GOLDHABER
<mgoldh@well.com>
I see the Internet as setting a new kind of economy: a postmaterial one. Of course, I am not alone in making such statements, but where I do part company with most is to argue that this new kind of economy is centered not on information, but on what it is that putting forth information might get you. Namely, attention.

Unlike information, which is only artificially scarce under current circumstances, attention is intrinsically scarce. As it must come from other human beings to be of value, there is only so much of it around per capita. Having some is definitely a requirement for humanness, and having a great deal can be highly desirable. The Internet is rich in holding forth the possibility that attention in abundance may be available.

Attention paid by one person and received by another is a different way of describing intersubjectivity. For attention to be exchanged, there must be a meeting of minds, or at least the feeling of such a meeting. But what of attention paid by many and received by one, which happens to be the common condition of successful Western art? Clearly on the part of the beholder there must be an illusion of intersubjectivity, but since, under most circumstances, the artist is not actually paying attention to the particular audience member, it is indeed an illusion, albeit possibly a deeply moving because deeply convincing one.

Whatever else it does, every work of art, to be successful, must succeed in focusing attention, pulling it in. In fact why not consider the ability to do that as the very essence of art in the contemporary world? Artworks must ensnare our attention to be successes as art, and if they do that, they need do nothing else. (Most of the time, at least in Western art, more happens; we note not only the art but the artist, and in fact our attention can be thought of as traveling through the work to its creator.)

This view of art puts it in a new light in the new economy. If the scarcity of attention and attempts to capture large amounts of it have become the central features of the postmaterial economy, then the attempt to create art is an increasingly central type of activity, whatever the medium used. One gets attention less by what may be called production, in the sense of routine production of standardized objects, but by performance, doing something original, and somehow in the (or a) public eye.

In this new economy, where attention is wealth, having attention is having a kind of possession or property. The conditions that best lead to gaining this property are quite different from those entailed by the somewhat contradictory category known as intellectual property. To gain the most attention, one generally wants one's work, or word of it, to be widely disseminated. The best way to achieve this is to allow anyone to copy or reproduce it, with no strings attached. But how then do you prevent someone from simply claiming your work as their own? The simple answer is to arrange to have witnesses as early as possible to every project you engage in. Imagine everything you do on your own computer automatically and immediately appearing on your Web site; that would go some way toward assuring witnesses very early on. For this and other reasons, all of life to some degree becomes part of one's art, one's performance. One gets most attention by having nothing to hide, or rather choosing to hide nothing. Thus success in any kind of activity depends on a performance ability, and innate and possibly deliberate artistry revealed in that activity.

An attention economy is highly creative and deeply aesthetic in nature, but it is not necessarily a very equal world. There remains only so much attention to go round. Those who are successful end up with far more than their fair share of attention, others with far

NEXT>

less. Full equality in this new economy can only result from an audience willing to give equal attention to everything. I have to admit I would not like to be a member of such an audience, nor can I imagine that many really would.

FROM: BEN WILLIAMS
<bwilliams@citysearch.com>
Wouldn't you say we've been living in an attention economy to some degree at least since the 60s, when TV became the dominant force it is today, and very possibly earlier, taking movies into account? Also, isn't it worth distinguishing between different kinds of attention (Benjamin's "The Work of Art in the Age of Mechanical Reproduction" being one obvious reference point)? The implicit assumption here seems to be that the best works of art are those that draw the most attention, in which case, "Baywatch" represents the apex of postmodern artistic achievement.

FROM: DANIEL PALMER
<d.palmer@pgrad.unimelb.edu.au>
Attention is not wealth. Attention is only valuable as a process of temporarily commanding viewers'/consumers' focus on an object (art or commodity) and thereby investing that object with value (in a speedy world of commodified time). The logic of advertising has to be the model here.

FROM: ROBERT ATKINS
<ratkins@idt.net>
In the new attention economy world order, what differentiates art (or anything else for that matter) from advertising?

FROM: MATTHEW SLOTOVER
<matthew@frieze.co.uk>
Artists shouldn't blame the viewers for not being able to understand them. All artists need a keen sense of how their work comes across to other people if, that is, they want attention. Many artists I know would never admit to catering in any way to an audience; nevertheless, they have a good instinct about when their work is communicating and when it isn't. You can't say that we need a new discourse for art in the digital age; the Web and multimedia are easy to use, and anyone should be able to get something out of art made for or with new media. If they can't, I would place the fault with the artist, not with the viewer. Damien Hirst always used to say, "I want to make art my mother would like"; that is, there must be something in it for the man on the street. Not that this is all there should be. But I think many artists working with new media would do well to take note.

FROM: SAUL ANTON
<Soainnyc@aol.com>
Why is art communication? What does art communicate? This idea, it seems to me, remains unexamined. It also remains unexamined in conceptual art practices and discourses that believed they could dissolve the art object into the discursive matrix of the artist and the viewer. That was a fairly short-lived idea, one that is tied to a whole tradition of thought not only in modern art, but most importantly in philosophy. Beginning with Hegel, we get the idea that the object will be overcome because it will be seen as no longer adequate to the meaning it is meant to uphold. That is an entirely different discussion. Suffice it to say that this dialectical conception of art, the one that grounds all theories of modern art (even the abstract ones—since abstraction was a critique, according to some formulations of it, of the adequacy of figural representation, an idea that leads naturally to the dissolution of the art object altogether into the objectless

ideality of conceptualism), works nicely with the way a certain techno-discourse has transformed art into media. Perhaps we should begin by asking what is it in art, or the arts—its plurality should be underlined—that resists the notion of media?

FROM: URSULA BIEMANN
<biemann@access.ch>

I feel it's necessary that art continues to be involved in a critical engagement with the symbolic production of other professions because I see the danger of art leaving a lot of terrain to other, less critical symbolic producers. Jeff Wall mentions the example of activist art in the 20s leaving the field of the symbolic image production unoccupied and thus easily appropriated by the fascists; Benjamin Buchloh focuses on identity politics and subjectivity in the 80s as responsible for leaving the public sphere to grand speculations of the capitalist media and real estate conglomerates. I feel those two strategies shouldn't be played out against one another, but the consequences of placing the focus on one or the other have to be taken seriously.

I don't see the significance of art in those administrative/preserving activities that provide jobs for many graduates. Of course, I basically agree on the necessity of art historians and art museums, but why do I always get so bored with it? In Europe, at least, the most interesting art activities are taking place outside of established art institutions, building their own networks, and I'm worried that if institutions are not able to adjust to what I call major changes in the symbolic economy, they might find themselves offside.

FROM: SUSAN HAPGOOD
<shapgoo@ibm.Net>

I see art made for the Web echoing certain developments in the art of the 60s, that is, it thwarts preexisting art distribution systems and markets, and it cannot easily be controlled by existing institutional power structures, which immediately gives it an independent footing and presence. Of course these observations are not exclusive to art; it's just that my background is in art and art history so I immediately contextualize it that way. Art during the 60s tried to do much of the same kinds of thwarting, and certainly succeeded in making the distribution, marketing, and exhibition contexts more evident, if not changing them for once and for all; it did change awareness, and provided alternative ways of going about making and showing and communicating art (the mail, the Xerox machine, the performance, ephemera, everyday activities). By the 80s, more traditional qualities crept back in (desire for objects, for marketable commodities, for singular star personalities), at the same time that the earlier work was being historicized and chronicled (and made precious simply by virtue of its cultural importance). Now the Internet seems to provide a new opportunity, with many of the old qualities built into it from the start—independent, cheap, accessible (only in terms of geographical distances and speed of communication), infinitely reproducible (hence nonunique, noncommodifiable). Another built-in feature is the networked structure, how virtual communities of like-minded individuals can work together to produce work, often suppressing their own egos in the process. Again I see parallels to early collectives in (admittedly American/European centric) art—Fluxus, Art and Language, Art Workers' Coalition, Colab, Group Material, and most recently, Parasite.

NEXT>

FROM: ALAN MYOUKA SONDHEIM
<sondheim@panix.com>
In the United States, museums are more popular than ever, in part due to the production of spectacles and accompanying connoisseurship that began in the 80s. As a result, viewers might know about King Tut, but nothing else about Egypt. Museums provide an area of dissemination or filtering not otherwise available. They subscribe for the most part to modernist and enlightenment ethos in their styles of presentation. If the cultural symbolic is up for grabs, at least in the United States, museums have got a role to play: look at MoMA's continuous shaping of art attitudes, vis à vis Pollock and other Abstract Expressionists, or the uses to which the Whitney Biennial has been put. In the States, for the past twenty years or so, the right has done better politically than the left in this regard. I think of the fetus films and symbols, the right-to-life actions, Crystal Cathedral, the NRA, and so forth. Even with PACs involved in the last, the fact remains that these wagers are being made outside the art world, the AIDS quilt being an important exception. How can one intervene on the level of popular demographics? One has to begin with the fact that for most people, museums aren't boring, or are becoming less so, without the deconstructive attitudes of current cultural politics, but just as display.

FROM: CARLOS BASUALDO
<Cbasualdo@aol.com>
I would like to suggest that the exhibition as a model of understanding of art production should probably be emancipated from the museum and be considered an institution of its own. Hans Ulrich Obrist has mentioned the example of Alexander Dorner. Obrist explained very precisely Dorner's position regarding the museum as a self-transforming institution and argued convincingly about its current relevance. In order to realize Dorner's ideas, the museum as an institution would have to become the exhibition as a temporary (urban) museum. More than turning art into everyday life, it would be a question of turning everyday life into an architecture of situations.

FROM: HANS ULRICH OBRIST
<HUO@compuserve.com>
I would like to add a fragment from a panel discussion on museums of modern art in the twenty-first century that took place in 1996. Rem Koolhaas pointed to the museum as an issue of urbanity and less an issue of architecture. "I think rather than architecture, which always induces enormous anxiety in its either/or logic—since architecture is, just like MoMA . . . about exclusion—the urban is the ideal medium, combining the unpredictable with a degree of organization. Because a city, of course, never preempts what is going to happen; rather, it offers the latent potential for things to happen . . . in a kind of related way."

FROM: CARLOS BASUALDO
<Cbasualdo@aol.com>
It would be interesting to think of Constant's "concrete dream" as a model for the museum of the future: a museum based and constructed on the instability of the archive. Digital archives are structurally unstable. The software and hardware are not easily fitted to survive for an eternity. We may be losing a lot, but maybe not. Eternity is the ultimate dream of authority: perfect wholeness forever. The traditional museum relies on this dream, or nightmare. The challenge, I think, is to conceive a museum that is structured on transience and not to attempt to reform the Museum of the Eternal (which is, by the way,

the title of a very interesting and ironic book by Macedonio Fernandez). New Babylon should be considered a preliminary sketch toward that kind of institution.

The issue of memory, then, becomes fundamental. I like Koolhaas's suggestion that the museological and the urban can become the same. In a previous intervention I suggested the possibility of replacing the institution of the museum with the exhibition as an institution. If that is possible, it would rely entirely on the city as the privileged reservoir of memory. Not only memory as information, but memory as lived memory, a know-how of everyday life, memory as inscribed in the body. Lygia Clark's therapy provides us with a model of this kind of memory, a model that could potentially be related to an archeology of the urban.

FROM: PAUL D. MILLER,
AKA DJ SPOOKY
<anansi@interport.Net>

What I find interesting about the museum issue is the extreme unwillingness of the Western art hierarchy to look at forms of nomadic culture that have already been at work in the European and American contexts for the last several centuries. Outsider artists like Sam Doyle and Bill Traylor, operating from the late nineteenth century up until the mid-twentieth, proved that a visual archive—referencing blues and jazz as vessels for cultural transmission, or even the Gypsies in Europe as one of the few groups to retain pre-Roman pagan traditions—never makes it to the discourse of "globalization," etc. The art world is in a crisis precisely because of these issues: how an institution based on feudal European structures can survive the dissolution of the social hierarchies that formed it. The new feudalism, as described by brilliant

science fiction writers like Neal Stephenson or Philip K. Dick, might open narrative spaces that the old orders, based on land/territorial control and colonial domination, now give way to the cybernetic milieu of systems narratives; and what theorists like Trinh T. Minh-Ha, Manuel Delanda, and Fanon, from very different perspectives, are discussing. This isn't to say that Obrist's remarks aren't intriguing; they are. But remember that the narratives that most Western intellectuals use (Frankfurt School, etc.) seem thin compared to the actual situations of fluid systems of international finance, and the shadows of the World Bank and the IMF in various regions of the world outside the G-7. He who pays the piper, as the saying goes, calls the tune. So with the premodern museum. But these days, to carry the metaphor, the songs will be samples and computer-generated algorithms, the images will be composite, and the videos will be downloadable. The museum as electromagnetic canvas, anyone?

FROM: FRANKLIN SIRMANS
<franklin_s@hotmail.com>

While I completely disagree with the ideas at the end of Paul's message regarding images becoming composite, and videos downloadable, and the museum as "electromagnetic canvas," I fully agree in terms of museums' (Western art hierarchy) "extreme unwillingness to look at forms of nomadic culture." And beyond nomadic even, they're pretty slow to realize that it isn't all still white and male. Alas, I would say that hope lies in exhibitions like the Istanbul and Johannesburg biennials, where some of these ideas have recently been touched on in an art context.

In Istanbul, you have someone like Semiaha Berksoy, an eighty-seven-year-old opera singer and painter in the exhibition; the work of

NEXT>

Seydou Keita, an example of art as the precursor to pop culture in redefining itself through art (note Janet Jackson's mugging of Keita's aesthetic), who was shown at Johannesburg and recently graced the cover of ArtForum.

The characters of Doyle and Traylor, even Pinter, are being consumed and contextualized in much the same way that the graffiti artists were in the 80s, but for various reasons (for one, they can be exoticized more universally) they may actually have staying power. There is a place for recontextualized museum space, not only on the Internet.

FROM: SIMON BIGGS
<simon@babar.demon.co.uk>
Carlos Basualdo's message makes me think of encoded mnemonics, as outlined in Frances Yates's book, *The Art of Memory*. Yates explores mnemonics from the Greeks up till the Renaissance, with a major focus on the work of Robert Fludd and Giodorno Bruno. The primary thesis is that in many cultures memory was seen as important and as artful as logic or poetics. The way this often manifested itself in the examples she provides sound awfully like what Carlos says above, about the city becoming a reservoir of memory. (Yates gives examples such as the Memory Theatre, where memories are encoded into architectural and object detail that can later be retrieved by the one who put them there or by another.)

FROM: CARLOS BASUALDO
<Cbasualdo@aol.com>
An art exhibition is always dealing with memory at some level. The possibility of inscribing contemporary art history in the urban has also been addressed by many recent shows, the last Documenta was probably one of the most ambitious and unsuccessful in this respect. The notion of memory engraved in the city comes from mnemonics, of course, but is also evident everywhere. The old section of Rome is one of the best examples for me of a city where the urban equals memory equals art. Of course, art was at the service of power there, so the attempt to develop a counter-spectacular model of exhibition comes to the foreground.

FROM: BRIAN HOLMES
<106271.223@compuserve.com>
What is interesting in Frances Yates's book is the technique: the association in one's mind of the images of specific places—palaces, rooms, streets, theaters—with important bits of knowledge and narrative sequences. The idea was to select an architectural environment, often one with niches, and to use it literally as a "topos," a palpable place in which to organize a more far-ranging cultural memory. It was a self-fashioning technique, or what Foucault calls a process of subjectivation, intimately connected to the collective dimension of experience because of the use of architecture as a mnemonic support, but at the same time, seemingly a much more fluid and personal way to build one's self than the discipline of the authorized book (which ultimately replaced the ars memoria as the main technique of self-fashioning in bourgeois Western cultures).

The relation between determinate urban space and a fluid individual-collective use of memory is something that surges up with every social revolution, when artistic practice really gets out into the streets. But while working toward the next upsurge, I'm wondering how computer memory could be used to further such individual-collective self-fashioning processes, in experiments that at once

recognize the binding weight of historical reality and yet aim toward material and symbolic transformation of it.

FROM: CRITICAL ART ENSEMBLE
<ensemble@critical-art.net>

Having attended more digital and electronic media arts festivals than I care to remember, I am shocked at the entrenchment of the monumental as a primary criterion in deciding the value of a given project. A project has to be big; it has to be overwhelming; it has to be global, and if one isn't doing a BIG project, it is somehow an insult to computer capability, hypertextuality, and nonlinearity. If the project does not possess monumental scale or volume, it's considered just the work of a common user. This attitude is supported by the structure of festivals, which all want the biggest attractions; by the prize system, in which big is a necessity just for entry; and by the granting system, which seems to function in accordance with monumentality regardless of whether the judges are specialists or nonspecialists. This prejudice in favor of scale is evidently a trace of the traditional art world replicating itself in a new territory. In order to intervene in art history, monumentalism has always been a good tactic, but in the case of electronic media it has become the only tactic. What makes this situation very odd is that electronic media research has not progressed to the point where monuments are really appropriate. This year's monument, after all, is next year's dinosaur. The technology changes too fast, and monumentalism requires technological stability if it is to stand the "test of time." Perhaps this is putting the cart before the horse: we are attempting to write multivolume encyclopedias before we know how to write an article.

The difficulties don't stop there. The monumental also compromises the work of the content minded. The two are almost mutually exclusive, not because an electronic monument cannot have content, but because the wowie-zowie effect of the scale overwhelms any content it may have. (When the project becomes a dinosaur, the content reappears, and can potentially save the project from extinction. Content seems to be the one cross-temporal variable common to all electronic media.) Spectacle can overwhelm even the most critically minded, and in light of the mystery of technology to the nonspecialist, and the heroic hype given techno-explorers, audiences are primed to focus on spectacular entertainment even when conceptual value is available.

Finally one must ask, is this structural replication of monumentality desirable (at least in its current form)? Politically, for antiauthoritarians, monumentalism is generally undesirable because it tends to transform the specific into the general (if not the universal). With electronic media under the domination of white males (with perhaps the exception of video, the financial runt of the litter), it's hard to support this new wave of monumentalism. At the same time, there is a research component to the monumental works that offers a shred of redemption. If no one experiments with monumentalism, no new or alternative possibilities will be realized.

Perhaps what this all comes down to is that process and audience are underexamined while product is overexamined (product seems to me to be the driving force in electronic media). The same old questions come back to haunt us: how is the electronic media artist identity constructed? and who is all this electronic cultural production for?

NEXT>

FROM: COCO FUSCO
<tongolele@aol.com>

Artists, arts institutions, and writers are cashing in on corporate advertising's euphoric presentation of an imminent cultural future orchestrated by electronic devices and artificial intelligence. Those who raise an eyebrow over such prospects, arguing that intellectuals and artists might also eventually be "phased out" by the techno-supported "downsizing," are usually written off as paranoid.

It might be useful to contemplate patterns in the productions and institutionalization of art practices, to see how they relate to the stresses and structured absences of dominant trends in cyber-theory.

1. Global exhibitions: In the 80s, biennials in so-called "peripheral" sites were instituted as a response to exclusionary definitions of internationalism, and to the continuation of tendencies from early modernism to relegate "non-Western" art to the status of catalyst or appendage to Western tradition. Today the art world map is quite different. The governments and financial elites of several once peripherable countries seek to achieve status as art world power brokers, to modernize the image using contemporary art as window dressing, and to draw more sophisticated forms of tourism. Artists working in most parts of the world recognize that there is premium placed on having one's work in many places at once (another version of the promise of digital disembodiment), rather than immersing oneself in the specificity of a particular site. Art centers struggling to stay afloat in an age of endless budget cuts turn to Web art as an easy way to avoid the costs of managing material goods. A limited number of art professionals circle the earth continuously traveling from show to show, transforming "sampling" into a curatorial gesture; curators create their own version of global culture that stresses the power to maintain a "total view" of world art in which "difference" is either rejected extra-artistic or restricted to style. This trend helps to make "global culture" a self-fulfilling prophecy.

2. Commodification of the ephemeral: At the end of the 80s, Rosalind Krauss noted that a characteristic of culture in the age of multinational capital was that commodification processes were successfully penetrating domains of leisure and ephemeral experience. In the 90s, we have witnessed a change in the theorization and economic underpinnings of video/film installation. These endeavors were in the 60s and 70s part of the project of the dematerialization of the art object, forming a critique of art market commodification. The period in which experimental artists flirted with engineering, now heralded as the "origin" of cyberculture's marriage of art and science, was actually severely curtailed by artists' disenchantment with tech-nology owing to massive destruction wrought by the Vietnam War. These days, video installation is considered easily commodifiable, and increased production within the genre relates to increased museum and collector demand, and the decline of classical academic training in many art schools. In addition, its transportability makes it ideal for global exhibitions.

3. The use of artists as inventors and technology testers by corporations: Remember that Photoshop was developed by an artist and now generates lots of money for Adobe. Artists have always depended on some form of patronage, and that relationship has always affected the character and content of

cultural production. That artists and museums working with new technologies are extremely dependent on support from the telecommunications industry might partially explain why so much work fetishizes individuals' relationships with the machines, aestheticizing the interface that multinationals seek to naturalize in order to increase their profits.

4. Experiments in artificial intelligence: If experiments with artificial intelligence have already proven that animal instincts are simulatable through computer programs, the possibility of simulating creative acts is probably already being toyed with. Cage's experiments with allowing chance and random phenomena to enter into the creative process are already being recast with computers that can generate and run programs that appear to articulate "randomness." What's next?

I don't mean to suggest that I am against these trends, but I am trying to understand what impact they have. Disembodied art is already a reality, not the future.

NEXT>

```
<,                    ,,;%%%$$(;o$$$$S;<%$%%%,  ,,,,,,;;;;;;;;;;;;;<<<<~(
~,                    ,,0xfx0<;oSyfoy,;8fXx8,     , ,,,,,,,,,,;;;;<<<~
~;                    XXSXX,,X/3S/( ,xX0oX        , ,,,,,,,,,,,;;;<<<
~;                    %X3og  Xy/oXx ,8xXX8           ,,,,     ,,,,;;<<
<,                    ,%%%%g  o%g%%/ ;%%%%g                      ,,;<<
<,                    ;%%%%g  yggg%/ <%%%%g                     ,,;<<
<,          ,X/       ((Xg%g%g< Sggg%/ ~gg%%8  ~X(;    (~ ,;;;,(xo/(x<
o, ;//XX~/~xx,   ySXXXXf<xXx0%X0%%%%gy/0%gggX(yg%%%8<(8ggg8S/
/8%%838g%%0SSy0yX(
%8088g%gg%8g%%%0%g3Sgg8800ggg%3388gggyy88080y/Sg888SXfg%g%%%g0%g
%%$%$%%%%$$%gSS0
880830S000oS00008X30838SyyyyXXXSS3S3Xyy/X80yoS3y3yX0fXX/XoXy3SoSXfg%%%
%%%%$$%ggg
Xx~//<<X~(//<<(;;~/((//<x(((x((xx/(x</X~x(xx//xxx/XxxxX//Xfffx3x/~/xxXfoXfXXXfX
/<;,i <;,,i  ,  ;<; , ,( ,<<;;<<;,~<;;(~(S3 ;;<<,~(;;<<  ;<<<~;(;  <, ;  ;; ;(;
XyXxXy3XX3yXyyxxyoXfoyoyy3yy3yyXSX3oSXofSxyx3fXSS3yXyyxoxXxX/XX(//<x/<<
<~<;~<;(/
```

JODI.ORG

Back Forward Reload Home Search Guide Images Print Security Stop

Location : javascript:ResetMonitor()

CHAPTER 5
LANGUAGE: THE TYRANNY OF THEORY

FROM: BILL JONES
<artbyte@dti.net>

I think the arguments about the place of theory, which include arguments for an ethics of beauty, is based on an age-old misperception (by those in the arts) of a lack of or continuing need for independent critical discourse. There have been but a few who have taken on the responsibility of whipping the unruly artist mob of self-indulgent dilettantes into shape, after they were loosed on the world by the church, who had kept them in check for centuries. Until the conceptualists took it upon themselves to police their own (outside of the art historians who are charged with cleaning up the messes left by dead artists, and the dealers who groom the lucky few who get on the ladder of success), philosophers and poets had been the lonely caretakers of the art discourse. In the past few decades, artists have had to catch up on their philosophy to stay in the discussion, often at the expense of both art and philosophy (or linguistics or psychoanalysis, etc.). Discussions on beauty have become the arena in which we vie for the prize of arbiter. Will the art discourse be a part of philosophy, language sciences, psychoanalysis, etc.? or can we as artists find refuge in the pure sciences? Maybe we can be musicians. They have had some success at avoiding the grasp of other disciplines. Okay, I know we asked for it by our territorial grabs and desire to play amateur academic, but let's step back.

It is valuable to remember that, but for a brief moment, the visual arts of the Judeo/Greek/European lineage have been indentured to their subject. For centuries it was to Christian scriptures. Then there was the brief, but for now discredited, modernist period where artists such as Rienhardt could proclaim that art was something unto itself. (I know artists who privately talk about visual primacy, speaking heresy by going against the fact that all is language.) What does this mean? I think it is simply a yearning for freedom. Let's be clear. We asked for it! And now artists must contend with what appears to be the need to justify their art making as either not offending public taste (even against charges of blasphemy) from the right or against charges of being nothing more than commodification from the left. Artists are often bad boys and girls. They would rather play than study. Ethics must play a part, just as it does in all endeavors, but let's focus on inclusion and access rather than prescriptions for the art itself.

Art is indefensible. I have seen over the years a gradual chilling effect as academic discourse entered the art making process. Artists needed jobs. They had to teach. As technique became less definable, and theory became more important, artist/teachers learned to speak theory. Some became theorists. Others mimicked the language. Most felt obliged to justify their work in terms of philosophy or

NEXT>

semiology, etc. Art magazines for a period of time stopped taking works of art for their subject and instead took "subject" as their subject. Then as times got tough, they dropped the theory altogether and just talked about popular culture in vague generalities as if it were art.

FROM: ROBERT ADRIAN
<rax@pop.thing.at>
Art is always theoretical at moments of social and cultural upheaval (most of the time the theory is not in the foreground). Art often finds formulations that show a problem in an entirely different way. It is then art and theory merge into an unmistakable, indissoluble clump.

The most recent and pertinent example is the few years at the end of the 60s and early 70s when some American and European artists (and curators) created a series of works, exhibitions, and texts which were both art and statements about art. In many cases there was no object or identifiable "work" to be experienced. It was also impossible to separate the texts from the works; in fact, the texts were often themselves the works (for example, much of Lawrence Weiner's work). These texts often pretended to be philosophy, appropriating the jargon and style (Kosuth, Art and Language, etc.), but the interesting thing is not the content of the texts but the fact that the text became the art object, an eventual object became only one possible, but not necessary, outcome of the predictions of the texts.

The point here is that it is not entirely a coincidence that artists began to work with a de-materialized art form just as the computer was coming out of the closet and the gleam of network technology was in the eye of the DARPA (Defense Advanced Research Projects Agency) scientists. At a time when no one could imagine a world in which information/ideas had more substance than things, artists in the industrial world were making works that described it.

The problem with text-based theory is that it can never escape from the demands of linearity and grammar. Art generates theory as image (or absence of image), difficult and vague but elastic and real. Moreover, it is always imbedded in the work. As Oguibe says (quoting Alliez): "theory can't be only 'understood,' it has to be life experienced, it is a field of sensorial comprehension!" Theory is too important to be left to the theoreticians.

FROM: GREG ULMER
<gulmer@english.ufl.edu>
Hello Bracha,

I wonder if you could offer some advice about the premise of the new consultancy sponsored by the emerAgency? The premise is that a good model of contemporary memory is the one offered to account for Post-Traumatic Stress Disorder. The point is not necessarily to claim that electracy [electronic literacy] is accompanied by generalized PTSD, but that PTSD, in which subjects lose access to their memory, is not unlike the way stars or celebrities lose access to their own images. To put it another way, following Fredric Jameson, in the postmodern condition of late capitalism individual subjects have no experiential access to the collective events structuring their lives (such as the workings of multinational corporations). The virtue of the PTSD metaphor is that it exposes in another way the inappropriateness or ineffectiveness of some of our favorite poetics of modernism, such as Walter Benjamin's reading of Baudelaire in the city—a poetics of shock. To put it in a silly way, modernist poetics treated angst the way we treat people with hiccups (by trying to

scare them: boo!). After modernism, in this traumatized condition, everyone keeps saying "boo!" obsessively. It does no good to say boo! to obsessional boo-sayers.

Perhaps I should start over: I want to move on to a description of the three levels of trauma in relation to Lacan's registers (Imaginary, Symbolic, Real). But my email demon won't let me. An implication of the premise of PTSD for consulting community selection of which events to consider as problems, and the kinds of policy formation these entail, is that positivistic utilitarian consulting amounts to denial, foreclosure, of the fuller nature of breakdown in the functioning of the community. Utilitarian consulting ignores two of the three Lacanian registers of the world. Any comments you might make from your perspective on this premise of the emerAgency would be welcome.

FROM: SJOUKJE VAN DER MEULEN
<sv103@columbia.edu>
Actually, I would be in favor of discussing more academic theories. How useful, for example, would be the work of Barthes and Derrida as a starting point for analyzing hypertext? What is the importance of Deleuze and Guattari's influential idea of the rhizome as a philosophical framework for the Web? And what is the worth for Web discussions of the dialectic legacy of Adorno in the field of aesthetics within the social/political field? It seems quite relevant, especially in relation to the Net, to explore these theories in more depth. Can't we stop thinking that we have to invent the wheel completely?

FROM: BRIAN HOLMES
<106271.223@compuserve.com>
Having studied with Jean-Luc Nancy and translated texts by him and other decon-

structionists, I share a passion for the thought that emerged from France in the 60s and 70s. But I'm struck by the operations of what Raymond Williams calls the "selective tradition." It seems to me that figures like Barthes, Derrida, and Deleuze and Guattari conceived their writing tactically, in response to the rigid disciplinary structures that governed intellectual and social life in 60s France. And they had very different positions: Barthes was initially very close to the Communist Party, Brecht, and Russian formalism; Deleuze grew to be more Maoist, encouraging transgressions of the rationalized body, what he called "becoming-animal"; Derrida maintained a philosophical respect for the gulf between the disseminating letter and the absolute, unattainable, never-embodied or knowable Law. In their different ways, each sought a confrontation with a powerful alterity. But it's as though a selection operated in the 80s, particularly in the American universities. The divergent positions are now conflated into celebrations of a free-floating textual indeterminacy that banishes any form of agency, subjective or otherwise. And the infinite permutations of semiotic combinatory systems or the restless prowling of schizophrenic desire fit in perfectly with contemporary capitalism's need for the constant proliferation of short-lived, magnetically attractive symbolic products, tailored for highly individualized consumption, perfectly adapted to the anti-disciplinary transmission structure of the Internet.

Against that backdrop, the brilliant and bitter realism of Adorno stands out today, not as a model—because Adorno's totalizing critique of capitalist reason leads to an impasse—but as a touchstone of ethical exigency. Adorno seems not to have been

NEXT>

selected by the postmodern period. Maybe that's a clue for us.

FROM: SJOUKJE VAN DER MEULEN
<sv103@columbia.edu>
Could Adorno still have an impact on contemporary thought, especially in relation to art and criticism on the Net? Beginning this year (February 1998), a conference took place in New York on one of Adorno's major works, *The Dialectic of Enlightenment*, which he wrote with Max Horkheimer shortly after World War II. Anton Rabinbach, an influential Adorno specialist, rightly concluded in the final panel that various interesting analyses had come up during the conference, but that surprisingly nobody had referred to one of the most important aspects of Adorno and Horkheimer's arguments, namely their persistent warning against the dangers of a technologically rationalized world. Rather than discussing in depth what relevance Adorno's fundamental warnings might have for today's culture and society, the book was mainly dismissed as being historically outdated. Yet I agree with Rabinbach that Adorno's thought is still relevant today. The digital age, one might argue, can be seen as just another disguise of the omnipotent belief in the Enlightenment and the capacity of the human mind to master nature.

Adorno's most aggressive war of offense against an uncritical embracing of technology can be found in his lesser-known essay, "In Search of Wagner," a dialectical analysis of the compositions of this German composer, whose music has been promoted by the Nazi's. According to Adorno, Wagner is above all obsessed with constructing a delirious phantasmagoric realm by means of totally mastering all musical techniques. He strives at a *Gesammtkunstwerk* in which the listener is completely absorbed into an ocean of sounds and images, loosing all his critical faculties in this deceptive theatrical and musical *fata-morgana*. Wagner's will to master represents for Adorno the dangerous other side of technology: intoxication. Wonder versus intoxication. Here we are at the core of Adorno's dialectical thought on technology: technology can be transcended, can establish wonders—Art—yet if it is misused as a tool for control, it is benumbing the mind of the human subject. Adorno's model of thought, ultimately based on the idea of the dialectic of opposites, reminds one of another writer on technology, Oswald Spengler, who viewed technology, apart from a will to master, as a Faustian pact with the devil. Yet Adorno came up with a more sophisticated philosophical framework for the complex orchestration of opposites. The idea of contrasts that never resolve but proceed dialectically, as formulated in his *Negative Dialectics*, provides us with an adequate critical model to think of the effects of contemporary technology, with all positive and negative aspects included. Take *Wired*. Since the early days of the Net, they have been the spokesmen for the wonders of technology. Yet they confiscated the New Media in such a way that a critical attitude of their fans has given way to *intoxication*.

Another reason to take Adorno seriously is that he insists on the interdependence of art and society. Adorno believes in a critical quality of autonomous modern art. This in contrast to Walter Benjamin, who rather thought of cinema and the mass-media as potential revolutionary forces. "Art becomes social," Adorno writes, "by its opposition to society." Art takes up a critical position within society, Adorno continues, by "crystallizing" in itself as something unique to itself, rather than complying with existing social norms, or simply qualifying itself as socially useful. Art, thus, can be trans-

formed into a tool of resistance to the norms of society through its autonomous, inner-aesthetic development. I do not yet know of an analytic model in Net Criticism, concerned with contemporary (digital) art, that leaves so much space for the autonomous aspects of art. Nettime, for example, claims that art should be read within broader economical and political structures, and does not, as Jordan has criticized so rightly, take into account what Adorno has called the enigma, or *das Rätsel charakter* of art—a thing-in-and-for-itself. The sophistication of Adorno's model (however much colored by American modernist thought in the 1950s and 60s) is that it relates artworks to *faits socials* without reading them, like Nettime, solely within one or another political program. Adorno rejects artworks that strive too literally for "social affects" or moral statements. Nettime, as far as I know, is hardly concerned with art as (also?) something worth in itself, unglued from economical and political aspects. So whereas *Wired* is too much *intoxicated* by technology, Nettime reads art too exclusively as a politically motivated tool. Thus the actuality of Adorno's legacy.

FROM: BRACHA LICHTENBERG–ETTINGER
<bracha@easynet.fr>
All kinds of rational confusions—this is not so paradoxical as it appears at first sight—can indeed be just uncritical products disguised as "radical" art. Rem Koolhaas's important observation with regard to urbanity versus architecture can be linked to Adorno's warnings concerning the delirious illusion of rational mastery. For me, the idea of endless multiplicity circulating in the air is no less a delirium of mastery then the idea of the One. What links Rem Koolhaas and Adorno is the realization that technological mastery without the breath of the spirit is a dead end. Dead. End.

FROM: BRIAN HOLMES
<106271.223@compuserve.com>
The interesting question is, how would someone with Adorno's insight describe the systematic lures of techno-capitalist rationality today? If "Dialectic of Enlightenment" is outdated, it is because the "authoritarian personality," the one that went along with dictators and industrial regimentation, has faded away. It faded because the last generation revolted against that regimentation, and all of us exchanging ideas in this forum are in some way children of that fabulous revolt, which lent an extraordinary openness to Western thought and allowed it to throw off much of its bourgeois past, to embrace the diversity that we now enjoy. I love the openness of today's world, which we no longer need to divide up into a first, second, and third. But those wide-open possibilities are still only available within specific precincts of experience. Elsewhere the instrumental reason of capitalist growth goes unquestioned, has no outside. Bitter exploitation goes on. The irony is that our new freedom of thought satisfies us, so that we rarely undertake the systematic analysis and critique that Adorno and his friends did.

What struck me most powerfully in the research and translation work I did for the Documenta X book, was the extent to which the gains of the 60s, the new possibilities for individual autonomy and spontaneity, the new acceptance of desire and creativity, the new recognition of cultural pluralism won through shared struggles with the Third World, all seemed to have been sucked up immediately by the managerial class, who spat them back out as the new, lightweight, all-terrain economic system of "flexible accumulation," apparently able to take immediate commercial and propagandistic advantage of

NEXT>

even the most outlandishly creative thoughts and gestures. Under these conditions it becomes important to characterize what one might call the "flexible personality," to sketch out its dynamics and its dialectical contradictions. This is why I suggested that certain French thinkers have been partially and selectively instrumentalized within the new information economy, with its preference for complex, lightweight, short-lived, non-standard products, including symbolic forms whose irreducible individualization does not preclude high integration to the surplus-value system. The net and especially the web are one of the most open fields for the development of such virtual products, and one must be careful not to take their proliferation as a sign of increasing freedom. Flexibility has all kinds of breaking points, which I think we should work to illuminate rather than obscure.

FROM: BRACHA LICHTENBERG-ETTINGER
<bracha@easynet.fr>
Co/in-habit(u)ating is a painful process.

FROM: GREG ULMER
<gulmer@english.ufl.edu>
The history of style tends toward a reductive pendulum swing from classic to romantic. The lesson is that both ends of the spectrum are legitimate and powerful modes of expression. My taste tends toward the baroque, including the neologism and pun, but as a teacher I strive for clarity of instruction.

FROM: BRACHA LICHTENBERG-ETTINGER
<bracha@easynet.fr>
If my language quavers, trembles, or is obscure, quavering and obscurity are then also the ideas it must express. Still when a word is to my taste precise, I know my language has attained simplicity. My words are in that way simple. Of course, sometimes a work, or a word, inspires too few people at the time it emerges. Immediate large reception is not a criterion for anything. But if the work, or the word, is necessary for others and for the world, it will inspire others in future time, though it whispers at the present time. It is a question of time; it is not given to each one of us to be open at any moment to any idea, even to such ideas we might one day really need.

But think what if we don't invent the word that becomes the simplest, precise word we need because it so happens that no new word presses itself at the threshold of that particular meaning, even if an idea is new and speechlessly shouting. It is the thing that is struggling to become more visible, which decides what it requires from the artist or the philosopher. And you have to pay the price the thing demands, as Lyotard had put it. Solitude and noncommunication, being offhandedly scolded and sarcastically mocked, are its common costs. The artist or the philosopher fights the thing back, and only if there is no other choice, surrenders to it. The word chooses itself. That's how an internal hollowed space takes off and spreads itself in the world and in the text, like a paysage you are going to see. For you to find in it—or not—what you were looking for unknowingly.

Jean-Francois Lyotard died last week in Paris and was buried yesterday in Père Lachaise. He, who had the gift of wondering. He, who knew that art begins in gifting outside of any commerce and is paid with your own body. Blessed be his soul.

Discussing art in the psychoanalytical context is inseparable, to my mind, from debating sexual difference, since we enter the function of art by way of the libido and through the extensions of the psyche closest to the edges of corpo-reality.

BRACHA LICHTENBERG—ETTINGER

NEXT>

Bracha Lichtenberg-Ettinger, *Eurydice No. 6*, 1992-95

Bracha Lichtenberg-Ettinger, *Eurydice No. 20*, 1994-96

Bracha Lichtenberg-Ettinger, *Mama Langne No. 2*, 1992

and institutions. . . . Art in this sense, on the Web or in the world, exists to rejuvenate the fiction of art. This notion of art as living meaninglessly on artificial life support impacts a variety (perhaps a plurality) of less theoretical social perspectives. . . . It would be sad if artists were the last people to either understand or accept that this analysis has both enough theoretical validation and public support to undercut the cultural impact of almost anything called art. If this were the case, there would be no time to escape what amounts to a burning house."

CHAPTER 6
DISAPPEARANCE: ART ON LIFE SUPPORT

FROM: MARGARET MORSE
<morse@sirius.com>

"Life" and "death" are engines of desire that saturate cyberculture. Virtualities or fictions of presence are also fictions of absence. We are not discussing late-nineteenth-century rumors that art or god are dead. This fiction does not need to look "real" to work its own "fiction effect." The subjunctive of culture, the ghosts of what was, what might be otherwise and what could be, are not necessarily figured or enacted in another scene—they share our world.

FROM: BRETT STALBAUM
<beestal@pacbell.Net>

This is an excerpt of an article I posted (at http://switch.sjsu.edu:/Web/art.online2/brett. links/conjuring.htm): "Art as represented on . . . the hundreds of museum, gallery, education, and working artist sites, serves to conceal that it is art practice itself that is dead. . . . A perhaps more accurate way of positioning art within such an analysis is that art is an impotent cultural form living on artificial life support through art administration

FROM: CARLOS BASUALDO
<cbasualdo@aol.com>

What political/aesthetic effects could be attained by relinquishing the concept of "art" when talking about experimental practices on the Net. I am curious not only about the effects that this would have on the Net, but also on the effects outside the Net.

FROM: ELLEN FERNANDEZ SACCO
<esacco@ucla.edu>

Artists are not among "the last people to either understand or accept this analysis"; if anything, this viewpoint overlooks community-based or even individual efforts to use cultural forms to sustain expression and identities despite the boundries presented by current structures of art administration and institutions. The thoughts expressed in Stalbaum's excerpt are reminiscent of those variously heralded "end of's" which seem to occur at moments when a space becomes opened to those usually outside the system. The United States has a long history of nongovernmental support and suspicion for the arts that goes back to the nation's founding. It also has a history of resistance and circumvention of strictures across a variety of issues: the house has been on fire many,

NEXT>

many times. Alan Sondheim's question—"For what purpose, all of this practice, for whom, for what audiences, within what political economy, with what histories?"—gets to the issues that will have to be rethought constantly in the face of the policies, foreclosure, and totalization brought by the pressures of the global marketplace that diversifies constantly. What formats will a manifesto take given the fluidity of social, cultural and economic barriers? The relationship of art making (as a range of localized cultural practices) to processes of self-determination is only obscured further by focusing on too big a picture (art as impotent cultural forms in the culture warehouses of the world, or a work or movement's getting lost in the definition of what "art" is), but I don't want to wax utopic either. Pathologizing metaphors for models of working through culture presents the risk of creating new binarisms, new us/them models. How time gets represented in regard to all of this (the location and positioning of "art") is important to consider.

FROM: BRETT STALBAUM
<beestal@pacbell.Net>

Ellen Fernandez Sacco is correct in pointing out that "How time gets represented in regard to all of this (the location and positioning of 'art') is important to consider." As those who have read my entire essay know, this is actually the general point I was trying to make. The excerpt I posted is part of an analysis of how Baudrillard's critique is interpreted to view contemporary art. That viewpoint has a certain dangerous currency; the "burning house," if you will. But I do not simply accept that analysis. The text proceeds to state:

There is, however, a way to view this situation so that the precession of models leads to an understanding capable of enabling routes of escape. There are deeper level models invested in the figure of the artist which need to be drawn out and eviscerated. These are for the most part related to the latent selfhoods of artistic identity from the modern era. This basically Foucaultian critique emerges from the idea that art is a historically determined notion based on practices and objects, which in art's case also meet various semiotic conditions. The gallery, the museum, the materials, the objects, the patronage, and the simulacra which form the art market are then seen not as deterrence machinery but rather as social practices which emerge from complex and contingent conditions. The focus then changes from contemporary art's worthlessness to how it can be made useful again. In this sense it is not enough to say that art is catatonic, but rather to understand how contemporary postmodern/postindustrial contingencies effect art practice and to situate that practice strategically within them (from "Conjuring post-worthlessness: contemporary web art and the postmodern condition," *Switch*, Vol. 3, No. 2 Fall 1997. URL: http://switch.sjsu.edu:/web/art.online2/brett.links/conjuring.html).

I go on to make a case against Foucault's turn toward "technologies of the self," in favor of artists becoming the kind of knowledge workers capable of agency within a postindustrial, network-based culture. It is necessary for artists from all backgrounds to consider this, or the answers to the questions "For what purpose, all of this practice, for whom, for what audiences, within what political economy?" may be resolved for us, instead of by us.

I by no means wish to indicate any sense of pessimism regarding this art-as-knowledge work-strategy. The cynicism and bitterness often expressed in poststructuralist critiques

such as those made by Baudrillard both accurately characterize the contemporary art problem and fail to offer solutions. It would be as flawed a strategy to dismiss the postmodern critique of art as it is to only raise the critique cynically in terms of art's death. I know many artists who are in denial on this point. What cannot be said often enough is that the postmodern state of art is not grim. The recoding of cultural software through many means, including even traditional forms such as painting, can become conceptually-based productive activities once they are re-thought and re-purposed. This situation wherein the Western social conception of art and its vast complex of semiotic signifiers can unjoin, dissipate, and connect with other discourses in a knowledge practice is necessary and exciting.

FROM: BRACHA LICHTENBERG—ETTINGER
<bracha@easynet.fr>
Art just told me that she doesn't mind being dead (in my mother-language art is feminine). She is very bored when being entirely assimilated into sociological discourse. She likes her cold discussions with some fellow deads; she believes she never was too far from death anyway; and from before birth. She even believes she has always had privileged relations with death, with disappearance, with loss, with the invisible, and the unheard of.

FROM: RICARDO BASBAUM
<rirobas@visualnet.com.br>
The question is not asking if art is dead, but if, in a domain beyond life/death, like cyberspace, is there yet possibility for something beyond art, closer to another quality of affect?

FROM: ROBERT CHEATHAM
<zeug@noel.pd.org>
Dead is an okay place to be, whether for art or artists. The problem comes for the survivors. There are times when the Net seems mostly about denial.

FROM: CARLOS BASUALDO
<Cbasualdo@aol.com>
Et tout le reste est literature. The question of localization is quite puzzling to me. I understand its intentions, but I cannot help thinking that it relies entirely on an act of faith. I-am-somebody is asking you to believe that I am here, that I have a history, and that I can describe the place where this history is currently unraveling. In the Net we are very close. Maybe closer than ever, in the intimacy of writing and sketching, almost without anything in between. At the same time we are probably very far away from each other, from each of the others with whom we are close. I am very interested in the proximity of that distance and with the strange relation with faith that it seems to impose. Bracha mentioned death in her posting. I cannot help but finding a relation between that notion of death that she seems to be referring to and that faith that I am trying to describe here. And even if it is a very far-reaching question, I cannot help but wonder about the political and aesthetical implications of that distant proximity with that death and this faith that we all share in the Net, that constitute our common ground.

FROM: SALLY JANE NORMAN
<norman@wanadoo.fr>
I am perplexed by what seems to be claimed here that time in the Net is of a totally different quality from "out there" in the real world, where we have to deal with the vicissitudes of life (and death). (Human) life for

NEXT>

me resides in (breathing) ideas as much as in breathing bodies, and I encounter these both within and without my electronic extensions (of life). Dead friends' letters; thoughts and words and works that touch me, from and of people I've never met and who may well be dead or alive; resounding myths that well up from untraceable sources—I don't give a damn whether these are vehicled in Internet works or in other purportedly technologically less sophisticated communication networks in which I'm inextricably enmeshed (books, figments gleaned from somebody else's conversation at the bar, whatever). They open me to other times, other registers of existence, perhaps akin to the spatial "moiré," the broiled physical and emotional geographies that a few other nomads have been referring to in this discussion. I feel nettled about this timeless cyberspace stuff. So many aspects of our everyday life are "timeless" or, rather, made of impalpable, elusive qualities of time. They're no more hard and fast than the ideas I'm throwing onto this screen. Life (and death) are everywhere there are humans, caught between Heraclitus's "panta rhei," all things are in flux, and Bladerunner's last replicant's "time to die." That's us. All over.

FROM: ALAN MYOUKA SONDHEIM
<sondheim@panix.com>
Why on earth is to practice (contemporary) art to touch death? I see more grandiose statements here than in the United States Constitution.

FROM: CARLOS BASUALDO
<Cbasualdo@aol.com>
Earlier, I wanted to point out the ambiguous presence in the Net of what deconstruction would call "the ghost"—even taking into account its resonances in the more psychoanalytic concept of the "phantasm." Also, the communicative aspect that seems to be involved in the Net, as information takes "here" clearly and literally the form of a message sent to somebody. So, there seems to be these two aspects that permeate exchange in the Net: the question of the ghostly nature of our presence "here," and the question of our being in the position of the one who puts the message in the bottle and throws it away. My question specifically referred to the possibility, and implications, of practicing art from those positions.

FROM: BRACHA LICHTENBERG–ETTINGER
<bracha@easynet.fr>
Art can only be safe as dead with regards to claims that assimilate her entirely to other disciplines. Art on the Internet or in other media concerns me if it evokes, affects, and transforms me, or you, creating some kind of relations, an exterior yet intimate space with the unknown other, with ethical value alongside aesthetic consequences. Art, for me, has to do with fragility and transference, which doesn't go without risk of disintegration. Techniques of communication like the Net do not offer affective transmission and transformative transference, in any case, not in any automatic way. If and when they do, it is certainly not the fruit of the media's potentialities alone. Most art I have seen on the Net doesn't attain this point, and I don't navigate on it to find it these days. I am interested in the Web only inasmuch as it can interlace intersubjectivity, whereby opening distance I am still joining others, and wherein joining with others each of us differentiates ourselves. This activity inevitably involves processing loss.

Critical Art Ensemble is a collective of five artists of various specializations dedicated to exploring the intersections between art, technology, radical politics, and critical theory. In addition to art productions, the artist group organizes performances and theory lectures in which they adopt a critical stance towards models of representation geared to a capitalist, political, economic ideology.

CRITICAL ART ENSEMBLE

NEXT>

"cult of the new eve"
1999
CRITICAL ART
ENSEMBLE

What rhetoric can be used to represent new biotech initiatives so that they can keep their distance from eugenics? If the secular utopian rhetoric of the enlightenment is off limits due to association with first wave eugenics, and cybernetics is has meaning for popular culture, then what is left? The pitchmen of biotech, whether corporate or academic, are turning to the utopian rhetoric of christianity (and the roman catholic church in particular). To be sure, scientists involved in new biotechnological developments are pitching their work to the pub-

lic in very theological terms offering promises of new universalism, the end of aging and perhaps immortality, miracle cures, and edenesque abundance. New universalism is the idea that if all DNA is part of every living creature and that it is all compatible, that the essential link between all living creatures has been discovered. DNA can replace the soul. This is the proverbial "we are all one" at the molecular level. or, as mellon professor of the sciences edward o. wilson puts it:

"We are literally kin to other organisms . . . about 99 percent of our genes are identical to the corresponding set in chimpanzees, so that the remaining 1 percent accounts for all the differences between us . . . aren't these small steps gradually enlarging the self by degrees until the self is identified with more and more others?"

The new universalism brings a special kind of redemption for humanity, one that could only be offered in the after life in the theologies of the past.

Now we can heal the sick and live forever in the spirit of capitalism. In regard to immortality, there are cautious promises such as this one by professor of biochemistry s. michael jazwinski:

"We are generating transgenic worms and mice to test the hypothesis that at least some of the longevity genes isolated in yeast are important in aging in mammals. If we can validate this notion, we will have contributed a foundation for drug discovery efforts aimed at ameliorating some of the deficits of old age. This in turn would help to further our goal for everyone to 'die young at an old age.'"

And wild promises such as this one from michael rose, professor of evolutionary biology at the university of california at irvine:

"Death rates go up sharply with increasing age, but once

you go off the edge of that ramp, you reach a plateau where you are dependent on the quality of your cell repair capability. . . . I believe there are already immortal people and immortal fruit flies. We just need to get the benefits of these genes conferring immortality at a younger age, before we suffer too much damage."

In all, utopia abounds in this new flesh frontier, and as with any new technological revolution there is no promise too great. In fact, the promises have to be big in order to keep the investment dollars flowing, and what promise is bigger than heaven on earth–paradise now! The "garden of eden" will be reestablished once and for all!

Within this context, and in reaction to it, critical art ensemble (cae), in collaboration with faith wilding and paul vanouse, began the performance project "cult of the new eve" (cone). The strategy was to move the advertising rhetoric of science and its marketers from a context of maximum authority and legitmation (i.e., the authority of science) to a context with the least amount. The social constellation that would function best in this regard would be a cult. Cults are the object of the most extreme skepticism. No matter what they say, it is assumed by outsiders to be uttered by a voice of madness that one only listens to out of perverse curiosity and condescending amusement. Through

this social filter, the utopian promises of the flesh revolution are sent back into the public sphere in the hopes that the legitimacy of this rhetorical system will become corrupted via association with cult activity.

In order to better dress this situation in the robes of a cult, cae has developed cone as a performative superstructure that works on both real and virtual levels. The cult does public and on-line preaching; it offers the sacraments (baptism and communion), it has relics, and it has sacred theological and cosmological texts and prophecies. Most important, however, it has a sacrosanct messiah–the new eve. For much of the history of the human genome project, its activity was based

on a sample of blood taken at the roswell park medical complex in buffalo, ny, from one female donor. For cone, she is the "new eve"–the one whose gift of life unlocked the human genome thus ushering in the "second biological age." Under the cover of cone's cult

trappings, cae vehemently extols the utopian promises of biotechnology, and claims to demonstrate that the redemption of mankind will come from material rather than from spiritual means. For example,

at communion, in which cone gives cult intitates a host and a small cup of beer. These items are made with yeast into which cae has spliced the entire human genome of eve. Cone then insists that unlike christian communion where only one eats a metaphor for christ, with the new eve, a person gets to consume her in the material sense.

With this project directed against the rhetoric of the biotech market, combined with other cae projects that attack eugenic traces in reprotech ("flesh machine"), extreme medical intervention in reproduction ("society for reproductive anachronisms"), and flesh materials acquisition ("intelligent sperm on-line), the collective hopes to contribute to the development.

CHAPTER 7
POLITICS: POWER IN CYBERSPACE

FROM: MARINA GRZINIC
<grzinic@img.t-kougei.ac.jp>
In the beginning of 1997 the opposition forces and students protested in Belgrade because the party in power lead by Slobodan Milosevic refused to recognize the victory of the opposition in the city elections. Firsthand information transmitted via email and then spread through the Web, but without additional analysis and reflection (that is, about what is really going on in Belgrade and who is taking part in the protests) was enough to lead some people to proclaim that they were also taking part in the "Serbian" revolution because they were obtaining firsthand and eyewitness information through the Net. The community on the Net and its opinions were the sum total of read and forwarded messages and information obtained there. Following the decade of the fall of the Berlin Wall, important issues today concerning the Internet are to identify who are the old and new actors in the construction of this brave new world, which could be renamed the World Wide Web, and who is allowed to develop a criticism of the Internet.

FROM: ANDREAS BROECKMANN
<abroeck@v2.nl>
I want to state a few points under the header Topology of Agency: The challenge is to understand not only the new topologies of form and of presence, but to tackle the problems of agency and events in connective translocal environments. On a political level, this leads to the possibilities of a new type of public sphere that may or may not be established in and by the electronic networks. This public sphere will only come into being if there are complex forms of interaction, of participation and learning, that fully exploit the technical possibilities of the networks and that allow for new and creative forms of becoming present, becoming visible, becoming active, in short, of becoming public.

Here are some clues toward understanding the topology, and maybe the politics, of the networks:

1. Understanding the spatial and temporal parameters of networked spaces: Carlos Basualdo hints at the strange "proxemics" of the Net: "In the Net we are very close. Maybe closer than ever, in the intimacy of the act of writing, and sketching, almost without anything in between. At the same time we are probably very far away from each other, from each of the others with whom we are close. I am very interested in the proximity of that distance and with the strange relation with faith that it seems to impose."

2. Understanding the tools, their embeddedness, and the ways in which we may have to reinvent ourselves and our politics in a changing environment: Kate Hayles writes that "the posthuman offers us a way to think about human-machine interfaces in ways that are life-enhancing rather than life-threaten-

NEXT>

ing. It also offers opportunities to get out of some old boxes, particularly the mind/body split, and to put embodiment back into the picture," she adds, "My response to this situation is to try to point out the ways in which all technologies, including virtual technologies, are of course embodied; they couldn't exist in the world if they weren't. At issue here, then, is not only how the technologies are constructed in fact, but also how they are constructed in discourse."

3. Understanding the new habits, routines, and behaviors we are confronted with, that we may have to learn or unlearn: Jordan Crandall writes about the limitations of language-based approaches and asks: "I'm wondering if one key might be in the realm of the habitual, of encoded/embodied routines." The flip side is the problem of "behavior engineering," something that Tim Druckrey has discussed extensively over the past years. The dividing line between art and manipulation seems to disapppear in the "reframing of consciousness'" that Bill Seaman describes as being key to his own work: "How can such an environment enhance or trigger particular 'states' of consciousness in the user? To what extent can we 're-frame' aspects of the consciousness of the artist, via specific modes of 'translation' of operative poetic processes and poetic elements of image, sound, and text, within functional computer-mediated networks?"

Brian Holmes touches on a related issue in addressing the question of how to act as part of dynamic processes of high complexity: "To identify predictable patterns is of course useful for controlling events or taking advantage of them. But beyond control, could a certain kind of sensitivity to the complex eddies and flows of intersubjective exchange allow one to help precipitate the unknown? Could one,

say, recognize pattern formation and intervene where a new pattern could possibly come into formation? Or in another direction: could an aesthetics of patterned consciousness reveal the social nature of human autonomy? Could one learn to accept one's own interventions as precipitating a shared unknown? Could this become a more powerful and pleasing game than proprietary accumulation?" These are highly problematic issues, viewed from a perspective informed by a humanist type of politics. Yet their discussion seems to be vital for mapping the room for maneuver that we may have.

FROM: ALAN MYOUKA SONDHEIM
<sondheim@panix.com>

For what purpose, all of this practice, for whom, for what audiences, within what political economy? With what histories, for that matter?

FROM: CRAIG BROZEFSKY
<craig@onshore.com>

What happens when we group together a multitude of different people under the guise of lack? In this case, lack of access to another fabricated whole: the Net? The poor, or more generally "the lacking" perform a special function here. What/who does this homogenization of local and global tactics into a simple dialogue of access/lack benefit?

FROM: BRIAN HOLMES
<106271.223@compuserve.com>

How can the Internet be used to strengthen and expand politically oriented cultural collaborations, with their necessary inscription in located and embodied day-to-day existence? Can localized artistic and political practices have a different kind of life on the Net, and if so, how? Can those of us with the knowledge and privilege to use this medium turn

some effort to the creation of culturally based forms of political resistance, on an international scale?

FROM: TIM JORDAN
<tjordan@myriad.its.unimelb.edu.au>
The further question is, do those of us with the knowledge and privilege to use this medium understand the politics this medium involves us in? Every time I help a friend get online or, more generally, use their computer, I wonder whether I am really helping them (especially those who look forward to working at home, invading all their private spaces with the productivity demands of their workplace). What changes do email, the Web, and [their] underlying technologies bring? Embedded in the technologies that create cyberspace are many peoples' creations and work, done in their particular way for their own reasons; what politics results from all these creations?

There is no doubt that politics can be "done" simply using the Net's technology. The question of the Net's politics can be refused or, out of necessity, ignored, but its particular politics then simply continue invisibly. Brian Holmes's question is, for me, the most important one that can be asked, but it also needs to be asked in a way that does not presume politics travels unchanged across the divide between online and offline.

FROM: SASKIA SASSEN
<sassen@columbia.edu>
There is challenging work to be done toward finding a language—visual, textual—that captures the specifics of networked environments. Not being an artist, I think of these questions in terms of the kind of space: produced space of the Net, the economic dynamics that can be enacted in that space, the political dynamics (the intensity and

complexity necessary for a public sphere on the Net). How is the commercial density of the street enacted on the Net? Is hyperclicking your way from one site to another the lineal equivalent? How does the code through which economic power is made legible on the street reconfigured on the Net? Is economic power legible on the Net the way it is in other material environments? Does the growing digitization of economic activities (finance, for example) transform the legibility of economic power?

FROM: TIM JORDAN
<t.r.jordan@uel.ac.uk>
Theses on power in cyberspace:

1. Virtual lives cannot be avoided. Who can now live entirely on coin and paper money? Virtual lives are experimental. If my body is not there, can I type myself a new one? Virtual lives are part of virtual societies whose stable forms are beginning to be seen. These virtual social structures are constituted by the interrelations between three circuits of power in cyberspace. These circuits are the individual, the social, and the imaginary/collective imagination, and each results from certain assumptions about the nature of cyberspace.

2. Many begin their journey into cyberspace as individuals. In front of the computer screen, reading the glowing words we confront our singularity before building a sense of others in the electronic world. There is a double sense of individuality here. First, people must simply connect to cyberspace by logging in: the individual entering his/her online name and secret personal password to be rewarded with a little home in cyberspace (usually consisting of things like their email, list of favorite Web sites, online documents, and customized browser/interface). The first

NEXT>

moment in cyberspace is spent by nearly everyone in their own individualized place. Second, moving from this little home to other virtual spaces usually involves some moment of self-definition: choosing an online name, choosing a self-description, or outlining a biography. Through both these continually recurrent moments cyberspace appears and reappears as a realm where we are individuals surrounded by other individuals.

3. If you believe that cyberspace is the realm of the individual, then cyberpower revolves around certain capacities individuals gain in cyberspace. Politics and culture then result from those capacities. Cyberspatial cultures based on the individual are fundamentally structured by the three revolving powers of identity fluidity, renovated hierarchies, and informational space. Identity fluidity is the process by which our offline identities can be transformed/played with online; we can be different subjects online. Renovated hierarchies refers to the reinvention of hierarchy online, with many online resources undermining offline hierarchies (such as access to expertise) while creating new hierarchies (as Gareth Branwyn quotes one cybersex enthusiast as saying, "in compu-sex, being able to type fast or write well is equivalent to having great legs or a tight butt in the real world"). Both these resources rely on cyberspace as an informational space; bodies can be rewritten and hierarchies reinvented because cyberspace is constituted out of information, both in the information users provide and the hardware and software that creates cyberspace. When looking at the three axes of cyberpower that result from this premise, all the various cultures the virtual lands call peculiarly their own, emerge: the importance of style, the peculiarities of cybersex, the wonders of MUD (multiuser dimensions, that

is, text-based virtual worlds), the vast extent of Usenet, and more. The visible or dominant politics of cyberspace also emerge from these powers, placing access to cyberspace and the maintenance of powers in cyberspace at the core of cyberpolitical conflict. Cyberspace appears here as the land of empowerment of individuals, of reinventing identities out of thought.

4. Many people report a transformation—often a slow one—in their perception of online life. From an initial combination of bewilderment, glee, and scepticism (a sort of bemused intuition of how simultaneously ridiculous and important online life is), many come to accept the world of avatars as normal—from MUD dragons to email. With stable online identities, in whatever form they exist, people begin to have ongoing conversations, to meet the same people and learn their peculiarities. The particular rules of different corners of cyberspace become clear and normal. But then the individual is no longer the bedrock or final cause of all life, for communities have emerged. The transformation is not magical but sociological. Even communities that begin by assuming the sovereign individual is primary soon come to realize that collective responsibilities and rules appear, created by many and over which no one person has control. As Marx once remarked, the idea of one person constituting a language or creating a society is, strictly speaking, absurd. Anyone can invent a word, but to have it understood means having a community.

5. If you assume cyberspace is the realm of societies and collectives, then a form of technopower becomes visible that increasingly offers control of the fundamental fabric of cyberspace to an expertise-based elite.

Technopower is the oscillation between using technologies as thing-like tools and creating technologies according to social values. The direction of technopower in cyberspace is toward greater elaboration of tools to more people who have less ability to understand the nature of those tools. Information is endless in cyberspace and creates an abstract need for control of information that will never be satisified; users constantly experience information overload—too many emails, too many web-sites, virtual commmunities that demand too much time—because of this sea of information. To control overload, users increasingly rely on technological tools that time after time appear as neutrally pointing the way to greater control over information but time after time result in different forms of information constituted by the values inherent in the new tools. The result is the addition of new, more complex layers of technology between the user and the information they seek and subsequent recurrences of information by the amount of information cyberspace contains. Control of the possibilities for life in cyberspace is delivered, through this spiral, to those with expertise in the increasingly complex software and hardware needed to constitute the tools that allow individual users to create lives and societies. Technology becomes increasingly elaborate meaning that most users are unable to manipulate the tools they rely on, they become disenfranchised by technopower. But those who have the expertise to manipulate cyberspatial technologies—whether it is through large corporate endeavours, collective efforts such as Linux or individual expertise such as hackers—become an ever more powerful cyberelite who define and control what it is possible for most other cyberspace users to do in their vitural lives.

6. The irony of technopower is that greater elaboration of technology is demanded by individuals and appears to them as tools for increased control of information. This demand produces tools that simultaneously answer one problem of information control while producing new forms of information out of control. There is no greater example of this than the World Wide Web, that made the Internet available to many but also made them dependent on browsers, plug-ins, ISPs, and the governments and corporations behind these. The continual elaboration of technopower delivers the fabric of life in cyberspace to an elite and is called for by individuals seeking answers to problems of too much or too poorly organized information. Individuals strive to free themselves in cyberspace with the tools of an informational world. As a consequence, we have become dedicated to the endless task of forcing information's secrets from cyberspace, of exacting the truest confessions from a shadow. The irony of this deployment is in having us believe that our "liberation" is in the balance.

7. The third form of technopower is that of cyberspace's imaginary. Societies all have hopes and fears that are shared among people who may never meet; these form their imaginary collective imagination. A recurrent characteristic of imaginaries is that they appear to be on the verge of coming true, they are in a constant state of almost becoming real. Imaginaries offer hopes and fears that often do not appear as hopes and fears, but as real projects just one or two steps away from completion. Much of the urgency people draw from imaginaries stems from this sense of being nearly but not quite completed, meaning people feel a need to act quickly to either prevent the imagined disaster or bring on the imagined benefit. Cyberspace's

NEXT>

imaginary creates urgency because technological leaps always appear to be almost completed. Cyberspace's imaginary is driven by this compelling feeling that change is near (the future is in beta).

8. Cyberspace's imaginary is structured by a twinned utopia and dystopia that both stem from the awed claim that everything is controlled by information codes that can be manipulated, transmitted, and recombined through cyberspace. From Kevin Kelly's libertarian vision of Darwinian "hive-minds" to Donna Haraway's revolutionary, difference-demanding cyborgs, the radical hopes and fears in cyberspace result from a belief that everything is now manipulatable through information codes. Certain particular visions are collectively imagined from this realization and provide some of the unifying thoughts that allow individuals in cyberspace to recognize each other as members of the same community. The sudden thought that all these different things—computers, life, surveillance, immortality, and godhood—are based on information codes that are within the grasp of information manipulating humans, leads to all sorts of passionately imagined possibilities.

9. Power is pre- and postpolitics, pre- and postculture, and pre- and postauthority. Power is the condition and limit of politics, culture, and authority. Power seeps through and around all forms of politics, at times bringing opposites into conflict in a way that reinforces the fundamental flow of power. Cyberpower aims not at the immediately obvious forms of politics, culture, and authority that course through cyberspace but at the structures that condition and limit these three. Cyberpower reveals the underlying workings of lives, societies, and dreams in

cyberspace that can be expected to endure for some time. A certain complex form of power that operates on the three levels of the individual, the social, and the imaginary can now be seen careening through the virtual lands, directing conflict and consensus toward certain distinctive issues and social structures.

**FROM: RICARDO DOMINGUEZ
<rdom@thing.Net>**

Zapatismo has infected the political body of Mexico's "perfect dictatorship" since January 1, 1994. This polyspatial movement for a radical democracy based on the Mayan legacies of dialogue ripped into the electronic fabric of The War Machine, not as cyberwar but as a virtual action for real peace for the real communities of Chiapas. As of September 1997, reports of the Mexican military training and arming paramilitary groups with the intent of moving the "low-intensity" war to a higher level began to circulate among the Zapatista Network. It took the massacres at Acteal to focus the world on something that was already known-the constant tragedy of late-capital. As manifestations took place around the world in remembrance of Acteal dead on January 1 and 2, the Mexican military with the full support of the PRI goverment began to move to the next stage of the war against peace. As the West stumbled about in celebration of a new year, the first report reached out across the Net and slapped us awake once more with the vicious and brutal reality of the neoliberal agenda.

This time Zapatista networks responded with a new level of electronic civil disobedience beyond the passing of information and emailing presidents. On Sunday, January 18, 1998, a call for NetStriking for Zapata (from Anonymous Digital Coalition) came in via email with the following instructions: In solidarity

with the Zapatista movement we welcome all the netsurfers with the ideals of justice, freedom, solidarity, and liberty within their hearts, to sit in the day January 29, 1998, from 4 pm GMT (Greenwich Mean Time) to 5 pm GMT (Greenwich Mean Time) in the following five Web sites, symbols of Mexican neoliberalism:

Bolsa Mexicana de Valores
<http://www.bmv.com.mx>

Grupo Financiero Bital
<http://www.bital.com.mx>

Grupo Financiero Bancomer
<http://www.bancomer.com.mx>

Banco de Mexico
<http://www.banxico.org.mx>

Banamex <http://www.banamex.com>

Technical instructions: Connect with your browser to the upper-mentioned Web sites and push the bottom "reload" several times for an hour (with an interval of a few seconds in between).

1. For Netscape Navigator users on PC, Apple Macintosh, and Unix o.s.: from the Option menu select Preferences and set up:
memory cache = 0
disk cache = 0
verify document = Every Time

From the Option menu select Network Preferences, and activate the No Proxies option

2. For Microsoft Internet Explorer users: from the View menu select Options-Advanced and in the Temporary Internet File box select Never.

This virtual sit-in not only brought the possibilities of direct electronic actions to the forefront of the Zapatista networks, it also initiated a more focused analysis of what methods of electronic civil disobedience might work.

FROM: BRIAN HOLMES
<106271.223@compuserve.com>
Tim Jordan, there is something quite generous about the way you follow an individual's journey into cyberspace: the initial skepticism and enthusiasm; the discovery of a new fluidity of identity; the gradual awareness of a social dimension to the cyber experience. Perhaps then when you cite Marx and you shift to another level of analysis in your fourth and fifth theses, you intend merely the deepening and broadening of a common experience. You depict the moment when the individual, reflecting on his or her inscription in a historical process, comes to question what before seemed a progressively greater conquest of freedom, and now appears as a more powerfully charged implication in the larger patterns of a civilization's development. You point to the ways that a fantasy of individual omniscience fuels an increasing dependence on technological tools for the management of information. At the end of your sixth thesis, when you speak of the irony of this situation, you are essentially quoting Foucault from the conclusion to his book on the will to knowledge—or reinventing him. At this point you have gone far beyond the specifics of the Internet, to deal with matters fundamental to the modern experience over centuries of development.

I am very much in agreement with this drift, because for me, the Internet in all its manifestations is simply characteristic of the current phase of our social or civilizational pattern, whose cellular building-block is

NEXT>

possessive individualism (which I see at work, very clearly, in the fantasies of omnipotence you describe).

You are outlining the specific of forms that social power takes in the individual and collective psychology of the online experience, and at the same time, through your references to Marx and Foucault, you are (implicitly) drawing critical connections to the larger world. This double thrust seems essential to the real power of "cyber-power." But I would suggest that it is equally urgent to make psychological/ideological observations, and to go beyond them.

After the several year period of research leading up to the Documenta X book, it became apparent to our group here in Paris that two directions are particularly promising for cultural-political engagement today. One, appealing to Habermas, involves a scandalously idealistic assertion of the social power that remains in the notion of the public sphere. I suggest that this public sphere acquires a specific form through the Internet, and through the interplay of national and international institutions that the Internet helps make possible. This approach can be developed as a necessary extension of enlightenment universalism in the age of globalization: an attempt to create worldwide norms of freedom and equality to balance out the effectively "universal" reach of capitalistic exploitation. Such an enlarged public sphere cannot even be fully imagined without the Net, and it cannot hope to attain its potential without the organizational capacities that the Net really does provide—for I wish to point out that not just ethereal information but also very real resources are managed by corporations and governments with the help of their encrypted channels, while

the transparent democratic public sphere, as usual, lags behind. One important thing to do today is to catch up to the corporations. But another approach must no doubt largely take place off the Net. It involves diving into the mesh of collective pasts, to discover and reactivate scattered threads, latent historical energies, which can allow individuals to recognize themselves in the mirror of potentially sharable and potentially alternative projects. This adventure, I think, is something that Foucault himself turned toward at the close of his life: the attempt to plunge into a collective past and to replay certain fundamental decisions. This is of course a dangerous game, and every good neoliberal will brandish the specter of identitarian fascism. Those whose heart and imagination goes out to the collective pasts of the losers, to the vanquished, and to the still unborn ideals gestating in whatever neighbors and friends one has been able to find, can best reply to this accusation by seizing the ultramodernity of the networks at the peak of their democratic potential, and calling out reasonably and with passion for a new common sense that accords every cultural pursuit some right to live in the city of man- and womankind. This is a message we can offer through this universal network: that there is a place in the world-space for all particular ideals, and not only for the collectivized and standardized grasping of possessive individualism.

Like all the realms of social life, the Internet is not only shaped by manipulative powers. It can still be a tool of emancipation, if it is tied to other levels of experience in such a way that the reciprocal differences between on- and offline are able to effect a valuable critique of what promises to be the very dicey experience of surviving the twenty-first century.

FROM: PEDRO MEYER
<zonezero@mail.internet.com.mx>
The significance of public opinion is starting to play in significant ways as it gains the potential to alter public policy. The Zapatistas in the Chiapas struggle would have been over-run with great ease by the government, if as in the past they (the government) were the only ones who had control of the opinion-forming media. Through the Internet, there finally was a potential for creating resistance to the government campaign against the Zapatistas, and in doing so, recasting the public perception of what was going on in Chiapas.

Just last week, the Zapatistas attacked the home page of the Mexican Treasury Depart-ment, in protest for what is going on in Chiapas. A page of Zapatista literature would come up every time someone requested the home page of the Treasury Department. Such political collaborations are surely going to make themselves ever more present during the years to come, as artists learn how to do such work.

FROM: ERIC LIFTIN
<liftin@mesh-arc.com>
The threat to public space on the Net will only grow as corporations develop next-generation high-speed networks to supplant today's Internet. Rather than the current nonhierar-chical distribution of bandwidth (relatively, of course most people have no access to high-bandwidth, but most people have equal access to Blast and to Time Warner), new sys-tems of access and distribution will link directly to shopping mall experiences. The key element that will set the tone for politi-cal involvement is a displacement of con-sciousness onto the Net. How will people become emotionally invested in the new space? The consensus is that local political action can be effective on the Net, but on a broader scale we should focus on informa-tion/communication. When will people begin to feel that actions on the Net have real con-sequences? The surging libel issues remind us that people still think of the Net as an underground space of unaccountability.

FROM: CARLOS BASUALDO
<cbasualdo@aol.com>
Right now there is a gigantic fire in the north of Brazil, close to Venezuela, that has already swallowed up 38,000 square kilometers, one-third of the state of Roraima. There are entire cities blocked by the fire. Up to yesterday there has been no international help for these people at all. The fire has been going on for weeks. A squadron of Argentine firemen start-ed working yesterday. I haven't seen any news about this in the *New York Times*. This may have a very strong effect on the global weather, besides destroying the local ecosysytem. Are we ready to do something about these kinds of things on the Net? At least, promoting solidarity, spreading the news, helping in any way?

FROM: BRACHA LICHTENBERG—ETTINGER
<bracha@easynet.fr>
All the art drops will not extinguish this fire. They will not extinguish future fires, which is worse. Every day art fails a little. Some days art fails more than others. The borderlines between aesthetics and ethics are to be rene-gotiated and reattuned again and again.

A potentiality to make a difference within/for others becomes beauty when the artwork vibrates and the spectator is attracted, trans-mits back to it, and onward to others. No con-tent, no form, and no image can guarantee that an event of co-affectation will take place

NEXT>

via a particular artwork for particular viewers and that beauty will arise. But when it does, a matrixial coaffectability hides behind the form and the image, and we can think of it as spouting, overflowing, and proceeding from sharable, eroticized antennae of the psyche, acting all over the synaesthetic field and channeled by the scopic drive inside the field of vision, to attest that imprints are interwoven between several subjects: that something that branches off from others engraves traces in me, and something that relinquishes me or is to me mentally unbearable is yet accessing others, that we are sharing erotic antennae but processing different re(a)sonating minimal sense from them. These erotic antennae register what returns from others as traces, and transmit a centerless gaze.

Would this gaze reach you in reality where and when you need it? Would this gaze reach someone where and when it could be healing? Will it extinguish this fire? Or would it operate, like poetry for Paul Celan, in the too early and the too late? So I say, every day I fail a little.

FROM: JOY GARNETT
<rglib3@metgate.metro.org>
Let's not confuse activism with certain somewhat more intimate practices that we gather (loosely) under the term "art," and which you seem to be trying to justify in terms of activism and not in terms of art. I think we can agree that art as a practice has served many people in different ways. Don't forget political prisoners—intellectual prisoners or otherwise—and many individuals of far-flung cultures over centuries suffering under various instances of political duress and oppression, from Osip Mandlestam to Breyten Breytenbach, not to mention the undistinguished, the anonymous, or the forgotten.

Activism and change may not even have always been the point. There are other points.

We all bear a responsibility when it comes to how we contribute to our daily fabric—be it painting, cooking, fighting bureaucracy, tying the shoelaces of children, experimenting with Web art, flinging away our brushes and fighting fires. Are they mutually exclusive? There are all kinds of doors that need opening, and only certain things open certain doors.

FROM: BRIAN HOLMES
<106271.223@compuserve.com>
I'd like to add my matchstick or water bucket on the matter of intellectual practice. Intellectual practice is this: look and listen, read, reflect, write, speak. It has diffuse but real effects: the formulation, expression, and reception of ideas can change what is tolerable in a society. When I said I'd like to hear more about the fire in Roraima state, I didn't expect the news would do anything about it. I wanted to use the unique possibility of this communications medium: the chance to hear an individual's opinion on a situation far away, inaccessible to me, given the limits of my social relations and knowledge. Not because I wanted to wring my hands, or cook up the kind of obscene, guilty-conscious installation that Olu Oguibe describes. For me, today, information and testimony about specific realities is the compelling counterpart to systems theory or the attempt to conceptualize the globalization of capital. Specific knowledge keeps that theoretical effort honest, helps guard against the blinders of ideology, a problem whose locus is "the media." But I'm not sure that "Artaud's scream cannot be heard in the Net," as Clifford Duffy writes. All I've ever done with Artaud is read him. The question is how you read, isn't it? And what you do with what you read. I think a lot of

information is still connected to worldly realities, which are not created by some apocalyptic "Planetary Whore" but by political-economic systems with which each specific person maintains relations of tension, between acquiescence and refusal. My aim is to get a lot of information, follow some of it to fires, push the limits of my own tense relation with systemic forces, and look and I listen, read, reflect, write, speak. Coherently if possible.

NEXT>

What we are looking at is the oscillation and transformation of potential agencies and potential (group) subjectivities in the interface, and we are testing what the political effects might be. By working with force fields, intensities, energy fields as formal elements of the projects, we move away from the analytical, rational conjunctive models towards open, unpredictable results. The aim would be an open interface that allows a bandwidth of agency between public access, excessive manifestations, connective confrontations, and tactical withdrawals. Such micropolitical interfaces have to be outlined, coded, and activated! http://io.khm.de

KNOWBOTIC RESEARCH

IO_dencies Tokyo 97:
Technologically based artistic practices and developments were taken as a start-
ing point for co-operations with local participants in Tokyo, Sao Paulo and Ruhr
Area. Urban processes were read collaboratively and made available in a data-
base. In continuous mutual transformations and re-articulations of the local par-
ticipants during several months, the recorded processes achieved an electronic
urban presence. Through these collaborative constructions and experiences, the
participants could address potential fields of intervention in their social living
environments.

IO-
DENCIES
tokyo

QUICK INFO

LOCAL

chg Attracting 1 0 hops 1 layer
chg Attracting 1 0 hops 1 layer
chg Attracting 1 0 hops 1 layer
chg Attracting 1 0 hops 1 layer

REFRESH

⎕ human flow ▯ information flow ☒ economical flow ⎕ traffic flow ⎕ architectural

UNKNOWN @202.228.135.100 | GOBAD_MM4@202.228.135.98

0.033

ship terminal
water bus

NEW SESSION

Profile : Hinode – passenger terminal
Attractor : None

knowbotic research - IO_dencies tokyo - 1997 - http://io.khm.de/tokyo

IO_dencies Sao Paulo 98:
Sandro Canavezzi de Abreu, urbanist Sao Paulo:
"Perhaps we need to make an effort of realizing what doesn't appear on our computer terminals and what is not reality of a universe dominated by the newest technologies. The description of this computerized world loses sense when we think about Somalia or about our slums. And what a tragedy: As long as this technological development continues to happen, the more social apartheid we will have."

familia santos

para Alphaville

metropolitan

trains/ruins

Argonauten
incomensuravel

SPnegro/branco

familia santos

bre o Tempo
tempo de pobre

Lilith costuras

knowbotic research - IO_dencies sao paulo - 1998

IO_lavoro Immateriale, Venezia 99:
IO_lavoro immateriale articulates connective interfaces which incorporate the potentials of agency in the multiple movements of information. The processes in the interface are fleeting and distorted, but they can be acted upon. The participants' interventions and modifications in the database manifest themselves as energetic condensations, twists and bendings. In the form of magnetic fields presented in the exhibition, Knowbotic Research designs an additional material-ization of the ongoing processes in the database and thus offers them to physical experience. Maurizio Lazzarato's central question is also raised by the interface: What kind of action is possible in the public space? Possible should here be understood in the sense of constructive, constructive in the sense of resistant, resistant in the sense of physical, i.e., physical in between the virtuality of the technological and the virtuality of society.

IO_dencies projects were coproduced with ZKM Karlsruhe (i3 research) KHM Cologne, Canon Artlab Tokyo, Goethe Institute Sao Paulo

keyword· lavoro immateriale

entro e fuori del capitale
bio - politica

diventare donna del lavoro

lavoro immateriale
sapere e conoscen.

forza di desiderare e forza di pensare

l' economia dell informazione

consumatore - comunicatore

molecular insubordinations
molar victories

knowbotic research - IO_lavoro Immateriale - Venezia 99

ALIEN INTERCOURSE:
THE POETICS OF A LISTSERVE CONVERSATION
MARGARET MORSE

> I write. I write you. Daily. From here. If I am not writing, I am
> thinking about writing. I am composing. Recording movements.
> You are here I raise the voice. Particles bits of sound and noise
> gathered pick up lint, dust. They might scatter and become
> invisible. Speech morsels. Broken chips of stones. Not hollow not
> empty. They think that you are one and the same direction
> addressed. The vast ambiant sound hiss between the invisible line
> distance that this line connects the voice and space surrounding
> entering and exiting.
> —Theresa Hak Kyung Cha[1]

> . . . I try to develop social sculpture as a new discipline in art—
> at first it is an invisible sculpture. . . .
> —Joseph Beuys[2]

I. GETTING WET

"WE WERE ALL practiced virtuals," Ellen Ullman writes about her "virtual" company.
"We were careful not to say too much about ourselves, careful not to make assumptions
about the future. . . . We knew better than to get involved."[3] Email's intimacy at a
distance is one solution to computer cell loneliness—but can it support far more

challenging and responsible levels of intersubjectivity? This essay reflects on the conditions of possiblity for felicitous conversation in the virtual realm.

Conversation is often lightly called an art form, but it is seldom treated seriously as such. What is usually implied by the "art of conversation" is not a genre in the art historical tradition, but the cultivation of congeniality and concern for etiquette, skills on a par with cooking, gardening, and perhaps the *ars erotica* of which Foucault wrote in his *History of Sexuality*. Making the earth fruitful, the fruit delicious and making love—all of these are the ingredients of a paradise in which the exchange of words—used instrumentally or cruelly on so many other occasions—is also fruitful and pleasurable. Heightened and framed forms of conversation are the heart of drama, literature, and philosophy (Plato's *Symposium* is the most famous example), but in this essay we are first discussing direct (or virtual) address in more or less improvisational social conversation that Erving Goffman called "fresh talk,"[4] and then an emerging mode of Internet exchange, the listserve or group email that blurs the distinction between conversation and writing. Literary salons of the eighteenth century, the cafés of fin-de-siècle Vienna, and certainly conceptual art, happenings and performance art from the 1960s on have embraced social conversation in its live and ephemeral form. Joseph Beuys, discussing "social sculpting" with an audience in New York in 1974, proposed his famous idea "that art is the *only* possibility for evolution, the only possibility to change the situation in the world. But then you have to enlarge the idea of art to include the whole creativity. And if you do that, it follows logically that every living being is an artist . . . "[5] Thus, conversation that is shaped creatively by all its participants can be both a vehicle for cultural change and the social sculpture that results—a semi-public sphere composed of "invisible distance lines" drawn by the erotics of encounter.

Unlike information, conversation as social sculpture is autotelic: it achieves its pleasures and purpose simply by virtue of coming into being. Like *community*, it "seems never to be used unfavourably, and never to be given any positive opposing or distinguishing term."[6] Here we are under the dominion of Eros, building greater and greater unities; one wonders what has happened to the death drive and what the erotics of encounter actually might involve. I propose that the death drive is never

far away and that, indeed, it is the awareness of finitude that makes us revere conversation. Most recently, my email was full of intense appeals in a strange, perhaps unprecedented situation. People under bombardment in Serbia and Kosovo (and to a far lesser extent, earlier in Iraq) were addressing their attackers in terms of "I" and "you." These were people under fear of death, who, via the internet, could describe their own bewilderment, suffering, and anger, and call us, citizens of NATO countries, to account.

A year before these terrible events, I received an invitation to participate in a listserve or group email exchange, the **<eyebeam><blast>** critical forum on Artistic Practice in the Network. Like Ellen Ullman, "I find it hard to resist that voice of the software urging, *Reply, reply now.*"[7] I was already overwhelmed by mountains of information—discontinuous, discrete items delivered randomly but incessantly—and averse to spending yet more unhealthy hours at the keyboard. However, this was conversation—in an asynchronous, on-line version—formatted and tended as an art. Aside from a few famous names, I knew neither moderator, the diverse hosts, other guests, nor the participants-at-large—a network of artists, media and cultural theorists, critics, curators, teachers, and others loosely allied with the art world. In other words, this was a well curated event that also had the elements of adventure and surprise. The diversity, experience, openness, and expressive abilities of the participants made the quality of discourse very high. The result of that three-month conversation, edited and organized thematically by thread in this book, speaks for itself. What I want to return to here is how conversation itself unfolds, and the pleasures of its dialogic form.

Wary from having been flamed, I had lurked but never posted in such a collective list before. Flaming is a kind of status or exclusion ritual that jams the lines of communication without anything much to say. The people on this forum had much to convey, so I felt I could expect an atmosphere of social trust that meant—unlike most events billed as a forum—one could let one's hair down. The format also possessed the basic requisite of drama—it had a beginning, a middle, and an end. Whatever happened, it would be over. I logged in, read, and, with trepidation, posted perhaps too intimate thoughts several times during my assigned week. I came to

cherish my virtual brush with the lives of others in a way that made me reflect on the art of conversation and our conversation as art.

Imagine sitting in a lonely cubicle, writing letters that are exchanged so quickly, it is virtually now. (Posters have time to think, time to compose, but not much.) Some posts allow a glimpse of a computer in another place—a vista of tundra, Carnaval in Rio, an atelier in Paris. In daily intervals, group email from strangers in six continents accumulates rhythmically in my inbox. Attention to the quantity and pacing of posts restores the sense of an interval, rectifying one of the most onerous aspects of the virtual life—speed-up or loss of "the float" (a financial as well as oceanic metaphor). Something akin to a conversation begins to take place in many threads that build from reply to reply, accumulating meanings, revealing personalities. Writing like this seems to look inside the mind of the other, but in a very different way than novelistic fiction. We can read the thoughts of a fictional character without personally confronting them. However, the poster of email is both author and character speaking as "I" to "you," the reader. The reader sometimes thinks she understands the other, and, after she has posted and received an answer, sometimes she also feels understood. Such a heady, albeit ephemeral experience of mutuality has a lightness or joy to it. In "The Lady of the Camellias," Roland Barthes found the desire of Marguerite Gautier for recognition quite pathetic.[8] Yet, who or what could be subject of a sentence without it? With it I am a subject and subjected, creator and created. I am an artist, and my material is invisible, links between subjects in the vast hiss of information that is not there for me and you. Such intersubjective recognition, be it a rare or ordinary occurrence, is part of the tacit dimension of life where core values reside.

It is not by chance that the participants in this virtual conversation are strangers. As Bakhtin put it:

> In order to understand, it is immensely important for the person who understands to be *located outside* the object of his or her creative understanding—in time, in space, in culture. For one cannot really see one's own exterior and comprehend it as a whole, and no mirrors or photographs can help; our real exterior can be

seen and understood only by other people, because they are located outside us in space and because they are *others*.[9]

Of course, conversation on the forum is virtual and, even if it occurred in contiguous space, the people and their otherness would still be a construct, the effect of signifieds produced by texts exchanged at intervals. Here is the enunciative fallacy at work, conflating the subjects of these network utterances with the minds of unknown actual people who typed them and clicked on Send. However, far from being a flaw, it is this difference between ourselves as enunciators or email senders, and the personas we create and above all, transform—that is the art. This space-in-between is what we can shift and turn around in: an edge of text weakens and a bit of wetness leaks in. At its most extreme, orgasmic pleasure in the loss of boundaries between self and other is called the "oceanic feeling."[10]

Far from being anonymous, these virtual strangers in conversation have the power of names, countries, continents, and experiences to challenge each other. There is an odd pleasure in gaining an unseen or disavowed bit of ourselves, when, in dialogue, we are called to account. (I am always surprised by my own or my students' gratefulness for a critical challenge to a statement, that is, provided that we sense good faith and feel that we are understood.) I rely again on Bakhtin to explain the desire to be "called to account":

> Thus, all real and integral understanding is actively responsive, and constitutes nothing other than the initial preparatory stage of a response (in whatever form it may be actualized). And the speaker himself is oriented precisely toward such an actively responsive understanding. He does not expect passive understanding that, so to speak only duplicates his own idea in someone else's mind. Rather, he expects response, agreement, sympathy, objection, execution, and so forth (various speech genres presuppose various integral orientations and speech plans on the part of the speakers or writers).[11]

NEXT>

Perhaps Martin Buber theorized the spiritual dimension of such responsiveness best as a dialogue between "I" and "thou" that has the potential to enclose human and horse, rock and tree in its sacred embrace.[12] This conversation with the other (that includes deity, animals, and things that can at least seem to answer back) offers rewards—orgasmic loss of self, discovery of what we might prefer not to know, communion with what is not self—that are as immense as they are terrifying. If the promise of self-transformation were enough to quicken dialogue, it would never cease.

One major theorist of twentieth century drama, Peter Szondi, proposed that entrapment or enclosure was necessary to produce the heightened dialogue of the stage that demands conflict and resolution. The alienation of people from each other in everyday life, in contrast, was unlikely to produce encounters that reveal and resolve social tensions.[13] What this suggests is that a conversation, like any work of art, needs a frame, a limit, the sense of an ending, the possibility of closure—even if it is refused. That quickening, be it spatial or temporal, is a reminder of mortality or, in perilous situations, the imminence of death. Sometimes even the art itself is about ending: consider that the exemplary "real experiment," recounted by Allan Kaprow, consists of leading a village in New York to disincorporate.[14] Anticipation of an ending quickens what goes before; my relation to my computer changed knowing that I would be able to open only so many <eyebeam> boxes and that this pleasure of many threads would be cut short.

II. STICKS AND STONES

> —and it would be very nice if the dialogue could be very intensive—
> — Joseph Beuys[15]

> Into the mouth the wound the entry is reverse and back each organ artery gland pace element, implanted, housed skin upon skin, membrane, vessel, waters, dams, ducts, canals, bridges.
> —Teresa Hak Kyng Cha[16]

A number of years ago, during a major windstorm, I was traveling to San Francisco in public transportation. About mid-point under the San Francisco Bay, the power went out, and our crowded car stood body to body in total darkness. The social murmur ceased. Then, the silence was broken by voices. Anonymous strangers shared an intimate and revealing conversation of jokes, rapid transit stories, and about being afraid under a mountain of water. As the lights came on after about a quarter hour, there was silence. We exchanged embarrassed glances—who had said what?—then the murmur began.

The Mir space station is a far more extreme situation of absolute propinquity without anonymity: the bodies of astronauts are encapsulated together for months-on-end in the hostile environment of outer space. "If you have a fight on Earth, you can go out to a movie or something and it is all better. But in space, you can't go anywhere. You are there."[17] (It is Mission Control, however, that is ultimately blamed by the crew for all its problems.) Since enclosure is almost guaranteed to produce dialogue that brings tensions to a head, psychiatric experts use it to study the conditions for an ideal, if forced conversation. Critical factors include numbers that produce an "out" group that "still has somebody to talk to," as well as degrees of otherness. Consider that Russians and Americans are face-to-face and they can't get away: "There is a school of thought that diversity during a long-term space mission might be a positive, because it keeps them interested in each other longer." Finally, there is the capacity to cooperate in achieving a goal. Now it appears that the Mir may be left to burn up in the atmosphere over the ocean sometime in the year 2000.

Such propinquity can be found in bomb shelters and countries under blockade; however, it is a rare situation in a global village of strangers. There, in Ellen Ullman's description, a physically separated exchange of words takes place virtually, "wrapped in the envelope of technology: one man, one wire." This "male sort of loneliness" is only to be assuaged at a safe physical distance via telegraph, ham radio, or the "single channeled-ness of the net."

NEXT>

The listserve, however, is a network, multi-channeled in effect, though one of its graces is singling someone out for a response just for them. I did this over a year ago to "never-ending-agony," who proved to be a Serb student, an artist whose every communal effort to stop her government's atrocities had failed. I sympathized that years ago I too was unable to stop the atrocities of my government, in this case, the bombing of Cambodia. Such a conversation has different conditions of possibility and a different impact than a group conversation, just as a conversation in the flesh is influenced by entirely different factors than a virtual exchange. Meeting virtual soulmates in the flesh is a thrill; it is also an experience that reveals the different potentials of social sculpting one-to-one and many-to-many, virtually and face-to-face.

Considering the loss of public sphere and diminishing venues for encountering the other, dialogue is a rarity and must be called forth with effort. The net and the web retain enclaves from the commercial and instrumental exchange of information. Despite their newness, these networks are part of an infrastructure that is a material social sculpture, created and tended slowly and incrementally over generations. Infrastructure—arteries, ducts, membranes—cannot be separated from the bodies of a people; thus, to destroy infrastructure is not a selective or temporary or trivial act.

The relation of a people to its government is also a tricky situation—to what degree is a whole, undifferentiated people accountable for the acts of its national leadership? I remember how devastated I was by a conversation in Ireland that identified me with my government's policies in Nicaragua. It seemed horribly unfair and yet, as a citizen, not utterly to be dismissed. The war in Yugoslavia has brought an urgency to attempts to think through the stakes of conversation and its conditions of possibility. Such thinking is best done from the bottom up, in conversation itself, but not at random in reliance on self-generating patterns akin to flocking algorithms. Applied to social intercourse, such models from physics, or for that matter, laissez-faire economics, have little to do with the work of tending and cultivating subjects, forcing dialogue like some bloom in winter. For that we need conversation as art.

1. Theresa Hak Kyung Cha, *Dictee* (New York: Tanam Press, 1982), p. 56.

2. In "A Public Dialogue, New York City, 1974," *Energy Plan for the Western Man: Joseph Beuys in America* (New York: Four Walls, Eight Windows, 1993), p.35.

3. Ellen Ullman, *Close to the Machine: Technophilia and its Discontents* (San Francisco: City Lights, 1997), p. 147.

4. Erving Goffman, *Forms of Talk* (Philadelphia: University of Pennsylvania Press, 1983), particularly in "Radio Talk: A Study of the Ways of Our Errors," pp. 197-327. Of course, internet chat—simultaneous and live exchanges in writing or speech—is far fresher talk than email. However, instantaneous chat is notorious for its time-zone inconveniences and for not working; it has also been faulted by many different critics for its weak content. Such exchanges are largely "phatic"—there to open channels and make "live" contact, however fictitious and virtual the setting and characters may be. There is, evidently, something enthralling in this simple act of mutually connecting.

5. Goffman, pp. 25-26.

6. Community is defined in Raymond Williams, *Keywords: A Vocabulary of Culture and Society* (Glasgow: Fontana/Croom Helm, 1976), p. 66.

7. Ellen Ullman, "Come in CQ: The Body on the Wire," *wired_women: Gender and New Realities in Cyberspace*, ed. Lynn Cherny and Elizabeth Reba Weise (Seattle: Seal Press, 1996), p. 14. According to Ullman, the desire to look fresh, "something fired off," rather than studied, discourages email editing. Eyebeam posts showed more effort at careful composition, yet retained the sense of intimacy and disregard for hierarchy that are email's most endearing attributes. Ulmann's story of an email love affair also has a different dynamic than the very instrumental work group posts she describes. The obsessive and erotic potency of email communication at its most intense is described in S. Paige Baty's *E-mail Trouble Love and Addiction @ the Matrix* (Austin: University of Texas Press, 1999).

8. Roland Barthes, *Mythologies*, trans. Annette Lavers (New York: Hill and Wang, 1972), pp. 103-05.

9. M. M. Bakhtin, "Response to a Question from the *Novy Mir* Editorial Staff," *Speech Genres and Other Late Essays*, trans. Vern W. McGee, ed. Caryl Emerson and Michael Holquist (Austin: University of Texas Press, 1986), p. 7.

10. As an aside, that a group conversation takes place is often enough to catalyze the notion of a "group mind" or "collective intelligence." However, what is this but the enunciative fallacy writ large and applied to a fictive collective persona? Such an idea implies some original unity and one signified that ignores the effort required in very specific ways to materialize a community and its common concern. See Williams, *Keywords*. Howard Rheingold's *Virtual Community: Homesteading on the Virtual Frontier* (Reading, Massachusetts: Addison Wesley, 1993) cannot be generalized to every virtual space online; his community occurred in a particular and bounded context, in the auspicious setting of the highly tended and cultivated discussion groups on the Well.

11. Bakhtin, "The Problem of Speech Genres," in *Speech Genres*, p. 69. Note that this responsiveness is not identical to the notion of a gift economy as it has been applied to and debated on the internet.

12. Martin Buber, *I and Thou*, trans. Ronald Gregor Smith (New York: Collier, 1987).

13. Peter Szondi, *Theory of the Modern Drama: A Critical Edition*, ed. and trans. Michael Hays (Minneapolis: University of Minnesota Press, 1986). The remarkable discovery process of the Truth and Social Reconciliation Commission in South Africa and of a similar commission in Guatamala might be considered a way of producing such dramatic confrontation that furthers or perhaps forces resolution.

14. Allan Kaprow, "The Real Experiment," *Essays on the Blurring of Art and Life*, ed. Jeff Kelley (Berkeley: University of California Press, 1993), pp. 209-12.

15. Kaprow, p. 26.

16. Kaprow, p. 57.

17. Dr. Nick A. Kanas of the University of California and the Veterans Affairs Medical Center in San Francisco cited in Paul Recer (AP), "Cosmic Crankiness Descends on Travelers to Outer Space," *San Francisco Chronicle*, May 21, 1999, Sec. A7. See also, "Russia to Abandon Its Beloved, But Aging, Mir," *San Francisco Chronicle*, June 2, 1999, Sec. A10.

NEXT>

Keller Easterling is an architect and writer living in New York. Easterling's research works include, *Call It Home*, a laserdisc history of suburbia, and a recent book, *Organization Space: Landscapes, Highways and Houses in America*.

KELLER EASTERLING

planation of Remotes : Make a *site plan* composed entirely of the logistical proper-
and physical componentry of large global organizations by cross-referencing and cross-
tching ingredients in the containers network seen here. Containers seen here actually
respond to physical objects whose spatial consequences can be tabulated in square feet.
member the market has no inherent values and the *site plan* as a series of remotes can
ver be viewed in total but only adjusted by new componentry and groupings.

Shred-It enjoys a lack of competition in the mobile shredding market.
collecting and shredding paperby the container for most Fortune 1000
companies in North and South America, Asia and Europe. doug@shredit.com

*Southern Fried Chicken Express, a Finnish Franchise concept
operating succesfully in over 60 countries worldwide and offering
chicken with a mild lemon flavor which is unique and much sought
after. So*

International Sea Land container 40 x 8 x 8/12 ✓		
	✓ Hens	
	✓ Bear Testicles	
	Men's knit underwear	
	Great Danes	
Other....		320 sq.

Tract House	40 x 20 x 10 feet 800 square feet ✓	
darlingest bluebird blue	asbestos shingles	

vinyl tile
contact paper
Washer dryer
Television set
carpeting

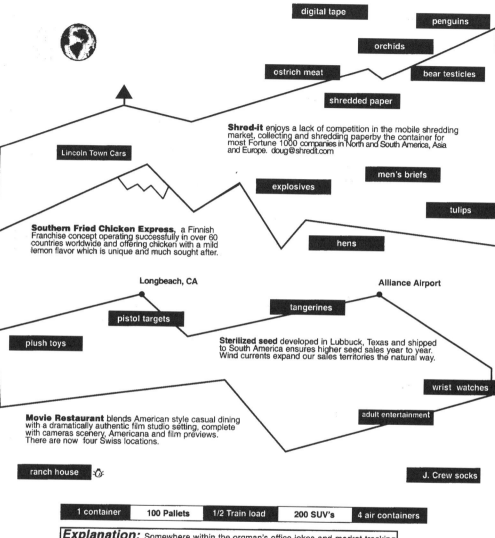

digital tape

penguins

orchids

bear testicles

ostrich meat

shredded paper

Shred-it enjoys a lack of competition in the mobile shredding market, collecting and shredding paperby the container for most Fortune 1000 companies in North and South America, Asia and Europe. doug@shredit.com

Lincoln Town Cars

men's briefs

explosives

tulips

Southern Fried Chicken Express, a Finnish Franchise concept operating successfully in over 60 countries worldwide and offering chicken with a mild lemon flavor which is unique and much sought after.

hens

Longbeach, CA

Alliance Airport

tangerines

pistol targets

plush toys

Sterilized seed developed in Lubbuck, Texas and shipped to South America ensures higher seed sales year to year. Wind currents expand our sales territories the natural way.

wrist watches

Movie Restaurant blends American style casual dining with a dramatically authentic film studio setting, complete with cameras scenery, Americana and film previews. There are now four Swiss locations.

adult entertainment

ranch house

J. Crew socks

| 1 container | 100 Pallets | 1/2 Train load | 200 SUV's | 4 air containers |

Explanation: Somewhere within the orgman's office jokes and market-tracking softward is a **site plan**, a space with no geographic specificity that is calibrated in containers and shipping durations. The containers, like the mid-century tract house, are a form of currency that formats the spaces, vehicles and goods of global commerce. These logistical organizations are the new properties of business and the new gizmos of the orgman. Any single piece of componentry in this network can **remotely** alter

dog toys

POSTCARDS FROM THE SOUTH:
AT THE MARGINS OF GLOBALIZATION

CARLOS BASUALDO

Translated from the Spanish by Vincent Martin

It is curious to bump into an eloquent metaphor on the effects of globalization so close to one's place of birth. On my last trip to Argentina, about a month ago, I had the rare privilege of having such an encounter. My hometown is called Rosario, which lies about three hundred kilometers east of Buenos Aires on the banks of the Paraná River. Located at the center of the country's preeminent agricultural-cattle region, Rosario is a city of immigrants. In the 60s and 70s this city of over a million residents was marked by a growing industrial sector, basically centered on the proliferation of small and medium-sized factories on the outskirts of the urban area. Many of those industries were linked to agro-cattle production. The oldest were located not too far from Rosario's business center, in areas that had been semi-rural some thirty years earlier, and which would later become slowly incorporated into the urban fabric as a consequence of the city's growth. Among them was a combine factory in front of which, as a teenager, I used to pass at least twice a day. I remember that the name of the combines was Gema and that the company's enormous plants were very close to the train tracks that crossed the city's main avenue, the Calle Cordoba. It is not too hard to imagine the magnitude of my surprise when, having just returned to Rosario after an exhausting trip of over twenty hours, I was invited to see a film at a so-called cinema complex that had just opened, incredibly, at the factory's old plant.

NEXT>

The taxi that hurriedly took us to the cinema had no objections to crossing the half-abandoned train tracks. Some ten or fifteen years ago the chances that a cargo train would go by when someone was about to cross the tracks was practically fifty percent. The fact was notorious and the neighbors had even filed complaints about the matter. At that time, the trains were the property of the Argentine State, which in turn had acquired them with a great hullabaloo from their original owners (companies of English origin) in the mid 40s. However, in the last ten years the country has been going through a profound process of restructuring public expenses, largely regulated by the IMF's cookbook, one of whose most important chapters was constituted by the sale of almost all the old State-run companies. The trains used to fulfill several different functions in the country, among which was the transporting of people and farming and industrial products. Obviously, some of the lines were more profitable than others, and this determined the course of the company's privatization process. Today, many of the old train routes remain annulled. In the 70s I remember having repeatedly taken the train to go to the club where I played sports in the city's center. That line no longer exists. Nor does the train that ran between Rosario and Buenos Aires exist. Those who wish to travel between the country's two most important cities, and who do not have a car and lack sufficient funds to pay for an airplane ticket, have only one option: the long-distance buses.

As I crossed the half-abandoned train tracks, it became evident to me that the six years that passed since I had left the country in order to move ahead with my work as an art critic and curator in the United States did not pass in vain. But I felt the certainty that what used to be had painfully disappeared moments later, when I saw that the factory of national combines had vanished in order to make way for a sort of suburb of . . . Miami! The "Village"—this is the name of the complex of cinemas, bookstores, and electronic games, complete with Burger King, McDonalds, and supermarkets into which the huge plants had been transformed—was a precise copy of any mall in the heart of the United States. For someone familiar (even perhaps too intimately) with the deep affiliation between Argentine imagery and the Old World, the vision of a glass entrance to a mall carpeted with little blue and yellow stars and an interminable row of popcorn vending machines seemed little less than surreal. Everything was copied precisely according to its frightful model: from the meticu-

lous uniforms of the pre-pubescent employees to the inflated dimensions of the movie screen. The few (and only) differences merely made the general result seem more sinister: the employees were almost always too attentive and the movie seats were rigorously and absurdly numbered. It was another very clear example of the over-whelming power that the copy inevitably possesses over the original (which has been analyzed to the point of exhaustion by the weary theoreticians of postmodernity). However, I don't wish to refer to the simulated world of consumerism, but rather to the pure and simple fact that a complex of cinemas constructed with foreign capital (Canadian, to be more precise) had cleanly replaced a national factory of agricultural machinery at the very heart of an industrial city located in the middle of the richest region of a country that is characteristically agricultural and cattle-oriented. The image was so extreme in its literalness that it seemed absurd. But I was destined to find its perfect complement a few days later when I decided to travel once more, after many years, to the little town where my grandparents lived and where my mother was born; the town lies 110 kilometers to the east of Rosario, in the middle of the Pampas. To get to Montes de Oca, you have to travel across the new road, a thin strip of asphalt that connects the two most important cities of the country's interior, Córdoba and Rosario. The road was also privatized years ago, and I remember my enthusiasm over the prospect that one of the most hectic means of communication in Argentina would eventually become, at least in part, a brand-new freeway. These were expectations that fully justified the high prices that were charged at the improvised tollbooths since the beginning of privatization. Nearly ten years later, the only thing that had substantially changed along the way were the tollbooths themselves, now more comfortable and spacious and recently painted. Not even the slightest trace was seen of the promised freeway, although, as I was told then, the company responsible for carrying out the project seemed to be on the verge of decid-ing the date to break ground.

The rest of my trip to Montes de Oca was like a profound dislocation of temporo-spatial coordinates. In sum: everything was the same. The verification that every-thing remained the same in a place from which one left long ago could provoke a comforting sensation of well being. However, it put me on the verge of a panic attack. The restaurants distributed along the road were the same; the towns I went through

NEXT>

seemed to have melancholically stopped in time; and, what is worst of all, the names of the herbicides and insecticides advertised on the billboards on the sides of the road were the same. The panorama was even sadder when I saw that, in the countryside, the tractors and agricultural tools that I was able to make out from the road were nothing more than a group of obsolete relics, though lovingly looked after, like the few cheap jewels of a middle-class family that had come down in the world.

I should point out the fact that Argentina was and still is basically an agricultural and cattle-oriented country, and that the products of exportation continue to be predominantly derived from this type of activity. The countryside in Argentina is not one more productive element; it is the center of its exportation ability and of its market activity. The desolate landscape I confronted represents the effects of globalization in a region like the Pampa Húmeda, an area traditionally carved into a myriad of small fields or farms occupied by the children and grandchildren of European immigrants that came to the country in the last decades of the nineteenth century and the first years of the twentieth. The new road crosses the entire south of the province of Santa Fé which, unlike other regions of the country, was profusely subdivided: not so much the territory of large companies as of peasants who own agricultural establishments, almost all exclusively family-oriented. Globalization, associated with price reduction of prime materials, meant for the Argentine countryside the progressive economic deterioration of the small and medium-sized agro-cattle producers and their replacement by large companies associated with foreign capital. In a short time, the economic structure of the region was drastically modified. If this process continues, it is possible that in a period of fifteen more years the country's agrarian structure will resemble what characterized it at the early part of the century: large extensions of productive land in the hands of a reduced number of companies, this time backed by foreign capital.

Breaking the deceptive monotony of the road, I noticed an enormous service station that looked like the only inkling of modernization on the plains of the Pampean horizon. As we approached, our first impressions were fully satisfied: the place was an enclave of efficiency equipped with vending machines with coffee, cappuccino, and sandwiches of all kinds, modern tables with immaculate white surfaces, TV sets

discreetly turned on, and microwave ovens. I'm sure that it would have even been possible to visit the web from some computer terminal strategically located next to the dessert display. And if that possibility remained remote for the moment, I'm sure that the logic that determined it would inevitably wind up imposing itself. Just as in the case of the brand-new cinemas in the city of Rosario, the most flagrant sign of the passing of time coincided with the specific improvement of services. The country's entrance into the first world, so boomingly announced (at least for the last five years by the governors on duty), was only as effective as a beauty makeover. The metaphor is appropriate: under the surface the old scars had only deepened.

An entertainment complex replacing a combine factory, an ultramodern service station on a two-lane road—the eloquence of both images is unquestionable. For the countries of Latin America, globalization has implied the erosion of the national productive capital and its replacement by foreign investors, for whom social priorities and questions of national interest are of little import. As has been said on various occasions, it is a question of a new form of colonialism that is imposed, in these cases, on a situation that had never ceased to be in some way colonial. The effects that this process necessarily brings upon the culture are, to be sure, extremely pernicious, and have scarcely begun to be quantified. On the other hand, the compensation for what happens on the level of the local cultures is that they have begun to be exported and consumed by central countries as a cultural good. The accelerated development of telecommunications has played a fundamental role in this process, which acts as the necessary balance to what has been described above. As the local cultures lose the vitality that characterized them fifteen or twenty years ago, their products come to be progressively accepted by the center, and they incorporate themselves into the center's narratives. The intellectuals of many Latin American countries, in many cases exiles for decades (voluntarily or not), contribute to this process with the conviction of making an important revisionist contribution destined to destabilize the cultural hegemony of Europe and the United States. In fact, it could almost be said that we are the cultural engineers of a new Europe, of some ever-changing United States. The greatest responsibility, and perhaps the utopian and impossible task set before us, consists of preventing our revisionist work to limit itself to the central cultures, insisting on maintaining a

NEXT>

permanent dialogue with the contexts that generated the issues that we discuss and upon which we attempt to reflect. Only inasmuch as we are able to debate ever more effectively the relationship between the local and the new internationalism of globalization, will we be able to avoid complicity with the unleashed forces of domination. The exercise is double: to contribute to a debate concerning the hegemonic narratives in the center, and to a discussion oriented toward the reinforcement of more regional paradigms in the periphery, in order to oppose both obsolete nationalisms and the facile seduction of the new internationalism. The role that the Internet in particular, and new technology in general, may come to play in the development of this strategy cannot, under any circumstances, be underestimated. The panorama is not too encouraging: confronted on one side by the ruins of our cultural memory, and on the other by the imposing and homogenizing machinery of globalization, it has rarely been so arduous for Latin American intellectuals to articulate a coherent practice capable of facing the processes of domination of such magnitude.

The mutable, triadic relationship between art, science, and nature has been the foundation for my investigations over the years. I am interested in the ways in which we (cultures) use science and art as devices or maps to construct belief systems. I like to look at the ambiguities in belief systems, the melding of fact and fiction, and the interweavings of the rational and irrational. "Only Questions" is a project in which I collected and compiled all of the questions asked by the participants of <eyebeam><blast>. A handful of the questions are my own.

EVE ANDRÉE LARAMÉE

NEXT>

ONLY QUESTIONS

1.How are these aesthetic fields positioned, even as they mutate,stratify, or implode? 2. What devices, procedures, and positions constitute the network that informs them? 3. What struggles, alignments, and incompatibilities animate it? 4. What tools do we use to intervene within it? 5. How do we develop informed positions within these territories that go right to the heart of the political question? 6. Qstn n: s rtspk n lss mnngfl wtht vwls? 7. Qstn tw: s gbbldgk n mr mnngfl wth thm? 8. For what purpose, all of this practice, for whom, for what audiences,within what political economy? 9. I really wonder what he means by modernization? 10. Why should artists be so concerned with questions of art? 11. Is it that art has become so hermetic it is left only with its own image to contemplate? 12. Who knows? 13. Should we assume then that this "here" may put us in a more intimate, in a more privileged relationship with art? 14. An art almost already dead? 15. Or maybe you suggest that we should forget about her (not death but art, or maybe both) in this intimacy with the ghostly realm of electronic exchange? 16. How can the Internet be used to strengthen and expand politically oriented cultural collaborations, with their necessary inscription in located and embodied day-to-day existence? 17. Can localized artistic and political practices have a different kind of life on the net, and if so, how? 18. Who knows? 19. What do I know about Malandros? 20. What does a Parisian know about an Apache? 21. What is SAUDADE? 22. does it travel well or ill? 23. is someone who works at a firm and receives intranet email on the net? 24. If she receives internet email? 25. If she has access to external ftp? 26. Should we really be asking for more Gate Keepers? 27. is this "temporal gap" increasing with technological development? 28. "For what purpose, all of this practice, for whom, for what audiences,within what political economy?" 29. So, does "no death in cyberspace" mean "no art in cyberspace"? 30. is there yet possibility for something beyond art, closer to another quality of affect? 31. Where should you/we go? 32. Could you expand a little on what you understand by 'virtual narrative'? 33. Surely all narrative is necessarily virtual? 34. Have we escaped our condition? 35. what [or who] am i staring at? 36. So what form of solid(arid-y) can we find on the net that wouldn't have a psychoanalytic component (matrix-child pair)? 37. yet wouldn't have a troublesome nostalgic melancholic air about it (which Habermas associates with resurgence of 'localized' tribalism/violence /attempt to dissolve the other)? 38. When we proclaim the death of art, whose art do we mean? 39. What art? 40. why on earth is to practice (contemporary) art to touch death? 41. and so what? 42. is arpanet the death of the net? 43. the death of a moo the death of the net? 44. the death of someone like Michael Current the death of the net? 45. the death of anarcho-libertarianism the death of the net? 46. the death of the theory the death of the net? 47. does art have any thing necessarily to do with death? 48. does death? 49. for that matter, what is "no death in cyberspace"? 50. What to do with these visual remains? 51. Politically oriented cultural collaborations ? 52. what constitutes a politically oriented cultural collaboration? 53. Yes there can be an intellectual understanding, but can it go beyond that? 54. what is a network practice, how do we articulate it in all is complexity and diversity, without falling into the traps, without jumping the gun, assuming that, for example, an image exists as such? 55. oh when does it end? 56. Why should artists be so concerned with questions of art? 57. Is it that art has become so hermetic it is left only with its own image to contemplate? 58. I really wonder what he means by modernization? 59. Is Lev aware of this, and how his argument simply deconstructs due to this? 60. what ever modernizing might mean? 61. do we need national schools of net art? 62. Led by great talents of dictatorial artists likening those of the canonized male auteurs of cinema, who have the vision needed for making "real" art on the web? 63. And who is this "we" anyways? 64.While discussing skills in net art, are we discussing technical skills, or issues of content, skills in networking? 65. Are we assuming the web artist to be someone self-contained in his skills, independent in his mastery of the medium, an Artist in the romantic sense -or, good lord, a networker, capable of co-operation...at large from the lonely atelier? 66. Does not matter what is "Art" in this case, or yes? 67. Isn't there also, and perhaps more importantly, a question of audience? 68. Who is the audience for net art? 69. This too, starts with questions of access, no? 70. am i the only one who finds this copywriting strategy of appropriating the net-address syntax and punctuation to make poy look "cyber" a bit idiotic? 71. i want to know who among us are artists who have chosen the web as their principal medium? 72. i mean who's going to take it forward? 73. For what purpose, all of this practice, for whom, for what audiences, within what political economy? 74. Isn't this sort of like the criteria for prime time television educational publications, etc? 75. Do "we" want information to look like that? 76. Thoughts? 77. Isn't it (CHOOSE ONE: ironic.absurd/rather disgusting) that deprivation and lack of access are always "local issues" when the person responding doesn't have a problem getting access? 78.Deleuze and Guattari? The Spanish guys, eh? 79. What are the "borders of artistic practice? 80. Are they not diffuse, or already imploded to a degree that they become meaningless? 81. Isn't the idea of penetrating a border a throwback to an expired avant-garde? 82. Are you posing questions about the different "virtuality" of being defined by numbers on a magnetic strip, or by a retinal scan? 83. Are you implying ethical problems with these technologies? 84. What are the "aesthetic fields" you describe, and what is the "political question"...personal identity, autonomy, being observed? 85. Does anyone recall the role an ATM camera played in the Oklahoma City bombing? 86. Can we represent an alternative to the Sensar Inc world? 87. Can we play the same game? 88. can we use the same language? 89. can we transform it? 90. how do we make a difference? 91. Are there still differences to be desired? 92. Can we believe in something new in the future without believing in our capacity to make a project about it? 93. Are we lost inside the language game of science and technology? 94. Could someone please explain why expansion is seen as immersion, & contraction to beaming? 95. The Big Bang was expansion, The Big Crunch, contraction......it could...? 96. what kind of 'recognition' will we have been waiting for? 97. Guess 'video' will stream my way? 98. But information? 99. What will my upload speed be? 100. How does class enter into these practices? 101. shouldn't we take note of the quasi-demise of what I call the 'darknet,' the older text-based Net? 102. So what sorts of virtualities, subjectivities, communities, are developing in its stead? 103. Can webchat do what IRC does/did? 104. An inverse instance of the above? 105. is it true? 106. something to do with Piaget? 107. why should the lens based scan of an eye have any particular veracity beyond the contingent parameters of our expectations of the media and the 'nature' of the image? 108. is it a useful goal, or a model received from previous generations of artists and critics? 109. What are the "borders of artistic practice?" 110. Are they not diffuse, or already imploded to a degree that they become meaningless? 111. Isn't the idea of penetrating a border a throwback to an expired avant-garde? 112.Why then would we continue to call what-we-might-do "art" and the person who-does-it an "artist? 113. Why might we still harbor such a disingenuous distinction? 114. (impossibly?) 115. Are you suggesting that the development of cybernetic technologies, as such, may help alleviate that problem? 116. Will posthuman cyberintelligence have a more supple approach to human relations than the earlier varieties? 117. Or will it just be more efficient? 118.Sometimes you sound too much like some sort of high school teacher, like when you say that you don't have time for melancholic introspections(?!) 119. "Why is there Being rather than nothing" might conceivably translate into "Why not?" 120. Does anyone else see these parallel? 121. Am I imagining things? 122. In this period of the posthuman, where you figure the human as a distributed cognitive system that includes both human and nonhuman components, what kinds of new languages, can we posit for dealing with our relationship to objects? 123. How is meaning generated here in relation between human and the object, what language arises, and where? 124. What is the code? 125. Given that computers can house "recombinant" digital elements of image, sound and text, how can the artist become an "author" of responsive, self regulating systems that enable "intelligent" emergent poetic responses to user interactivity via the encoding, mapping and modeling of operative poetic elements? 126. How can such an environment enhance or trigger particular "states" of consciousness in the user? 127. To what extent can we "re-frame" aspects of the consciousness of the artist, via specific modes of "translation" of operative poetic processes and poetic elements of image, sound and text, within functional computer-mediated networks? 128. perhaps there would just be a furious clash of 'performances' as each tried to install realities, whether the phenomenological or the political or the luddic (though goodness knows how one discriminates those -- and the performative command is lost at that point, no?) 129. Portuguese Português estranho na propria lingua sem acento sem poesia sem teoria sem fala sem calculo sem ordinateur sem Sao Paulo sem rede sem network sem tradutor sem veracidade sem localizador sem digitalizacao sem o grande deity Komunikassao? 130. essa linua de brasileiro? 131. (as well as some of the interest?) 132. Does some of the ghostliness of which you speak participate in a denial? 133. Are they in Virilio's sense, dromomaniacs? 134. Are they cyber travelers (having already seen the world through the television screens of their lives) disguised as real travelers, virtual nomads disguised as tourists? 135. IS this, to quote Johnny Rotten, a Cheap Holiday in Other People's Misery? 136. television is the 'museum of accidents.' If that is the case, then what is the web? 137. What is the cyber-space? 138. Can poetry be read on the flickering web pages? 139. Does it make any difference? 140. Has it really changed the medium itself? 141. Paris...Montreal "a Canadian"...Moscow? 142. Should a poet publish "on" the web? 143. How can one "publish" "on" something that is not there, and is merely the imaginary flicker [the virtual?] 144. of electronic-chemical circuitry? 145. If all text is a deconstructed seamless flow of breaks and hazards stretching back and forth, sideways and "rolling" into the depths as well as contracting on the surfaces, if the pusillanimous "real" paper texts of the dead cannot reach us and be read, then what purpose to play the margins of the strange dead land called the web? 146. But how can one read a web page? 147. How can Poetry in all its myriad and many difficult forms survive this further dis-

embodiment? 148. Is it desirable? 149. It is one thing to download personal letters, gifts and poetry, prose excerpts, and essays, but does one own want to "down-load" [what demeaning lingo!] the whole cultural inheritance of literature? 150. To what purpose when the books already exist.*** On the other hand, there is always room for experimentation and glorious innovation, and if It Works don't fix it.*** ** No position taken, except that of personal taste? 151. Is that what one is left with in the end? 152. A personal space, a merely personal taste? 153. What is cyberpidgin? 154. Of what does it consist? 155. do we have a good example? 156. Or perhaps I witnessed extravagant gifts being exchanged in the street of little girls? 157. Why bother? 158. so what would be Net.specific? 159. Bandwidth, browsers' interfaces, shockwave, real-audio? 160. "Net.specific" an end in itself? 161. Marketing a worldwide audience? 162. did they determine the design of the film camera? 163. the frame rate? 164. Screen ratio? 165. acceptable length of a feature film? 166. how the film would ultimately be promoted? 167. Is it the delimited agenda that only the socio-political efficacy of art online be at issue? 168. Is this a place for working artists who happen to either do digital image stuff or display what they do in conventional media in cyberspace? 169. what makes good art, or anything Art? 170. is art more good than not-art, or rather is it just more good at being Art? 171. What about netartists? 172. Do they look the same as Real Artists? 173. Or just like actual artists? 174. Or like something entirely new? 175. Has the discourse, or have the social facts, produced interesting images, or facts following images, following facts? 176. Or the other way around? 177. will there be -- or are there already -- netartist Heros? 178. what about with this virtual territory? 179. And its protruberences elsewhere? 180. (brrrr...,cold? 181. warm? 182. Has anyone ever experienced it?...) 183. (Qu'en est il de la memoir information? 184. Pourquoi commencer par toutes ces comparaisons et ces constations? 185. If we do choose, ethically and legally, to take the route of manipulating our genetic make-up then what does this imply? 186. We will still be human? 187. Just how much manipulation would be required before we would have to conclude we are a different race of beings? 188. Doesn't this indeed, represent progress? 189. Doesn't the refusal to admit this amount to self righteous sneering? 190. "Perhaps the lifespan of a species is inversely proportional to its degree of intellectual development? 191. The disembodiment you find politically dangerous, Kate, is perhaps even more dangerous than we think...is this just one more clever way of killing ourselves, out with a whimper and not with a bang? 192. And the idea that the net can somehow breathe new life into Art? 193. My beautiful French wife teaches temporarily at Duke and supports me in my free-wheeling lifestyle: we'll be installing semi-permanently in Paris at the end of this coming summer; any ideas on what I'm going to do there? 194. "Virtual communities of like-minded individuals working together suppressing their own egos in the process"? 195. Do we really want a "disturbed cognitive system" like that? 196. Why all this mail are redirect to me? 197. What are you doing? 198. Have we been hijacked? 199. delete what? 200. (postspeech?) 201. But who is setting the agenda? 202. How does one address one's work to a wide audience on the net without getting caught up in the maelstrom of reorganizing protocols, procedures, and versions? 203. Can I be expected to produce art that supports every browser? 204. If I do, will I have time to read this listservr? 205. The dictatorship of the proletariat, you remember? 206. So how do you collate this sort of reality with your analysis? 207. I don't know about posthu-man. Maybe? 208. Does post happen to us or may we participate? 209. Are we still in the coming-about of the new syncretism, yes, the creolizing into afrojewgreek? 210. (how many tribes or clans was it?) 211. effect? 212. NOW, extrapolation? 213. (how many nationalities is it?) 214. What practice could craft this attention to guide such an experience of postself? 215. PREHUMAN? 216. But what kind of chaos would it spread? 217. Could there be a meme for intersubjective exchange? 218. For intelligent politics? 219. Not sheer diversity for diversity's sake, but a higher level of evolution that preserves and re-articulates the best of human memory? 220. Would that kind of meme qualify as art somewhere? 221. How can I address the localized privileges in my life? 222. Given that computers can house "recombinant" digital elements of image, sound, and text, how can the artist become an "author" of responsive, self regulating systems that enable "intelligent" emergent poetic responses to user interactivity via the encoding, mapping and modeling of operative poetic elements? 223. How can such an environment enhance or trigger particular "states" of consciousness in the user? 224. To what extent can we "re-frame" aspects of the consciousness of the artist, via specific modes of "translation" of operative poetic processes and poetic elements of image, sound, and text, within functional computer-mediated networks? 225. Is it possible to have an electronic disturbance that will significantly alter the Internet, even retrospectively, the way "Les Demoiselles" altered visual representation and would that be a good thing to happen? 226. Was the recent alteration of the Mexican Government Web Site by the Zapatistas an effective intervention or like a Greenpeace publicity stunt (effective but not the main event)? 227. My question then concerns how a contestatory network practice would locate itself, without falling into a 'romance of resistance.'(?) 228. What it is about the MAI treaty that provokes such a reac-tion from people in France? 229. Does this protest against the MAI treaty have anything to do with net.culture? 230. Hasn't the rhetoric of the internet always been about breaking down spatial and temporal barriers, unifying the globe? 231. Why should the freedom of the internet user be affected by the labor conditions of Indonesian work-ers or the kinds of movies shown in Parisian cinemas or on Portuguese TV? 232. Does the research carried out by people like Saskia Sassen on the hierarchical concentra-tion of power in the networked systems suggest anything to the rugged individualism of the electronic surfer? 233. The same question, minus the irony: Can those of us with the knowledge and privilege to use this medium turn some effort to the creation of culturally based forms of political resistance, on an international scale? 234. Speaking of which, what do you think about the current interpretation of SMDM as a masterpiece of critical subterfuge, and the emerging role of Steve Austin as a cult icon among cultural studies graduate students? 235.Weird, huh? 236. But beyond control, could a certain kind of sensitivity to the complex eddies and flows of intersubjective exchange allow one to help precipitate the unknown? 237. Could one, say, recognize pattern formation and intervene where a new pattern could possibly come into forma-tion? 238. Or in another direction: could an aesthetics of patterned consciousness reveal the social nature of human autonomy? 239. Could one learn to accept one's own interventions as precipitating a shared unknown? 240. Could this become a more pleasing and pleasing game than proprietary accumulation? 241. Can we really be sure that this will not affect the Net in a radical fashion? 242. Are "net practices" enough to counteract the fact that more and more software design for the Net is aimed at fire-walling and at making electronic commerce viable. (?) 243. But again, could it be that practices can resist/counteract the effect of software design? 244. The further ques-tion is, do those of us with the knowledge and privilege to use this medium understand the politics this medium involves us in? 245. Every time I help a friend get online or, more generally, use their computer, I wonder whether I am really helping them (especially those who look forward to working at home, invading all their private spaces with the productivity demands of their workplace)? 246. What changes does email, the Web and its underlying technologies bring? 247. Embedded in the technologies that create cyberspace are many peoples' creations and work, done in their particular way for their own reasons; what politics results from all these creations? 248. What about the rest of the world? 249. Or is this medium too "western" in nature? 250. Can we use the Net to create culturally based forms of political resistance? 251. A crucial ques-tion is in how far people who use the Net as artists, activists, or whatever, are able to understand, if not master the technology that they are using, and understand what this technological frame does to their work. (?) 252. Howzat? 253. Continuing, is it just because we lack "language for describing social and aesthetical specificities of networked environments in appropriate ways" that we resort to discourses on art, life and death ? 254. In light of the above, might this not, yet again, simply result from our desire to communicate the communicable to a wide audience? 255. - life and death being ultimately meaningful for all of us? (I think) 256. can we think of network-ing proxemics along these lines, whilst remaining sufficiently close to the (back-)bone of strategy and practice? 257. Why ? 258. Are you suggesting that any interactive work that is emotive is controlling in a negative way? 259. "Do you think 'tropical parrot' is right for you, dear?" said vitruvius. 260. Outside of this territory, which is human rather than strictly geopolitical, to think of any presences on the internet as "Others" is to invite questions over who on the net indeed has the right to selfhood and apart from whom anyone else--everyone else--must be consigned to "Otherness"; who has the right to confer this centrality and preeminence? 261. What possibly could be described as a Mexican style, for instance, or a Chinese style, or a South East Asian style, or an American style, or a Western style, without making the implausible mis-take of grand monolithism? 262. What, stylistically, could possibly bind Jacob Lawrence and Jeff Koons under the girdle of a national style; or indeed Kara Walker and Lyle Ashton Harris. Or Ana Mendieta and Alexis Leyva? 263. What might we possibly claim for Carey May Weems that we may not also find in Christian Botanski? 264. How will people become emotionally invested in the new space? 265. "So why isn't vitruvius a household name?", the skeptics ask. 266. Installations, ant colonies, internets....how does order develop in seemingly spontaneous ways in complex systems? 267. How and why does self-organization work? 268. Is it all one big accident? 269. Or do paral-lel accidents converge in a braided stream of "consciousness"? 270. "What were the essential components that would be needed to create an intelligent entity and how should those components be put together?" 271. (sound familiar?) 272. How Other are you if you have to express yourself in someone's else's language? 273. And, follow-ing Fanon, therefore in someone else's culture and their civilization? 274. Too western? 275. Is not the medium defined by its users? 276. Are we not individuals before we are political beings? 277. Is not the sanctity of our individuality the very foundation of what is best of our "western" way of life? 278. Shall we shape the new medium by

committee vote? 279. "De-westernize" the medium by injecting "otherness"? 280. But shall we spend our time west-bashing, or propagate what is best of the west in terms of democratic and moral excellence? 281. But why stop here? 282. so what are we going to create now, a new "utopia"....based on computers? 283. Where did you study your arts Olu? 284. Do you think for a moment that a Chicano working out of Los Angeles comes up with the same art that a Mexican artist in Mexico City? 285. How about a Jewish and a Palestinian artist , do you think that they are producing the same sort of imagery? 286. I ask, and what does "thematic concerns" come from? 287. thin air? 288. A Mexican Style? you ask.... 289. American style? 290. why do you think Hollywood films are made in Hollywood and not in Zacatecas? 291. Chinese Style? 292. who is this "other" if not the person who is not me? 293. Is the difference between the national and international others not a social construction of the West? 294. Do these others see themselves as self identified "other"s? 295. do they watch and say: Oh here comes another subaltern? 296. Are we interested in hearing what the putative other has to say? 297. What are we willing to displace within our selves to hear? 298. What is the function of the specular, here? 299. what is the access to the mechanical/technical means of transmission? 300. Would some of you be kind enough to share the address of your favorite web piece? 301. "What Do Cyborgs Eat?" 302. (may never?) 303. ¿is there a difference in the way people from different places use the Net to create? 304. ¿Or are the characteristics of the medium too "western" (linear-nonlinear, logo-centric, etc.) for people from cultures that are used to telling in different ways? 305. remember the slogan "Think Globally, Act Locally"? 306. Remember Three Mile Island? 307. "Titanic" is a huge box office hit -apparently 25% of US teenage girls have seen it SEVEN times - does this make it a good film? 308. Consciousness as the "end" product of a series of networked values? 309. Does this seem to be a "stream of consciousness" narrative? 310. If (x) then (?) 311. (the reproduction scam?) 312. And what about Andreas Broeckmann's call for responses from Africa, Antarctica etc? 313. Who is this authentic other which you are searching for , out there? 314. An unconscious search perhaps for the authentic, primitive other? 315. Has anyone got something worth saying? 316. Is anyone actually listening? 317. How is the commercial density of the street enacted on the Net. (?) 318. Is hyperclicking your way from one site to another the lineal equivalent? 319. How does the code through which economic power is made legible on the street reconfigured on the Net. (?) 320. Is economic power legible on the Net the way it is in other material environments? 321. Does the growing dig-itization of economic activities (finance, for ex.) transform the legibility of economic power? 322. Ever noticed how the media process loses everything but the climax or high points? 323. But denying that this happens and is produced every day in many ways, is not an option either? 324. But there is also a specificity to digital space; this specificity is not a given--except in some basic technical sense, but even here we could wire the systems with a different politics? 325. Soft and Aware (what do we know about malandros?) 326. Other Others: what the hacker is that? 327. Does this mean relocating your political consciousness? 328. You don't think that the spread of fire-walled corporate sites on the Web and the more recent surge in software for so-called virtual business networks -- via "tunneling" or encryption -- matters? 329. What do you think about the growing privatization of the infrastructure? 330. Does it possibly signal a time when the price-setting for access will be affected? 331. The question formed in my mind, why do we like to lose control? 332. Furthermore, what is this losing control? 333. an oceanic feeling of fusion with others with all its delicious and dangerous implications? 334. if there is a death drive involved in the temporary loss of ego boundaries,is there also a drive toward creating greater and greater unities or life? 335. Are they so easy to separate? 336. [Western art? Latino art? Eskimo art? Chinese art?] 337. Do you believe that the "net" has its own ["western"] structure which limits how one ["others"?] can make use of it? 338. Do you agree? 339. Who's in charge of this thing, anyway? 340. Do we have a moderator? 341. Have I missed some cru-cial preliminary agenda? 342. If it's about art, have we agreed on a definition, or are we going to talk in ever widening circles of p.c. jargon until we're all bored and go out for some fresh air? 343. I wonder, does he think I have suggested otherwise? 344. Has he an alternative? 345. I would rephrase the questions you ask slightly: 1. What forms of speaking are appropriate to new media forms (not just the Net) for saying things that are important (individually and collectively)? 2. If anyone is listening, then how do they listen to these particular forms? 3. Flowing from (2), how do we get people to listen? 346. Is Keith a minority? 347. Isn't this the content of Keith's work? 348. Does anybody knows where it is? 349. I ask myself, what future has a language, only two million people on the Earth understand, in the "global village". (?) 350. Why to embrace what I am not opened for? 351. And why invest in rejecting it? 352. what is happening (not just here)? 353. English, is that my language? 354. "how did you become fluent in so many languages?" I asked 355. Didn't any of your relatives speak any other languages around you when you were growing up?" 356. Is there no way to embed html in these postings? 357. Can we free the impulse - free indirect discourse - the lived situation. (?) 358. What procedure of identification arises to take its place or augment it? 359.Would that kind of meme qualify as art somewhere?" 360. I would like to ask you "why?" 361. What about firewalls and encrypted traffic causes you concern? 362. Do you think these artifacts are representative of certain processes on the 'Net' that are counter to what you call 'net practices'? 363. Could you tell us what you think that role would be? 364. What kind of ideas do you have about private space online? 365. What do you think helps it, or hinders it? 366. How would you relate public and private space to one another? 367. Summary: How to order this catalogue? 368. "Dancing?" the people say. "Whatever do you mean? 369. Someone once protest-ed, saying "Come vitruvius, surely you do your best work when you're in love?" 370. They are thus in-relation- to the nexus of the self, its dialectical or interpenetrating defining which inverts upon an ego, speaking in which language? -- 371. When I say hello to you, my next-door neighbor, is there not a transmission of an absolute for-eignness; when I speak to my own family, is there not this gap of misrecognition, faltering under the guise of universal enlightenment? 372. Perhaps it's just plain old pas-sion that will fuel the forest fire? 373. Or is the discussion hear mainly about this "z" world we have trouble plotting on our grid? 374. USA? WHERE IS IT? 375. Why do I write this story for you all netpeople? 376. Has anyone them seen it? 377. processes ...'net practices'? 378. - _contours_ of language or a deconstruction? 379. * "privi-leged" - Why do So Many Believe having "access"* to the net is a form of ePrivation? 380. Maybe Millions-Billions of People Could Not care less; perhaps they fear the impingement of Yet another addiction Machine Into their Psychic machinery; Why assume the 'majority' whatever that is, even want to spend their 'time' such as it is, 'on' the net? 381. Who runs the Reality Machine???? 382. Scarcity???? 383. even for those who could afford the very cheap rates --still out of the reach of 2 billion poor// Again the Old Assumption that the Poor Want the same thing?? 384. Why, the captain said is this being put forward? 385. Are we not already poor enough? 386. Whose Principles? 387. Why do "they need to know?" 388. Why would the Poor want to get on Line when they Can't Eat?? 389. But I ask along with William Reich and with Deleuze and Guattari: Why Did the Masses Support Fascism? 390. Why do the Masses always Lie down and Take the Shit which is Meted out to them? 391. How Can I be useful to others. (?) 392. What strange animals lurked inside the danger dynamic of the beast? 393. Why is it that it seems so difficult for you--at least in the context of what you've written--to think of Brazil in relation to any other country/culture that is not the US? 394. why is it that the open process of non-identification that you call cannibalism, tropicalism, etc is reinscribed--in both your discourses--as a national(istic) trend? 395. Why the 'fascination' with the US? 396. Why? 397. " O que jaz no abismo sob o mar que se ergue? 398. What lies in the abyss under the sea that grows? 399. Can we think nationality out of traditional categories? 400. Can we think nationality in a globalized world? 401. Can what is proper fortifies without bringing back its conservative sublimated memory? 402. So what does this have to do with the internet ? 403. How, after all, could astrological causation operate, if it were impossible to coordinate the time of a sublunar event, such as one's birth, with the temporal events in interstellar space? 404. How could a plausible horoscope be written that took into account the radically divergent, multiple temporalities of stars whose light came from vastly different dis-tances from the earth? 405. How do these ruminations on the temporally delayed implications of the discovery of the speed of light help us to understand the second theme suggested by our title, the meaning of the new technologies of virtual reality, or more ambitiously, the purely simulacral world of which they are sometimes taken to be emblematic? 406. Can we simply extrapolate from the lessons of interstellar space to the implications of cyberspace? 407. Haven't we in, fact, argued that the telescope, for all its disruption of notions of visual presence and immediacy, nonetheless resists reduction to an apparatus of pure simulacral construction, a model of total visual semiosis without an original object behind it? 408. isn't virtual reality normally understood as precisely such a reduction, producing a hyperreality that has no referential origin? 409. And isn't that hyperreality often assumed to be rooted in the accelerated temporality, even simultaneity, of a cyberspace in which distances no longer matter? 410. Would this not also be the case for a reality in which the image of a thing still appears, but is no longer there?" 411. is not the light reflecting off us, radiating our images to any eyes open to receive them, somehow destined, even if in increasingly diffused form, to travel forever, making our present the past of innumerable futures still to come? 412. is it "scientistic"? 413. By this I assume you mean, do I think that because some scientific researchers are arguing for a distributed cognition model as the basis for human cognition, do I necessarily think they are correct? 414. Are such ideas teleological? 415. Is this desire? 416. Does it involve possible majorities? 417. Non.identification -- isn't this a intellectual concept? 418. Why is still illiteracy so high? 419. But why have Brazialns to justify themselves for that? 420. What you call nationalistic is cultural -- where else "cultura" and "sociedade" is not seen separately? 421. Why it puzzles you? 422. Sorry, but what kind of possible relation do you have

in mind between favelas and globalization? 423. How would you relate the discussion above with your experience between Argentina and USA? 424. Does this have anything to do with Freud and oral regression? 425. In a "recombinant" art work, what pleasures will reward the reader for what may be random and low-correlation connections? 426. Does randomness have pleasures of its own? 427. Why, he asks, does he subvocalize as well as dial the numbers? 428. What might a 'history of light' entail? 429. Would technology be the mode of processing, producing, and circulating spatial and temporal relationships that have long since been detached from anything astronomical? 430. Is it even the same light at all, this light that hits us through the cathode ray tube? 431. (Hello, question archivist -- Who are you?) 432. As a reader/viewer/participant, how does knowledge of an artwork's production affect your experience? If it were conclusively proved that Nabokov wrote "Lolita" using the I-Ching, would that alter your perception of the text? 433. Why is randomness in hypermedia (particularly hypertext) so often seen as a sign of artistic laziness? 434. Is labor-value (the amount of work the artist put into it) really more important than use-value (what the participant gets from the experience)? 435. Why is it that HT fiction can provoke this type of confusion within a reader? 436. Is it just this lack of an atypical narrative structure [disemboweling the narrative has such a nice ring to it] &/or the actual structural/physical/mechanical differences encountered within the text itself [hyperlinks etc]? 437. That is, if a reader/viewer/inter-actor expects to have invisibly crafted cues/clues/concept arrows concretely embedded/foregrounded in the fiction itself in order to enhance meaning or signification, why bother trying to grapple with new types of fiction/function? 438. ["but what does it MEAN?"] 439. Whatever happened to the notion of reader/viewer actually participating in/cogitating upon a work, and making an overt effort in order to glean something from it? 440. is this "posthuman" any different than the human inscribing itself? 441. Where are we going that we must rush to a so-called posthuman condition? 442. Where are they? 443. My problem is more about how to think their open conception of nationality today? 444. what came back off your piece was a combination of: 1. your initial reactionary comment on Talvin Singh's work (with a tinge of anger of your own ?) 445. But is it sound to accept that detachment as part of our ideology rather_ then simply a nuance of our communication? 446. Has anyone polled the citizens of a dying third world nation on their feelings towards greater bandwidth? 447. What GIS are you attempting to comprehend? 448. Didn't his (Yves Fissiault's) theories of determinism and stochasticity in complex dynamical systems derive from his studies of ant colonies? 449. (I know this is a little off the subject, but it's pretty fascinating, no?) 450. Do you know about percolation theory? 451. He was also making these films about ants.... Do you have any recollection? 452. What happens when we group together a multitude of different people under the guise of lack? 453. What/Who does this homogenization of local and global tactics into a simple dialogue of access/lack benefit? 454. For whom? 455. What makes the power structure of that public sphere which you think is surfacing in the wake of translational corporations any better from those local spheres within which people are already embroiled? 456. The players become larger, the stakes higher, the control moved away from your immediate situation? 457. What makes you call the internet an arena of democratic exchange? 458. What specifically about it is democratic? Who is making the decisions behind it's policies, who is setting the parameters for participation within this arena? 459. Am I mistaken in that assumption, and if so, how? On the other hand, does anyone else shiver at the notion of artworks, hypertexts and so on being calculated to provide the perfect 20 percent repetitiveness? 460. Or perhaps it is power? 461. is this net art, no, yes, maybe? 462. Isn't the Net about communication? 463. The question is: are these positions mutually exclusive or can we combine 1. and 2. as parts of the same "guerrilla" (life, art, existence...)? 464. Are both figures adequate for a "model" of artistic action as intervention inside/outside a culture? 465. Is there a certain topology where center and margins interchange continuously, so in one moment the subject locates him/herself as center and in other moment as margin, membrane? 466. (For the end of god's judgment. is that the translation?) 467. at a certain point Artaud was asked what is cruelty? 468. 'What are poets for in a destitute time?' 469. Isn't National Identity as an open process only a regulative idea? 470. is it interesting and desirable to live without it? is a global identity possible? 471. is global against national? 472. and NOW? 473. why? 474. what is it that makes one the One and the next 475. the Other? 476. why would anyone willy-nilly grant preeminence to a software writer in Seattle over one in Tokyo other than the fact that one has been designated the Other in real-space discourses and therefore, quite uncritically and dangerously, we condemn her to perpetual Otherness irrespective of her significance in, and contributions to, the creation of these media? 477. How can you even contemplate another post given how far behind you are on your other projects? 478.When's lunch? 479. Is it really true that the mind automatically channels contradictory viewpoints into a "continuous, uninterrupted thought"? 480. Seen? 481. Death? 482. Seen More deaths? 483. More Melted bodies? 484. Seen death? 485. Seen bombs? 486. Seen bodies mutilated? 487. What democracy and for who? 488. How does the 'web' feel about death? 489. And bombs and gas masks? 490. Where to? 491. Oh men and women Where to? 492. (where was it or is going to be published?) 493. Or is it possible that even the simplest, most taken for granted, most universally produced, piece of technology, when incorporated into some aspect of a particular culture, so expresses that culture that we can read through it the relative position of that culture in the global economy? 494. Does poor people's housing always look alike? 495. Isn't that already a build in "otherness" in every single story ? 496. Isn't it interesting that in South America nationalisms in XX century have been so closely associated with militarism? 497. "The question, however, which remains to be answered is this: has the signifier 'America' without distinctions, without separation of the South from the North, any possible role to play as far as the Latin American peoples are concerned? 498. Are quilombos still existing? 499. Are they adapted to Brazilian authority thinking or do they share self-regulating mechanism? 500. What would be typical for such a place? 501. Who can now live entirely on coin and paper money? 502. Ever wonder what those Europeans are up to, trying to form a more perfect union? 503. Any thoughts on what happens to the behavior of those using distance technologies when they are not online? 504. Do they/we begin to experience themselves/ourselves differently and so begin to act differently in our immediate setting? 505. How do you understand the relevance of philosophical concepts of "distance" to decisions about design or style in work prepared for electronic distribution? 506. Now again the question is: what kind of world do you want to inhabit? 507. Wouldn't you say we've been living in an attention economy to some degree at least since the 60s, when TV became the dominant force it is today, and very possibly earlier, taking movies into account? 508. Also, isn't it worth distinguishing between different kinds of attention (Benjamin's "Work Of Art in the Age..." being one obvious reference point)? 509. Isn't that precisely a market-based model? 510. Do we need to agree on the latest position of gender theory within women who have been introduced to feminism in 1991? 511. Is the net -are we- ready to do something about these kind of things? 512. Is this one of the cross-platforms that somehow helped to coordinate the diverging terms of discourse -- the different languages, positions, and histories? 513. Are there differences between Hegel and Videla? 514. Would this gaze go out and reach you in reality where and when you need it? 515. Would this gaze go out and reach someone where and when it could be healing? 516. Will it extinguish this fire? 517. Or would it operate, like poetry for Paul Celan, in the too-early and the too late? 518. Do you know the publisher, title and ISBN of the translated book(s) of Kittler's? 519. Maybe the shared thing is there? 520. Can some Brazilians or anyone else tell us more than the New York Times? 521. How to get beyond an imprisoning pseudo-recognition, without losing all the historical-geographical richness and specificity that Pedro describes and whose existence is for me so obvious? 522. Ursula - where can we find out more about the expo and the symposium? 523. What did it achieve, in your eyes? 524. At least promoting solidarity, spreading the news, helping in any way? 525. I still don't see why they should be 'unrecognizable to traditional art discourse' - because gallery-goers and art critics don't know what 'parsing' is? 526. but isn't that a bit like saying the art world cannot understand an artist who makes work about certain intricacies of molecular biology because they lack the discourse? 527. Surely egos, and intention for that matter, are pretty irrelevant when evaluating a work of art? 528. I can say, though, that the power of the work was indeed 'inscribed on the object itself' - here else was it inscribed? 529. Does this make the work less interesting? 530. Michael: an interesting thesis on attention, but what do you mean by a post-material economy??? 531. Quite aside from all the material structures supporting the various nets in which we find ourselves imbricated -inc. the Internet- surely even the most posthuman bodies within them are thoroughly and utterly *material*? 532. I would like to ask: is power related to a specific place or is it a possibility of precisely investing against the solidity of the fixed "locale"? 533. What do we need power for? 534. For becoming mobile centers of power (to gain conditions of existence as individuals)? 535. For constituting a solid powerful place and erase power as "problem" (stopping the inside/outside flow)? 536. ("Why are there still urban planners filling positions in city administrations when there could be art historians, postcolonial critics, gender theoreticians, media analysts and net critics?" 537. "Why are there still media analysts filling positions in monopolistic multi-national communications conglomerates when there could be art historians, urban planners, postcolonial critics, gender theoreticians, and net critics?") 538. ...Surely, sir, your paintings "opened doors" of some description, possibly within your own head, or else why would you have bothered making them in the first place? 539. (are the two mutually exclusive?) 540. Who has? 541. The Sunday guards with their families? 542. Are they governed by reasons of state? 543. Reverse? 534. Reserve? 535. Should the net substantiate more than just what I just mentioned? 536. I for instance would like to hear from the Eyebeam crowd if they think interactive art can save? 537. Prevent? 538. Can an art piece on the net change a man's mind for not raping his girl-

friend, wife,or a total stranger that day? 539. Can it prevent a mother from drowning her newborn baby in a bathtub? 540. in what way the internet might be developed as a support for a more holistic collaborative approach to knowledge and problem-solving across the practices of specialization? 541. "To whom does the schizophrenic write? 542. To whom the psychotic? 543. Would you be that person?" 544. To whom does the schizophrenic speak? 545. To whom the psychotic? 546. Would that you would be, that person? 547. Would that you would be, that person spoken to? 548. From whom is the speaking? 549. For whom is the speaking? 550. Why is it people want to polarize things ? 551. Perhaps Gert wants to out marginalise himself? 552. and just remain outside ? 553. (did you get that in Holland ?) 554. Do you think this sort of visualization would be applicable to Brazil? 555. Why is "art" communication? What does art communicate? 556. about...what was it again? 557. ...netcriticism? 558. --how is it said again?-- 559. Becoming what? 560. Who are the front-line soldiers shining the light of an evolving consciousness? 561. Are we really so afraid that there's a Hitler in our ranks? 562. It doesn't matter what it all means does it? 563. I mean, you want to make things that are cool, right?" 564. I don't know, what do you think? 565. collective_subject ask, "vit are you dancing?" 567. Onno_Guest says, "what the heck...?" 568. collective_subject [to vitruvius]: "are you going to dance? 569. (4 mill americans?) 570. What does the dancer do when she is not dancing? 571. What sort of dancer is a member say of an ecological movement, or were there many dancers say who were members of the Maoist wing of French leftist politics in France in the 1960's? 572. But what of Rilke say? 573. What if Rilke had not written his Sonnets to Orpheus and had chosen instead to act. Must one be silent to act? 574. How do we politic? 575. How useful, for example, would be the work of Barthes and Derrida as a starting point for analyzing hypertext? 576. What is the importance of Deleuze & Guattari's influential idea of the rhizome as a philosophical framework for the web? 577. And, last but not least, what is the worth for web discussions of the dialectic legacy of Adorno in the field of esthetics within the social/political field? 578. Can't we stop thinking that we've to invent the wheel completely? 579. a question that follows on from his analysis is the relationship between such mapping devices, and a notion of critical *agency*. is the webstalker a purely descriptive tool, or does it allow for more or less deliberate and controlled interventions into the mapped webspace? 580. what are artistic projects for the internet that try to tease out and develop new, creative and/or critical forms of agency that are germane to this environment? 581. Brian, could you say a few words about the concept of 'possessive individualism' - i remember from way back when that i looked at the book by - was his name MacPherson? 582. (a forum for true democracy?) 583. Matthew, have you ever heard of the Institute for Old and New Media, working out of Amsterdam? 584. What more is to be said on this? 585. But how far will this comparison take us? 586. Will the architecture of control in the twenty-first century simply be an electronic version of that of the nineteenth century? 587. After all, wasn't it a Panoptic impulse that prompted the U.S. government in the 1950s to try to impose a centralized command structure on the ARPAnet? 588. What will become of privacy if both intimacy and violence can materialize without warning? 589. (Woops! Didn't Benjamin in "Art in the Age of Mechanical Reproduction" call that particular phenomena "fascism"?!) 590. as founding editor of one of the most influential contemporary art organs in the nineties, what in your opinion are the implications of the net. for art publishing, criticism, and the art media in general, and perhaps for media-artist-critic-impressario-consumer relations? 591. in the age of electronic and network publishing and practice, whither the art mag. and its all-powerful editor, and why? 592. Is it not true? 593. How Many Englishs are there in a city like New York, in a city called London? 594. BTW, fellow writers, is the Village Voice (for whom I wrote for many years) the only publication demanding that writers not write about artists whose work they collect? 596. (who are they?) 597. How does it become a tool on the artist palette? 598. How does one design an online space that propagates a community of people who have no time? 599. And, how may attention economies and the aesthetics of navigation be consciously utilized in the creative process of online art work? 600. If art is defined by the audience/market, and there is no marketplace for online art, where does this position artists working on the net? 601. How may this marketplace manifest? 602. (I wonder is Saskia has some thought on this?) 603. Specifically I wish he (Jon) would elaborate on how we may learn from the problems of marketability of conceptual work in the traditional art world? 604. What would compel them to return over and over again? 605. Are we watching idly as it is being defined for us? 606. Or is this an opportunity to help define the emerging marketplace as the existing art world is sitting still, dazed and confused? 607. What do you mean by money? 608. is it paper or electronic... Now, how does this resemble (or not) feudalism? 609. As such, what are the capabilities specific to this instrument and what new questions does it raise? 610. First, what is telerobotics? 611. How is this claim justified? 612. Lacking recourse to an external authority, how can one differentiate a live telerobotic site from a forgery? 613. Finally, does it matter whether a telerobotic site is real or not? 614. We are talking, though, aren't we, Simon? 615. At least, I'm listening ... Only thing missing is a pint or two of beer (or a cuppa) or why not? 616. ... and for Phillipe Mora as well, why not?). 617. What did even that do for the artists in the end? 618. Where's Jules Olitski now? 619. How do you define intelligence? 620. How do you define consciousness? 621. As for "neo-bourgoise", perhaps your preference for Mezcal and mine for fine wines explains that? 622. The question is, on what basis do you make the tactical moves? 623. Using what common sense? 624. Who can offer them, what forms of communication can best propagate them? 625. (Are you serious that the 1969 U.S. landing on the moon could have been simulated???) 626. I'm curious as to why you feel (or maybe if?) that forgery is traumatic? 627. Does the origin of the effect of participation in a mass delusion like the 69 moon landing make the effect any less real if the origin is shown to be false? 628. What authorizes the determination of the human from the point of view of the technological? 629. Art is indeed a polyssemic (?) 630. (is this process already being carried on? 631. Is History, as a discourse technology, being experienced differently anywhere?) 632. Can you give us an example of one of your telerobotic projects? 633. Since you include the 1969 moon landing in your examples of forgery and refer to it as "the widely believed US moon landing," does this mean you have doubts that this event actually occurred? 634. What do these issues imply for your theory of telepistemology? 635. Could you give us an example of one of your "site plans" for cultural habits or production protocols? 636. How do people move through these, how to these see and activate these spaces? 637. How is perception formatted and aligned with buying modes.(?) 638. How is the buying body seen and figured through statistical computations? 639. A related question: what kind of public space is inside (not outside) these structures and systems, and what might be the role of artistic practice in the facilitation of that space? 640. To take the example of the restroom above,what if those who enter the stall are not unsuspecting but instead are actors playing a definite role? 641. How is the viewer/activator seen? 642. Does it matter to them if the site is real or not? 643. I wonder therefore: like we must build the interactive relationship between an artist and a scientist in reference to the new techniques of communication where the principal characteristic is the interactivity? 644. But how then do you prevent someone from simply claiming your work as their own? 645. In the new, attention-economy world order, what differentiates art (or anything else for that matter) from advertising? 646. Perhaps that is intellectual fatigue, or perhaps it is another way of looking at things? 647. Perhaps it is just cynicism regarding what people get up to when they have too much spare time on their hands? 648. We take advice from people we trust - what's wrong with that? 649. It's not perfect, sure, but what is? 650. And how could it be changed? 651. Is that an awful thing to say? 652. How about creating a situation where people really want to find out about your work, rather than pushing it at them all the time? 653. Anybody has read "The Conscious Universe" by Menas Kafatos and Robert Nadeau (a historian of science and an astrophysicist), 1990? 654. Does anyone know who coined the term? 655. What will you do? 656. How will you call her? 657. What now? 658. Will you try to make love with a border, prove you are not a letter with eating a carrot or pay the dragon to burn the book? 659. Remember "The Specialist"? 660. How many people are still in the Bus? 661. But where do digital art and the internet come in? 662. Who then will question its uses? 663. So isn't the cultural studies question more or less infinite? 664. Isn't the net just a particularly promising medium in which to go on asking those questions about each specific discipline: What is it good for? 665. Who is it good for? 666. Where does one turn one's own efforts, and why? 667. I'd never describe myself as Post-Colonial... I mean how could I? 668. (Simon can you enlighten us when you get back from Portugal?) 669. What voices?????? ***************** speak to us *************************************** from the fires of Brazil and Venuzuela? 670. Does the ghost of Vallejos cry out ****** Spain Take This Cup from Me! against the brutality South American faces, even if this time it is disguised as a 'natural' disaster.(?) 671. (Who really proudly includes themselves in this movement anyway, beyond your inner circle of five?) 672. And if art is irrelevant to understand the 'serious business' going on in the 'real world', just what does nettime have that has more potential to effect change? 673. And whatever power you think you have, what good is it when it no longer stands for inclusivity, but for exclusion? 674. If we have such a clear experience of how participation of artists and counter-cultural producers has been squeezed out over the past few years, why not take it into consideration when theorizing the use and full capacities of the net? 675. Why are there still art historians filling curatorial positions in institutions when there could be urban planners, postcolonial critics, gender theoreticians, media analysts and net critics? 676. Why didn't museums ever bother to buy satellite time? Does it make sense that we show computers running digital projects in the art space (appropriating it as yet another medium) or to continue to do individual aesthetic productions on the net and develop a proper digital art discourse (but remaining marginal if not irrelevant to the public affairs)? 677. should he have? 678. should he have not? 679. mazrui concluded that

okigbo's sacrifice was a waste of beauty--yet, as the igbo of biafra say, all beauty end in dirt. if beauty may not rise to the call of the needy, or indeed make way, where then is its essence? 680. when a voice in the wilderness beckons and asks: "there is fire in the forests of Brazil; what shall we do?" 681. shall we cry in return: the horror, the horror. 682. or shall we go beyond the silly rhetoric of bad poetry and do something concrete to help? 683. may we not, on the other hand, exercise our right to face away and indulge in the silly rhetoric of bad poetry? 684. are we under any obligations? 685. are we not, after all, free? 686. what shall we do at the cry of "fire!"? 687. do a net-based installation? 688. write a lyric? 689. apply to the national endowment for the arts for a grant to enable a multi-media event on the tragedy of conflagration, using five hundred bags of lint, two million painted matches with the colors of the Amazon, and fifty volunteers from the afflicted community? 690. paint a mural of fire and redemption? 691. curse the capitalists who are raping the rain forests? 692. face away? 693. or.....? 694. why not? 695. are we not, after all, free? 696. Could you elaborate more on this? 697. How many fires are still left burning? 698. Does such a thing exist, I wonder, or is anybody working on it? 699. Does such a thing exist, I wonder, or is anybody working on it? 700. As an artist hasn't art altered any of your perceptions? 701. Well, why blame earlier victims? 702. Can I visit it, as a "tourist apprentice"? 703. Maybe (or perhaps also) the other way round? 704. I mean is there such a thing as "material" disaster? 705. Riding a bicycle or playing a guitar? 706. "Do you need anything, soldier?" 707. Are those two guys closer to me, than a father defending his daughter, just because we wear the same uniforms? 708. "Is this a sperm, soldier?" 709. "Your grandfather was an Ustasa, wasn't he? 710. Are you an Ustasa too? 711. Begin some discussions about the politics with him and then tell us, what he thinks, will you?" 712. Where shall we go? 713. Who recuperates what in this case ? 714. Could it deliver art to our cognition in a way that is as effective as contemplating a painting , which affect on the soul reaches you after having scrutinized the work many,many,many times,in different moods under different lights? 715. Same for a book,film,.....but infiltrate us in lesser time.? 716. The question I am trying to ask,which Robert found too literal,can art through the matrix of the net provide an interactive deciphering of "The most complex form of knowledge"which is at the base of all art forms? 717. In real time through a new visual language? 718. As I asked, can art save effectively through the web? 719. We could also ask can it deliver representational, iconic symbols of persons afflicted by a tragic epidemic, like aids,that would forgo any"schmaltzy"watered down images and impersonations through mainstream media,and give us the real dilemma? 720. Paul: could you tell us more about your work as DJ Spooky and its strategies for negotiating these gaps? 721. Of course, I basically agree with your comment about the necessity of art historians and art museum but why do I always get so bored with it? 722. Do we hearken back to some shamanistic role? 723. Is there a worry about losing spiritual rigor by becoming part of the larger world? 724. by coming out of our salt mines/monkcells? 725. Or is this just a part of the nineteenth-century crap--part of the problem really-- that still holds the arts in its grip, according to Paul D. Miller? 726. A lot of romancing the shaman that we should de-bunk and toss? 727. No? 728. Yukiko: Could you explain more about this new state of images - this change in the moving image, this image refigured through patterns of mobility? 729. (liana tree?) 730. Isn't it great? 731. How can a group of disparate, local, and relatively unknowledgeable entities interact in such a way as to produce emergent semantic results that exhibit intelligent behavior? 732. What syntactic structures, architectures, or networks, will produce desired patterns of behavior beyond mere compromise? 733. Isn't this the whole point? 734. Could this vein of knowledge contribute to our understanding of dialogue between people, cultures, and institutions in a practical way? 735. I was at a talk with Hal Foster the other night and he casually, out of context, said "it was like a plague in New York in the 80's" ..and the whole audience -educated, mostly white, middle class, academic art audience, knew exactly what he meant - but put a slab of the more general public in the same room and would they know? 736. .. did the bugs from Starship Troopers invade? 737. What would it be to function without this? 738. You ever notice how the most vociferous critics of power seek it most energetically? 739. How does that work? 740. If we follow Dorner's suggestion that "We cannot understand the forces which are effective in the visual production of today if we do not have a look at other fields of modern life" -- why does this lead us back into the museum? 741. Would natural scientists claim that it is possible to experience their object of study? 742. Social scientists? 743. Do theorists of culture claim that it is possible to experience their object of study? 744. CONSEQUENCES? 745. The question becomes, what sort of politics results from these sorts of thinking? 746. What is a politics of multiplicity? 747. How can multiple collectives be thought and practiced? 748. But if the fact of claiming that some groups of people are exploited is itself exploitative (because it submerges the differences of the exploited into an Otherness), how can liberatory thought and practice move? 749. How do we think non-universal, non-essential, social groups (particularly exploited groups) without simply helping to establish their otherness? 750. [the rhizome?] 751. haven't we already learned this lesson? 752. what is at stake in claiming that the web is or is not a rhizome? 753. what do we have to take for granted to believe one side or the other of this question? 754. (a rather totalizing gesture, no?) 755. Is this the art of televison? 756. And besides were the impressionists' ideas of Art crap? 757. tell me, then what is your experience EXPERIENCE that is of science/research/scholarship? 758. Who is the subject when she is not home? 759. Is she the object which moves from Objectivity to Objectivity? 760. causing the dialectical flows to pass through the inertia of the practico-inert? 761. Of the line up at the bus-stop where the reified selves stand each day only wishing the other would disappear, because the other is always 'de trop'? 762. How can one defeat what is the substance and source of one's being? 763. Is this happening in the arts? 764. After all, what we need theory for if it is not for living? 765. (how long will CD-ROMs be with us?). 767. The Web did not exist in its present form five years ago: what is the chance that it will exist five years from now? 768. my question would be where can the interactive net technology deliver such a potent visual stimuli to get a message across without taping in the pornographic jargon? 769. I mean net potentials go beyond the - watching, reacting (learning?) -interactivity of a film?! 770. Where can net technology intervene in deformalising,rending transparent structured social morays that have rooted deep down into the modern social psyche? 771. Is what Marina described really pornography with political statement and social commentary? 772. If yes,could a voyeuristic visual language be developed through the net technology that can both play as a welding material for disrupted and broken cultural institutions? 773. The net as discourse? 774. The net as a violent medium? 775. The net as a secondary body of interactivity for a morally balanced space of reality and readability of transparency? 776. We are all concerning with improper uses of Derrida/Barthes/D&G, so why not of Turing ? 777. "Who are you and why are we here?" 778. Who ev-ver said you couldn't try? 779. Gosh, is there enough money to do this? 780. Are they collectible? 781. Should I save the file to reproduce it again in five years, with better more stable materials? 782. Should I specify that the piece be remade every five years? 783. (perhaps a little like a bygone era of American pioneerism or..?) 784. But isn't there something of a potential here? 785. As I lose my coherence, I wonder what's the difference between a non hierarchical multicultural expression and a lack of focus? 786. In regard to identifying the new actors in this 'Brave New World': post Berlin Wall, post-apartheid South Africa, and on... are not the players the same?: 787. The interesting question is, how would someone with Adorno's insight describe the systematic lures of techno-capitalist rationality today? 788. "What are the functions of these semiperipheral states? 789. Why would a slave want to resolve his servitude to his 'master'? 790. What is this blood for the blood the beautiful dead ones? 791. How does one stay healthy while working with sickness? 792. "What do you think of that?" 793. This statement is tricky business, yes? 794. But, which of us hasn't been moved, enlightened even, by moments of intoxication (whether drug induced or of a more organic character)? 795. And which of us hasn't been intellectually inspired by such experiences? 796. Isn't this in one sense the left doing the work of the right? 797. OR if Adorno is the right, of the right arguing for subtle control mechanisms over everything? 798. Do these distinctions still hold in a culture of category in which the categories are growing exponentially? 799. And yet why did Celan and Adorno correspond if all Adorno had to offer was a moral muzzling? 800. If Adorno meant a total silence then what of his own comparison of Beckett's landscapes to that of the world after the Holocaust (which is not as trite as I have made it sound)? 801. don't you wish that we were in an eighteenth centurydrawing-room?' 802. Might I also suggest that a 'resolution' of master and slave might see the destruction of both categories, not an accommodation to them? 803. Can I recommend Adorno's critiques of both Hegel ('Three Studies') and Kierkegaard ('Kierkegaard. Construction of the Aesthetic')? 804. I assume she refers to prenatal being fathers' sperm? 805. Bracha, couldn't you have squeezed in the word "empathy" somewhere? 806. what is this egoism that allows me to believe that I should occupy the niche of artist - is it so arbitrary? 807. from where come the humours that push me to take exception for myself amongst all the others? 808. Why do I feel I have the right to think? 809. What is there about this place where I live that conspires to bring such common doubt into my thoughts? 810. Should it be that I must seek to gain approval? 811. What is this world to me and can I never cease to be a part of it? 812. So I want to stay can I change it like the slogans on the wall of the school clinic? 813. like they inspire renewal? 814. The question, I think, is: accessible in what form? 815. If direct distribution over a global network wasn't important to your artwork, then was your art really made for the Web in the first place? 816. Who is there to control the environmental performance of TNCs globally? 817. Are we to rely on the good sense of corporate planners to fight off catastrophe? 818. Can we trust the fugitives from law to protect the law? 819. Let me know if someone already has... (Roy Ascott possibly?) 820. would I be immune? 821. The question, I think, is: accessible in what form? 822. If

direct distribution over a global network wasn't important to your artwork, then was your art really made for the Web in the first place? 823. What will become of an artist's precisely rendered 800 x 600 pixel bitmap if screen resolution jumps to 10,000,000 x 10,000,000? 824. So who finally protects the workers inside the U.S. or outside? 825. Who is there to control the environmental performance of TNCs globally? 826. Are we to rely on the good sense of corporate planners to fight off catastrophe? 827. Can we trust the fugitives from law to protect the law? 828. What are we actually watching? 829. Are we not to be allowed the freedom of humour or irony? 830. More to the point, what is wrong with Gullit's point? 831. Who is going to use the technology? 832. Given the entrenched skepticism about bio-engineering, what would make an individual embrace reproductive technologies (the most extreme form of biotech)? 833. Can you help me out here? 834. Finally one must ask, is this structural replication of monu-mentality desirable (at least in its current form)? 835. The same old questions come back haunt us--how is the electronic media artist identity constructed, and who is all this electronic cultural production for? 837. another way? 838. What can you do? 839. Am I wrong? 840. It can't be just those leather coats and boots can it? 841. Have we learnt from documenting ephemeral practices of the 60's and 70's without resorting to coffee table CDroms? 842. Do you really think that Debord's concept of the specta-cle is narrow and can not be use to productively describe the proliferation of commercial porn? 843. It looks as it's more like you are the one who doesn't really have a sense of humour, do you? 844. Do you really want to suggest that watching the Hustler web site is like reading "La philosophie dans le boudoir"? 845. The sexual subject is sat-isfied, for the reproduction we have cloning, sperm banks, test tubes, incubators...but, what do we need a reproduction for, anyway? 846. the new consultancy can do bet-ter than that, you would think? 847. (why so many #?) 848. (the Copernican revolution in problem solving?? 849. (another "not attractive? 850. What breaks the cycle? 851. Anyone going to that? 852. Is the question really unanswered? Or are we just pretending not to know? 853. And what happens when your retirement money is invest-ed in the stock market? 854. Whose health and wealth do you worry about? 855. The great unanswered question might be this: will the rapacious exploitation and effec-tive political monopoly of translational corporations spark any powerful new alliances between bourgeois intellectuals and those who have little or nothing to lose? 856. (remind you of anything?) 857. Anyone have thoughts on this, and how the digital world might overcome these obstacles, or simply be as easily coopted by careerism, pol-itics and greed? 858. So you think it is amusing that governments attempt to control what we see, seek to regulate the internet in order to intercept our communications, and classify encryption as a dangerous munition? 859. Perhaps you imply that "high culture" is more valid, more "authentic" than popular culture? 860. Are you accusing me, or Gullit of trying to shut down complexity? 861. (join forces?) 862. What is the role in this landscape for critical artistic practice? 863. Could you elaborate on this con-fluence of the museological and the urban? 864. What would replacing the institution of the museum with the exhibition as an institution entail exactly? 865. How would the city serve as the privileged reservoir of memory, as inscribed in the body and its lived practices? 866. How much do you hear about the Human Genome compared to microsoft windows? Which of these two is the nonspecialist public more familiar with (knows more about it than just the name)? 867. How many members of the nonspe-cialist public know the difference between DNA and RNA, and how many know the difference between a hard drive and a zip drive? 868. How many more biotech projects can you name that are as big as the Human Genome, and have the same public recognition? 869. Can the same be said for biotech? 870. (is that true?). 871. What is your view, as an entrepreneur, of citizens using stockobjects to communicate with each other, themselves, assuming they are authoring not-for-profit? 872. What breaks the cycle? 873. But what was the price? 874. (who will pay for you to be buried for a year in some arcane coding problem? 875. Is there another way? 876. So, where is the solution? 877. Is revolution as option? 878. It would be easier for humans to set up the objects to fight for, but would it be applied to all the culture..? 879. Can you tell me a bit about the display you did there? 880. What is the role of the architect ? 881. Can you tell me a bit more about how this process works in general, and perhaps more concretely through the example of the Fruit Museum? 882. How do you see the role of the architect and the urbanist in terms of providing public space, to "make public" ? 883. Where are the boundaries between public and private space in the city now? 884. It's like a membrane he's interested in creating. How do you see the distinction? 885. In contrast with Europe? 886. How do you see these exploring or emerging cities in South-East Asia and China, the incredible high-rises in these cities, this vertical-ity? 887. how do you see the development in cities like Kuala Lumpur, and can you talk about this concept of horizontality instead of verticality? 888. Are you interested in bringing environmental issues back to the city? 889. Could one extend this to a building - a "building on the move", in permanent transformation? 890. Can you talk about this kind of shifting/floating between the two, this in-between-ness? 891. How many people work in your office ? 892. Could you tell me about the process of the work-shops? 893. Would you call it a collective building, a collective process? 894. Architecture as a trigger? 895. post human? 896. Strikes me as profoundly human, no? 897. Was it produced by Anne-Marie Duguet? 898. Who is there to control the environmental performance of TNCs globally? 899. Are we to rely on the good sense of corporate planners to fight off catastrophe? 900. Can we trust the fugitives from law to protect the law? 901. Who is there to control the environmental performance of TNCs global-ly? 902. Are we to rely on the good sense of corporate planners to fight off catastrophe? 903. Can we trust the fugitives from law to protect the law? 904. So your questions were like saying, hey, where is that long due essay? 905. What "problem" did you have in mind exactly? 906. And how was the "holocaust" a solution to it? 907. Do you real-ly think that the systematic humiliation, expulsion, imprisonment and murder of several million people was an accident like a plane crash - or a natural catastrophe like a hurricane or an earthquake? 908. Just one of those things ... ? 909. can we conceive of a anti-monumental memory of the city and enhanced it through an art exhibition? 910. Isn't that a suitable description for the urban? 911. Have "authoritarian personalities" really faded away, or do they just have new uniforms and/or camouflages? 912. Why can an artist more easily assimilate into this discussion with less friction if they are versed in the apparatuses of French and German intellectual thought? 913. How does it happen that meanings and domains of knowledge are so often (if not always) nonexistent until we coax them into existence? 914. Any ideas? 915. EVIDENCE? 916. Where does the boundary between determinism and contingency lie? 917. SITE FACTORS might determine which pathway post-disturbance succession takes (?) 918. acci-dent? 919. "What is science hiding? 920. Where did that trajectory go? 921. Into the W.A.S.T.E. bin? 922. are we working for life, or are we working for death? 923. "Who are the brain police?" 924. "She had heard all about excluded middles; they were bad shit, to be avoided; and how had it ever happened here? 925. With the chances once so good for diversity? 926. Buckminster Fuller who could convincing create plans of cities that could float in the air? 927. Iannis Xenakis whose symphonies could be trans-lated into architectural schematics? 928. A.G. Rizzoli's ficitional palaces? 929. Is it for their lightness That you reproach our tents? 930. Have you eulogies only for hous-es of mud and stone? 931. "What about the fire in Brazil?" 932. If you're interested in alternative futures, why talk about memory? 933. And why those restricted "Euro-ref-erences" that annoy the Subliminal Kid? 934. But hey, aren't we supposed to have gone past the stage of the hybrid identity? 935. Are we not now, in the wake of that bad phrase called "globalisation" in what I would call connectivity land? 936. I would like to ask about what qualifies as "real people" and "homeland", because that is what is being disputed now and will continue within cultural theory? 937. Does anyone care anymore about the artificiality of the seductive digital image, which cannot be any-thing but artificial? 938. But would you also credit the fact that during the 80's in Glasgow, working in relative isolation before the popularity of Photography as art, my contemporaries included Christine Borland, Douglas Gordon and Roderick Buchanan? 939. So here it comes, what is non-western about my practice? Why does Alstatt feel the need to label me as a Nigerian, when I hold now a British citizenship. Does the virtue of having been born elsewhere leave traces that ensure that one can always return to the authentic "homeland"? 940. Or rather is it not impossible to return, yet one never truly forgets, even though one doesn't feel to fit into the new adopted "home"? 941. "Between worlds"? 942. What would one's aesthetic be? 943. Would it be, as I would suggest that of the "mistaken identity?" 944. Would you say that this misunderstanding was fortunate in that it has motivated nearly 400 years of critical development? 945. Why did "fetish" have such rich evolution, and not some other word from this pidgin situation? 946. Perhaps it is time to find another term from a similar setting, perhaps one just emerging now, in order to jump out of "fetish"? 947. Can they exist in the same moral universe? 948. What can one say? 949. And if in expressing the malevolent sights of that inward eye we alight on beauty as our transport, will not that beguil-ing craft capture the reader and conduct him into depths to which he otherwise would not have descended? 950. Why this exasperation in the face of Invention?? 951. Why this small reaction in the face of Imagination?? 952. Why should a thinker rest easy with a simple vocabulary? 953. Why should she do that? 954. A parody? 955. Why because you don't understand it and don't have the humility to admit so even to yourself? 956. Sense in your world? 957. Are you writing out of that vacuum of meaning called common sense? 958. What sense doesn't it make sense to? 959. Whose sense? 960. Whose epistemology? 961. Whose ontology? 962. Yours? 963. What is that ontol-ogy you are speaking out of? 964. What art have you practiced? 965. What writing have you done that dares to take language beyond its norms and to be inventive and that takes risks with both language and sense? 966. What does it mean Empathy? 967. have you show any Empathy to the author whose work you attempt to be caustic about? 968. And why? 969. Do you really believe this? 970. First of all, how can "critical artists" bring the knowledge out of the labs? 971. You presume there is knowledge

to be brought out--what if you presume mistakenly? 972. How could they know? 973. Do they know what's happening with D & G? 974. Or Lacan? 976. Are not the languages used in these specialized fields highly specialized themselves? 977. Do you, as a critical artist, think you can, without years of dedication, without learning the language, begin to understand particle physics, or the habits of retro viruses enough to present them to the nonspecialist public? 978. But what of "Asia" ? 979. And the futures? 980. And the "Asian" city? 981. Love? 982. (even Lysistrata - how many schooled in Latin, Greek?) 983. Stop the war? 984. Or, how many apologies for not being "good enough" does a priest have to make as he is grotted or slaughtered with baseball bats in the hands of adolescents? 985. Which of her 'neologisms' were irrelevant? 986. Shall we say, in good 'proper English' We could not Care Less, or say Care less????? 987. Why? 988. Is it a coincidence that so many have written about her work??? 989. So many women and men of words have been drawn to her and her work??? 990. Is it is a coincidence?? 991. That she Makes you Question Your position? 992. Que Dirait Eurydice? 993. What would Eurydice Say? 994. Do you think this is right? 995. (are you listening, Alan? 996. Are these issues considered unpopular? 997. Unfundable? 998. Unexciting? 999. how many sweatshops in your home city? 1000. how much casual labor? 1001. And why would we resist that passage unless our own refugee selves trammeled in 1002. repression were screaming however quietly that we desired our own death that our desire desired us to repress and forget our repression and forget the act of forgetting? 1003. Yet if we are too get through the madhouse we now come to accept as everyday life, where violence is the norm how can we with any sanity refuse what is after all a very real work that makes maps of what it has seen? 1004. We call the body and mind separate things - but it is not so - what is this this actual moment here as I write to you Readers but the mind that has made a body in the ether in the body which has now grown new organs and made desire another space in which to walk its ways? 1005. Shall we love her or hate her? 1006. 'What is this escape? 1007. Who can resist this? 1008. who can say this is not the path to tread? 1009. Therefore how can one imagine an art-form which realizes itself pas the anxiety which toils nightly in our bodies? 1010. Who knows the answer, who knows if life is death or death is life? 1011. And has not Feminism in all its varieties not done exactly what the young boy hoped and longed for? 1012. (who was who said: "There may be hope ...but not for us"?) 1013. I wonder if you could offer some advice about the premise of the new consultancy sponsored by the emerAgency? 1014. 'For without a disturbed sense of ourselves,' he maintains,' what will prompt most of us...to turn outwards toward each other, to experience the Other?' 1015. Why can they only make the assumption that new technologies solve problems? 1016. Yet, is art communication? 1017. Can one say that the postal system is a new medium for making art? 1018. Why would they care? 1019. But what does this information actually tell you? 1020. What does it mean to have a heart rate of 110 beats per minute? 1021. Is that healthy or cause for concern? 1022. And who is Simon Tegala anyway? 1023. Does he really exist or is he the figment of someone else's imagination? 1024. Is he someone moving about the city at this very moment that we are gazing at his heart rate? 1025. When the images of 'precise' target bombings were beamed into our homes, how many of us questioned the precision of this new technology or considered the effects of this anonymous technology on individual (and invisible) lives? 1026. You're playing a political game with AIDS,aren't you? 1027. The other side? 1028. Which other side are you talking about? 1029. The patients? 1030. Non-government forces? 1031. Anyone who is doing research, any doctor dispensing hi-tech drugs, are they all to be lumped together with the evil drug companies? 1032. Evil governments? 1033. Can you blame me? 1034. How does one for instance, think the question of trans-sexuality? 1035. What are the biological differences which present themselves as memories which cannot be said to be exclusive to either male or female subjects? 1036. But what happens to the male-being during the various stages of conception, pre-birth and birth? 1037. At least in one type male body say 5000 years ago or more? 1038. A chance for bodies meeting? 1039. [dare I say it?] 1040. their union? 1041. (I always regret. Is there anything else?) 1042. Shall I, now, almost about to leave Japan, within another two weeks, begin already to speak of exile, this body robbed from myself, not my own, or doubling homes or vacancies? 1043. What happens in the process of cauterization, displacements from which one slides into the flesh or skull of another? 1044. Home or nation or _name? 1045. What are the bones or processes of bones in this maternal safety, as if exile were an addiction, a drug, as if there were a _gathering_ of sorts, a coalescence, around this one word, _Japan_? 1046. (What if there were no word? 1047. What if the maternal is nothing more than the comfort of ignorance?) 1048. I am more concerned, that whilst the boundaries of science and art need to be brought together, it is vital to ask what we aim to achieve by this process-anew 'truth'? 1049. But refuted by who? 1050. I applaud CAE's motives in somehow 'redressing' the balance between the lab and the outside, but why should artist ethical doctors of this ailment? 1051. Can any one tell me when in the history of western art it had been possible to change societal aims through the emancipatory aspects of art? 1052. Is this not a case of borrowing from the language of the institution to show how clever we artists are? 1053. I would like to end by asking what qualifies an artist in these days? 1054. Is this how you would categorize the work of Caravaggio, for his critiques of the Catholic Church? 1055. Jonathan Swift, for his satires of Britain's inhuman public policies in Ireland? 1056. Goya, for his swipes at the Spanish aristocracy? 1057. Manet, for his unmasking of the idealization of the female body? 1058. Picasso, for Guernica and his open hatred of Franco? 1059. Duchamp for his critique of outdates notions originality and the fetishization of craft? 1060. Beckett for his focus on the perspective of homeless people in many plays? 1061. Warhol for his subversively ironic celebration of the vapidity of American consumer culture? 1062. All the artists involved in creating "A Day Without Art" to raise consciousness of AIDS? 1063. Or do you simply reserve your hatred of pseudo-political art for some unnameable OTHER out there who asks too many probing questions about your institutions practices and your taste? 1064. (on May 1--is the date significant?) 1065. Cage's experiments with allowing chance and random phenomena enter into the creative process are already being recast with computers that can generate and run programs that appear to articulate "randomness" - what's next? 1066. goodbye? 1067. What is the basis for justified true belief under these conditions? 1068. Is there a difference between good ol' hacking and these types of 404 uploads?

Robert Adrian is a Canadian artist working in various media including, since 1979, telecommunications media. He lives and works in Vienna.

Oladele Ajiboye Bamgboye is an artist whose work concerns Nigerian life and the politics of African identity.

Saul Anton is a writer and critic living in New York. He has written for *Artforum, Artext*, and *frieze*, as well as Salon and FEED. He is currently the website editor for *Artforum*.

Adnan Ashraf is a writer working in the digital field.

Robert Atkins is a Research Fellow at Carnegie-Mellon's Studio for Creative Inquiry, editor-producer of *Artery: The AIDS-Arts Forum*, and arts editor of *The Media Channel*.

Ricardo Basbaum is an artist and writer who lives and works in Rio de Janeiro.

Carlos Basualdo is a poet, critic, and curator based in New York. He is a curator at the Wexner Center for the Arts in Columbus, Ohio; a member of the curatorial team of Documenta 11 in Kassel; the International Coordinator for Apex Art Curatorial Program in New York City; and a co-founder (with Hans Ulrich Obrist) of the Union of the Imaginary, an online forum for the discussion of issues pertaining to curatorial practice.

Ursula Biemann studied art and critical theory in Mexico, at the School of Visual Arts (BFA), and at the Whitney Independent Study Program in New York (1988). Her art and curatorial practice relates to the representation of minority identities and discourses of gender in the media and in post-urban zones, such as the US-Mexico border or Istanbul. Her videos include *performing the border*, on the gendered condition of the global digital industry; and *Writing Desire*, on female sexuality and the bride market in cyberspace.

Simon Biggs is an artist working with digital media since the late 70s. His practice has primarily involved working with immersive interactive environments utilizing remote sensing technologies and behavioral systems, but he also works with the Web, CD-ROM, and animation. He is currently Research Professor (Fine Art, Digital Media) at Sheffield Hallam University, UK, and lives and works in London and the Peak District of Derbyshire.

Josephine Bosma is a journalist and writer who lives in Amsterdam. She has published articles and interviews at *Mute* magazine, *Telepolis* online, *Ars Electronica* catalogue 98, and several books on net art.

NEXT>

Mez (Mary-Anne) Breeze is a professional net.wurk artist who has exhibited in a multitude of venues and journals both online and off. Mez holds degrees in applied Social Sciences and Creative Arts, is the avataristic author of the networked polysemic language system termed *mezangelle*, and has her wares regularly displayed on the conference circuit. Mez contributes to online e-zines such as *Cybersociology, Switch* at the CADRE Institute, *Journal of Media, Meaning, Communication & Culture*, and *Untold*.

Andreas Broeckmann, who currently lives in Berlin and Rotterdam, works as a project manager at V2_Organization, a Rotterdam-based center for art and media technology. He is co-maintaining the V2_East/Syndicate mailing list on the Internet, which distributes information about electronic arts events among more than seventy artists, curators, and institutions in most European countries; and he is one of the founders and coordinators of the European Cultural Backbone (ECB), a network of European media cultural centers.

Craig Brozefsky is a Lisp programmer who spends much of his time participating in the Free Software community on such projects as Debian GNU/Linux.

Robert Cheatham is the senior editor of *Perforations*, and a founding partner of Public Domain, Inc., a non-profit organization devoted to an examination of the crossing of art, technology, theory, and community. He is also an installation artist and musician.

Jordan Crandall is an artist and media theorist who focuses on the cultural, subjective, and political dimensions of new technological systems. An anthology of his critical writing on technology and culture will soon be published by the Neue Galerie Graz and the Zentrum für Kunst und Medientechnologie (ZKM), Karlshrue. He is the author of *Suspension* (Documenta X, 1997), the founding editor of Blast (http://www.blast.org), and director of the X Art Foundation, New York.

Critical Art Ensemble (CAE) is a collective of five tactical media artists of various specialization including computer art, film/video, photography, text art, and performance. Formed in 1987, CAE has been focusing on the intersections of art, critical theory, technology, and political activism.

American media artist **Andy Deck** lives and works in New York City. He is the founder of Artcontext, which aims to develop collaborative process in the context of art and connectivity. He makes public art for the Internet that resists generic categorization. Among his best-known works are *Graffic Jam, Icontext, Space Invaders Act 1732, Commission Control, Open Studio*, and *CultureMap*.

Ricardo Dominguez is a co-founder of The Electronic Disturbance Theater (EDT), a group who developed Virtual-Sit In technologies in 1998 in solidarity with the Zapatista communities in

Chiapas, Mexico. He has been a Digital Zapatista since 1994 (www.ezln.org). He is Senior Editor of *The Thing* (bbs.thing.net), a former member of Critical Art Ensemble, and a Fakeshop Worker, a hybrid performance group presented at the Whitney Biennial 2000.

Keller Easterling is an architect and writer. She is co-author of *Call it Home*, a laserdisc history of American suburbia from 1934-1960. Her most recent book, *Organization Space: Landscapes, Highways and Houses in America* (MIT Press, 1999), looks at eccentric episodes in the development of American infrastructure and development formats. She is currently working on a book about exported American formats. She is a professor in the School of Architecture at Yale.

Ellen Fernandez-Sacco is currently completing a manuscript called *Racial Displays: Creating Identity in the Cultural Landscape of the Early Republic* as a Post-doctoral Fellow at the Bain Center for Research on Gender at the University of California, Berkeley.

Coco Fusco is a New York-based interdisciplinary artist and writer. She is the author of *English is Broken Here: Notes on Cultural Fusion in the Americas* (1995), and the editor of *Corpus Delecti: Performance Art of the Americas* (2000). Fusco is also an associate professor at the Tyler School of Art of Temple University.

Alex Galloway is Editor and Technical Director of Rhizome.org, a leading platform for new media art.

Joy Garnett is an artist who makes paintings derived from scientific and pseudo-scientific images. She is interested in the relationship between the intended uses of such images and the fantasies they inspire as they are transformed into instruments of adventure, romance, reverence, and fear by popular imagination and culture. She is a co-founder of First Pulse Projects, Inc., http://www.firstpulseprojects.org, which produces collaborative projects between artists and scientists, as well as the founder and editor of *Newsgrist*, an alternative electronic news service for the arts community.

Michael H. Goldhaber is working on two books, one on the attention economy, the other on science and the social construction of reality. Formerly a theoretical particle physicist, a Fellow of the Institute for Policy Studies, in Washington D.C., and editor of *Post-Industrial Issues*, he now lives in Oakland and is currently a visiting scholar at The Berkeley, and a columnist for *Telepolis*, the German web magazine.

Marina Grzinic Mauhler is doctor of philosophy and works as a researcher at the Institute of Philosophy at the ZRC SAZU (Scientific and Research Center of the Slovenian Academy of Science and Art) in Ljubljana, Slovenia. She also works as a freelance media theorist, art critic, and curator. In collaboration with Aina Smid, she has produced more than thirty video art projects,

NEXT>

a short film, numerous video and media installations, Internet websites, and an interactive CD-ROM. She has published hundreds of articles and essays, and five books.

N. Katherine Hayles, Professor of English and Media Arts at University of California at Los Angeles, teaches and writes on the relations of literature and science in the twentieth century. Her current projects are two books on electronic textuality, *Coding the Signifier: Rethinking Semiosis from the Telegraph to the Computer*, and *Linking Bodies: Hypertext Fiction in Print and New Media.*

Susan Hapgood, Curator of Exhibitions at the American Federation of Arts, is an art historian who has written numerous articles and reviews, and organized exhibitions for the past fifteen years, including *Neo-Dada: Redefining Art, 1958-62* and *Fluxattitudes*. She co-produced a web project that was later adopted by the Guggenheim Museum's cyberAtlas.

Brian Holmes is an art critic and translator living in Paris. He holds a Ph.D in Romance Languages and Literatures from the University of California, Berkeley.

Martin Jay is Sidney Hellman Ehrman Professor and Chair of the History Department at the University of California, Berkeley. His most recent books include *Downcast Eyes: The Denigration of Vision in Twentieth Century French Thought* (University of California Press, 1993), *Force Fields* (Routledge, 1993), and *Cultural Semantics* (University of Massachusetts Press, 1998). He is currently writing a history of the discourse of experience in modern European and American thought.

Bill Jones is a media artist, writer, and editor. He was the founding editor of the film and video journal *The Independent, Trans*, and most recently *ArtByte*. He is currently Chief Operating Officer of CharacterWare, developer of interactive 3D characters for computer, Internet, and wireless platforms. Exhibitions of his work include *Bill Jones: 10 Years of Multiple Image Narratives* at The International Center of Photography, New York, and *Bill Jones: A Survey* at The Vancouver Art Gallery.

Tim Jordan is the author of *Cyberpower: The Culture and Politics of Cyberspace and the Internet.*

Knowbotic Research, KR+cF (Yvonne Wilhelm, Alexander Tuchacek, Christian Huebler), is an artist group that has received major international media art awards, including Prix Ars Electronica 93 and 98; and Medienkundtpreis ZKM Karlsruhe 95. KR+cF teaches New Media at University of Art and Design Zurich, and was an Austrian participant at the Venice Biennale 99.

Bracha Lichtenberg-Ettinger is an artist, theorist, and psychoanalyst working in Paris and Tel Aviv.

Eric Liftin is principal of MESH Architectures, a New York firm that combines the practice of physical and web architecture. He founded MESH in 1997 to work toward the eventual integration of these spaces.

Lev Manovich frequently lectures around the world on new media aesthetics and digital cinema. He is the author of *The Language of New Media* (MIT Press, 2000).

Pedro Meyer was responsible for creating the Latin American Colloquiums of Photography, now into their twentieth year; he also founded the Mexican Council of Photography. He created the first CD-ROM that was produced with photographs and sound, *I Photograph to Remember*. Most recently he has been involved in creating a website dedicated to photography called ZoneZero, which presents the work of photographers, artists, and writers from all over the world.

Paul D. Miller, aka DJ Spooky That Subliminal Kid, is a conceptual artist, writer, and musician. As DJ Spooky That Subliminal Kid, Miller has recorded numerous CDs, remixed everyone from Steve Reich to Metallica. A senior editor-at-large at *ArtByte* magazine and a regular contributor to *Contentville* (a new online publication of Brill's Content), Miller's articles have appeared in *Artforum, Parkett,* the *Village Voice, Spin's Guide to Underground Culture, Paper, Nomad,* and online magazines such as *Slate* and *Word.com*. He live and works in New York City.

Margaret Morse is Associate Professor of Film, Video, and New Media at University of California, Santa Cruz, and author of the book *Virtualities: Television, Media Art, and Cyberculture*.

Sally Jane Norman, an adoptive European of South Pacific origin (New Zealander/ French), is a cultural theorist and practitioner working on art and technology links and issues. She is the director of the Ecole supérieure de l'image (Angoulême/ Poitiers) in the Southwest of France.

Since 1993 **Hans Ulrich Obrist** has run the Programme Migrateurs at the Musée d'Art Moderne de la Ville de Paris. He was the founder of the migratory Museum Robert Walser (1993) and the Nano Museum (1996). Since 1997 he has been editor-in-chief of *Point d'Ironie*, which is published by agnes b. Most recently he curated the first contemporary art show at the Sir John Museum in London, *Retrace Your Steps: Remember Tomorrow*. He lives and works in Paris.

Luiz Camillo Osorio is Professor of Aesthetics at Universidade do Rio de Janeiro. He is also an art critic contributing to *O Globo* newspaper, and to various cultural magazines and art catalogs in Brazil.

Daniel Palmer is a Public Programs Coordinator at the Centre for Contemporary Photography in Melbourne. He is currently completing a Doctorate in Cultural Studies on New Media Research on New Media at the University of Melbourne, and is a regular contributor to local and international art journals.

NEXT>

Saskia Sassen is a Professor of Sociology at the University of Chicago. Among her latest books are *Globalization and Its Discontents* (New Press, 1998) and *Quests and Aliens* (idem, 1999). Her books have been translated into ten languages.

Waltraud Schwab is a freelance journalist in Berlin. He turned thirty-three the year the wall came down.

Yukiko Shikata is an independent curator and critic of media and contemporary art. Since 1990, she has been co-curator of Canon ARTLAB, and has produced many works of media art. She works as a Japanese editorial advisor of *ART AsiaPacific* (G+B Arts International), and is a member of command N, a non-profit arts organization in Tokyo.

Matthew Slotover co-founded *frieze* magazine in 1991. He is also co-founder of Counter Editions with Carl Freedman and Neville Wakefield. The aim of Counter Editions is to commission and make available limited edition artworks of the highest quality at affordable prices. We can do this by producing a relatively high number of editions (300) and using economies of the internet to show, sell, and fulfil the orders.

Alan Sondheim lives in New York City with his partner Azure Carter. His work is available on CD-ROM from Railroad Earth.

Brett Stalbaum is an artist from San Jose, California, specializing in tactical network algorithm development, net.art, network theory, and net aesthetics. He is co-founder of the Electronic Disturbance Theater and is a research theorist and programmer for C5 corporation. In addition to his work with EDT and C5, he teaches network art and computer programming at various Bay Area colleges and universites.

Gilane Tawadros is the Director of the Institute of International Visual Arts (inIVA) in London, an organization which has been at the forefront of developments in contemporary visual art, new technologies, and cultural diversity in both national and international contexts. Since its founding five years ago, the Institute has established partnerships with a wide range of individuals and organizations worldwide to realize an innovative and internationally-renowned program of exhibitions, publications, research, education and multimedia projects.

Andrej Tisma is a Novi Sad (Yugoslavia)-based artist, art critic, and curator. He is the Founder of the Institute for the Spreading of Love (1991) and Embargo Art campaign (1992).

Gregory L. Ulmer, Professor of English and Media Studies at the University of Florida, is the author of *Heuretics: The Logic of Invention* (John Hopkins Press, 1994). His current project in collaboration with the Florida Research Ensemble is a choragraphy of Miami.

Sjoukje van der Meulen, a Ph.D. student in Architecture at Columbia University, New York, is an art critic and curator.

Ben Williams has written about music, art, theater, movies, and the internet for the *Village Voice, Artforum, Paper*, and *Citysearch New York*. His essay, "Black Secret Technology," is included in the collection *Technicolor: Race and Technology in Everyday Life*, forthcoming from New York University Press.

(There a few omissions to these Notes because the contributors could not be located.)

NEXT>

INTERACTION is the inaugural publication of an innovative new series of books on new media and the arts co-published by D.A.P./Distributed Art Publishers and Eyebeam Atelier, a not-for-profit new media arts organization established to provide access, education, and support for students, artists, and the general public in the field of art and technology. Amy Scholder, Series Editor, also edits books for Verso, Serpent's Tail, Grove Press, and The New Museum of Contemporary Art. Jordan Crandall, Guest Editor, is the founding editor of Blast and director of the X Art Foundation. John S. Johnson is the Executive Director of Eyebeam Atelier, which is currently planning a new 90,000 square-ft. facility devoted to the collaboration of art and technology. The new building will be located in the Chelsea area of New York City and will serve as a public resource for the dissemination and discussion of cutting-edge new media art projects.

A study guide was made especially for **INTERACTION** for Lisa Safier. It is a learning tool for students and teachers to explore this book in depth. Find it at www.eyebeam.org.

The next books in the Eyebeam series will be *Re:Play* about the design and culture of digital games, and *Revisioning Television* about the new dimensions of television as a medium for mass media, interactivity, and the arts.